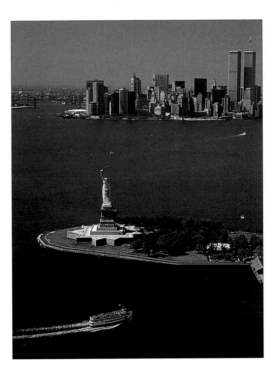

A multitude of little sails seemed to skim the water—our fellow travelers pointed out

a cloud of smoke at the farther end of the bay—it was New York!"

Frederick Auguste Bartholdi
19th-century French sculptor and creator of the Statue of Liberty,
upon seeing New York harbor for the first time.

NEW YORK CITY

A PHOTOGRAPHIC CELEBRATION

COURAGE
BOOKS

AN IMPRINT OF RUNNING PRESS
PHILADELPHIA · LONDON

9 8 7 6 5 4 3 2 1
Digit on the right indicates the number of this printing

Library of Congress Cataloging-in-Publication Number 97-66816

ISBN 0-7624-0284-9

Designed by Paul Kepple
Photographs researched by Susan Oyama
Typography: Silhouette, Felix, and Adobe Caslon

Published by Courage Books, an imprint of
Running Press Book Publishers
125 South Twenty-second Street
Philadelphia, Pennsylvania 19103-4399

(half title page) View of the Statue of Liberty, the downtown skyline, and the harbor.

(title page) Downtown skyline at night.

"If you imagine something that Old logic says cannot exist,
you are likely to find it—or at least go searching for it—in New York."

—Anthony Burgess

ALL THINGS ARE POSSIBLE in New York City.
It is a city of firsts and mosts, biggests and bests. It is home to the Statue of Liberty—a
legendary symbol of freedom—as well as to the World Trade Center, Times Square,
Lincoln Center, the Empire State Building, the Flat Iron Building, the Metropolitan
Museum of Art, Rockefeller Center and more. With more than 7 million inhabitants and
321 square miles, this center for banking, commerce, fashion, publishing, television, and
advertising has everything and anything to offer.

New York's art museums have some of the finest—and largest—collections in the
world. The most popular museums to visit are the Metropolitan Museum of Art, the
Museum of Modern Art, the Guggenheim Museum, the Frick Collection, the Whitney
Museum of American Art, and the Cooper-Hewitt National Design Museum.

For theatre or concert enthusiasts, the wonder of a Carnegie Hall concert, the beau-
ty of a Lincoln Center ballet, and the glamour of a Broadway show are unsurpassed. From
jazz clubs in Harlem to the New York Philharmonic at Avery Fisher Hall, from a rock
concert at Madison Square Garden to bar bands on Bleecker Street, the music scene in
New York has an eclectic diversity and depth of quality that is not found elsewhere.

For an authentic New York experience, many enjoy going to a Rangers hockey
game, a Knicks basketball game, or a Mets or Yankees baseball game. The New York
sports fans are devoted to their favorite teams. When one of their teams wins a cham-
pionship, they have a ticker-tape parade to celebrate the victory.

Other extraordinary sights include: Ellis Island, the Cloisters, the Bronx Zoo, the
Seaport, the Statue of Liberty, the Chrysler Building, the Brooklyn Bridge, Central Park,
and the Brooklyn Botanical Gardens. For thrill-seekers, Coney Island's main attraction,
besides its famous fhot dogs, is the legendary roller coaster, the Cyclone.

As a result of New York's ethnic diversity, there are foods from almost every country in the city. From Chinatown to Little Italy, different ethnic foods are available from block to block. A veritable culinary melting pot, New York City offers a wide selection of restaurants from the finest in haute cuisine at Le Circque to delicious, homemade pizza at the renowned Patsy's Pizza in Brooklyn.

With all of the action at street-level, it is hard to remember to look up once in a while, but do so and you'll be rewarded. Stunning views of a myriad of architectural styles abound when it comes to New York's skyscrapers, brownstones, and storefronts. The Chrysler Building—William Van Alen's Art Deco masterpiece—and the Guggenheim Museum—Frank Lloyd Wright's 1959 landmark—are some of the most famous buildings that are beautiful to gaze up at, but lesser-known examples of architectural grandeur are also there to enjoy when looking skyward.

The architectural hodge-podge reflects the contributions from all different eras and ethnic groups. In Manhattan alone, there are dozens of neighborhoods, each a city unto itself: Chinatown, Wall Street, Tribeca, Soho, Greenwich Village, Chelsea, and the Lower East Side are just some of Manhattan's famous districts. With the surrounding boroughs of Queens, Brooklyn, and the Bronx, there is a metropolis whose variety surpasses that of any other city in the world.

This photographic tour is accompanied by quotations from some of the many renowned novelists, sculptors, poets, architects, and philosophers who came to New York seeking inspiration. They found a singular and enduring subject.

"I too lived, Brooklyn of ample hills was mine,
I too walked the streets of Manhattan island, and bathed in the waters around it,
I too felt the curious abrupt questionings stir within me. . . ."
—**Walt Whitman**

(**right**) The hustle-bustle of a New York street is legendary.

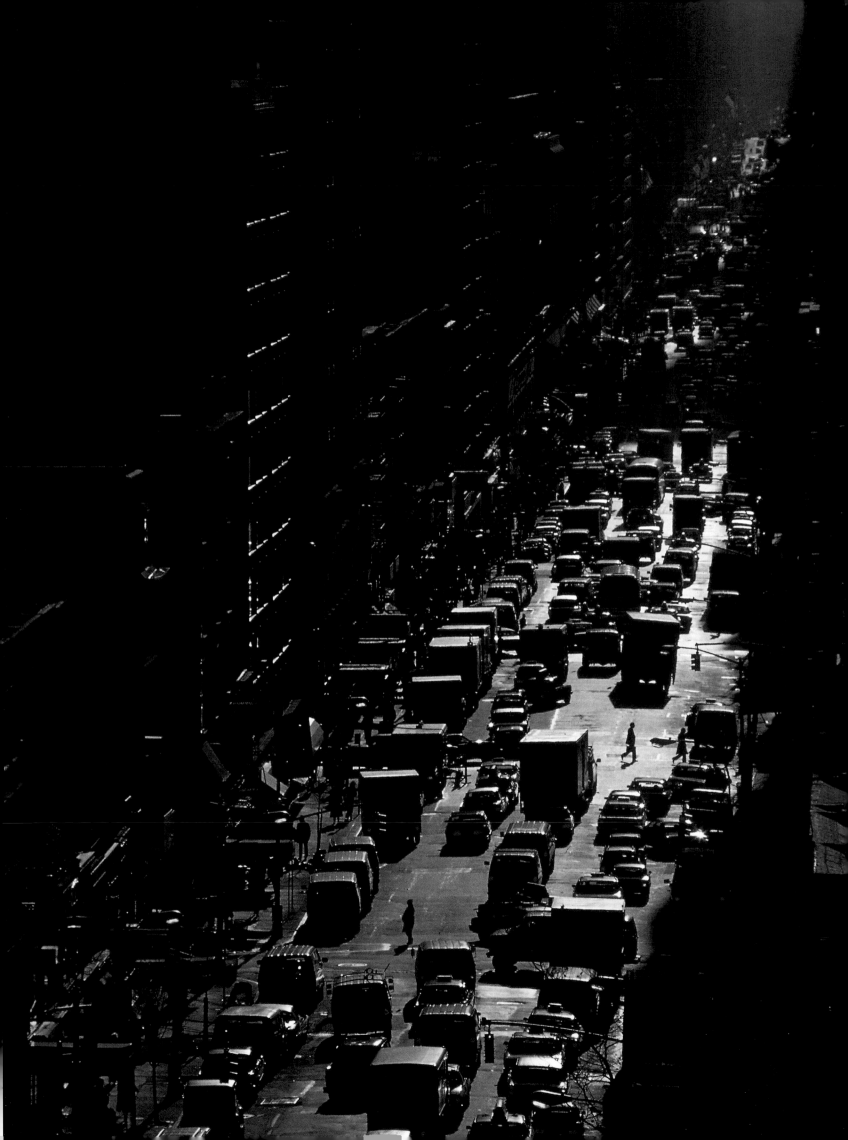

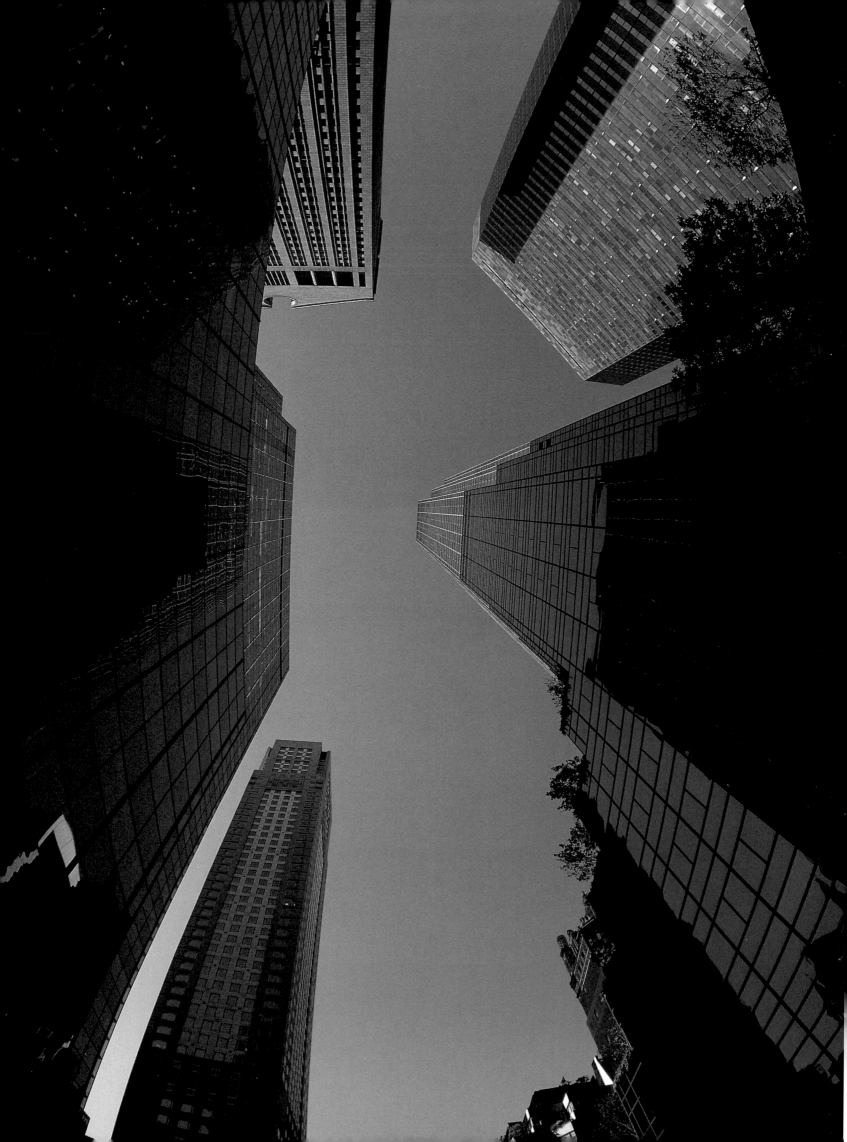

D O W N T O W N

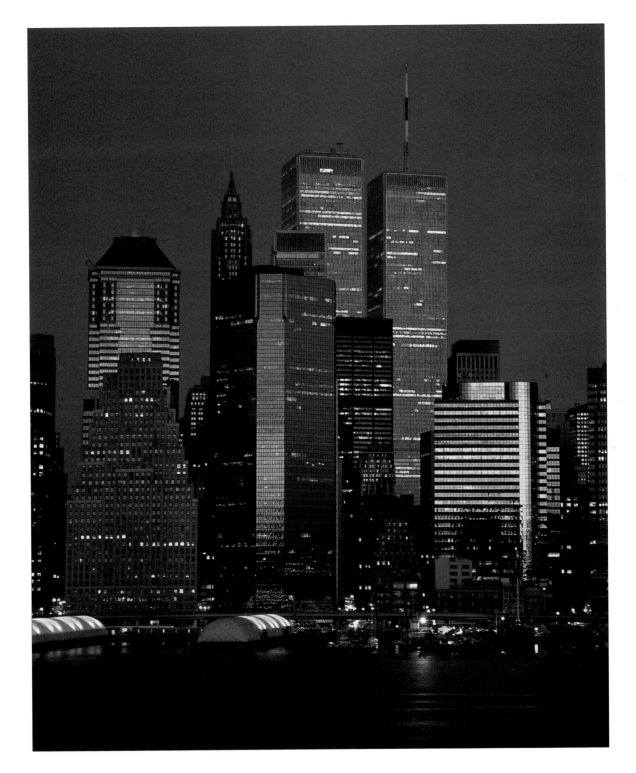

9 **(left)** Worms-eye view of downtown New York City. **(above)** Downtown as seen from the harbor.

(overleaf) Statue of Liberty. The Statue of Liberty weighs 225 tons and stands 152 feet over New York harbor. The French people gave this statue to the new nation to represent the ideal that the Americans founded their country upon.

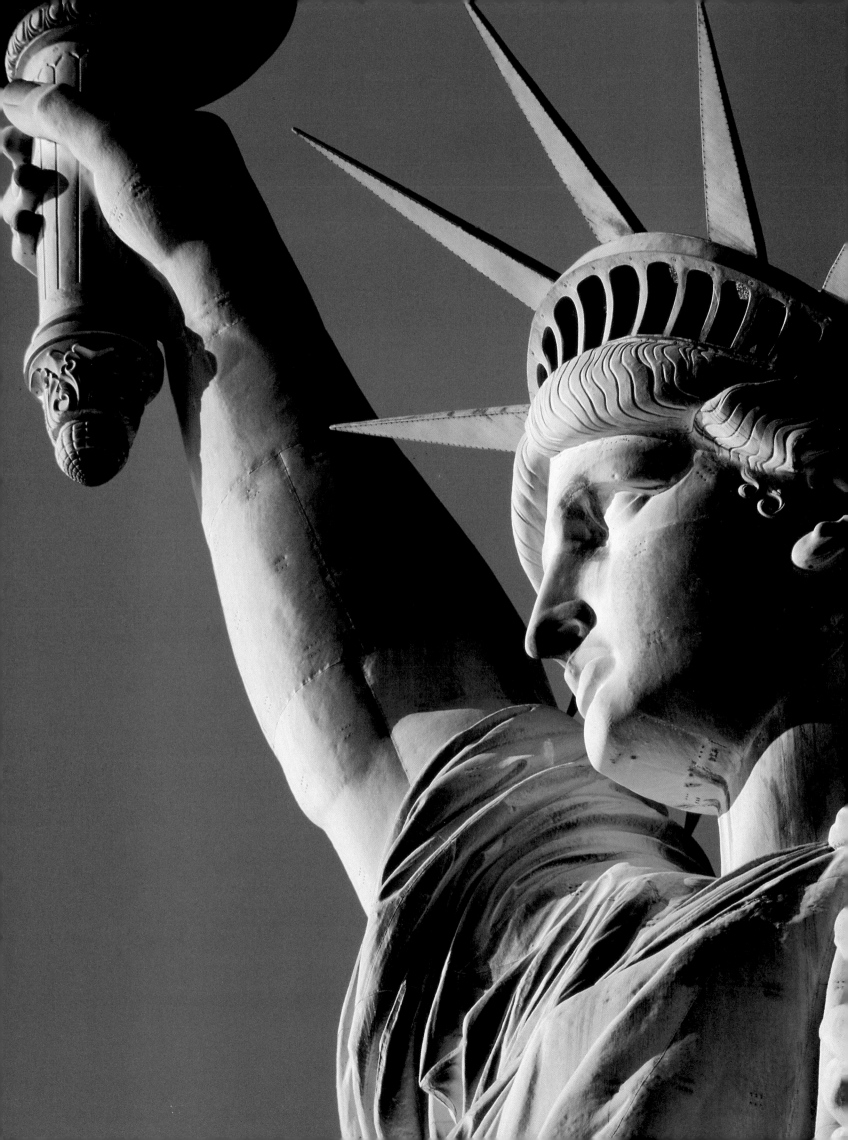

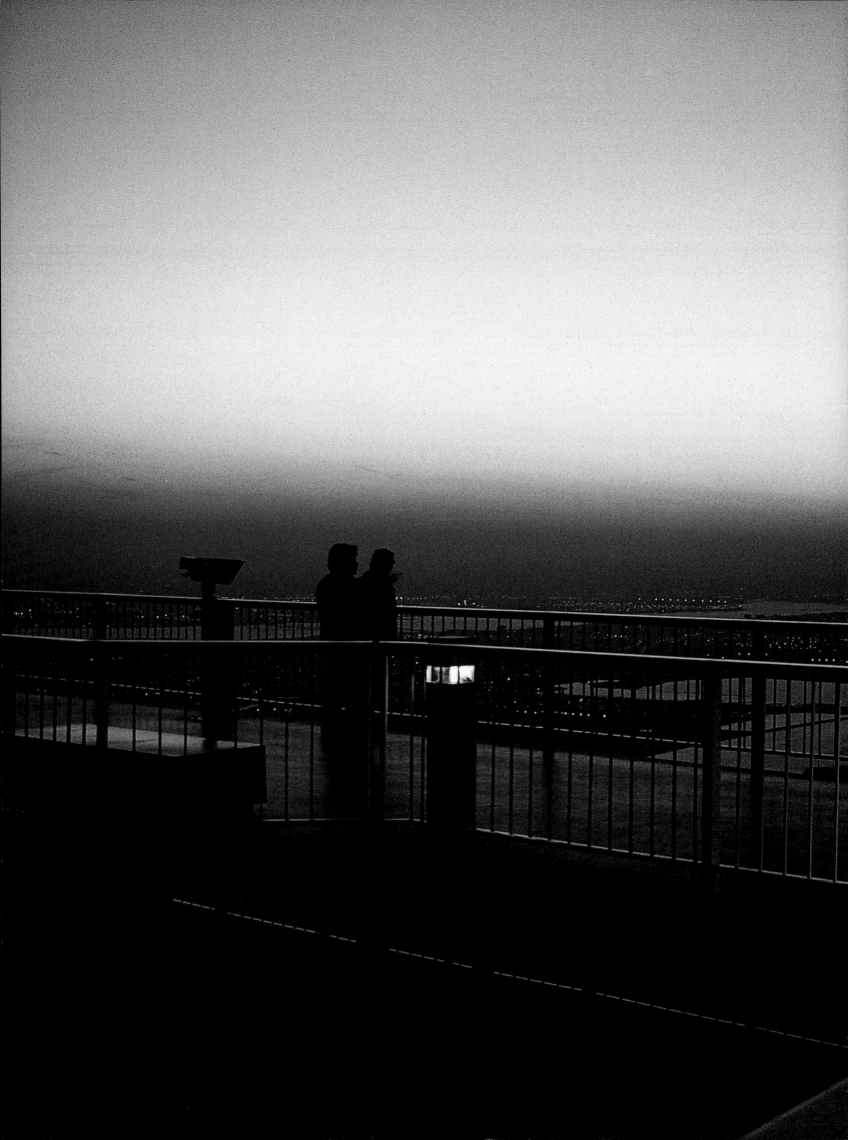

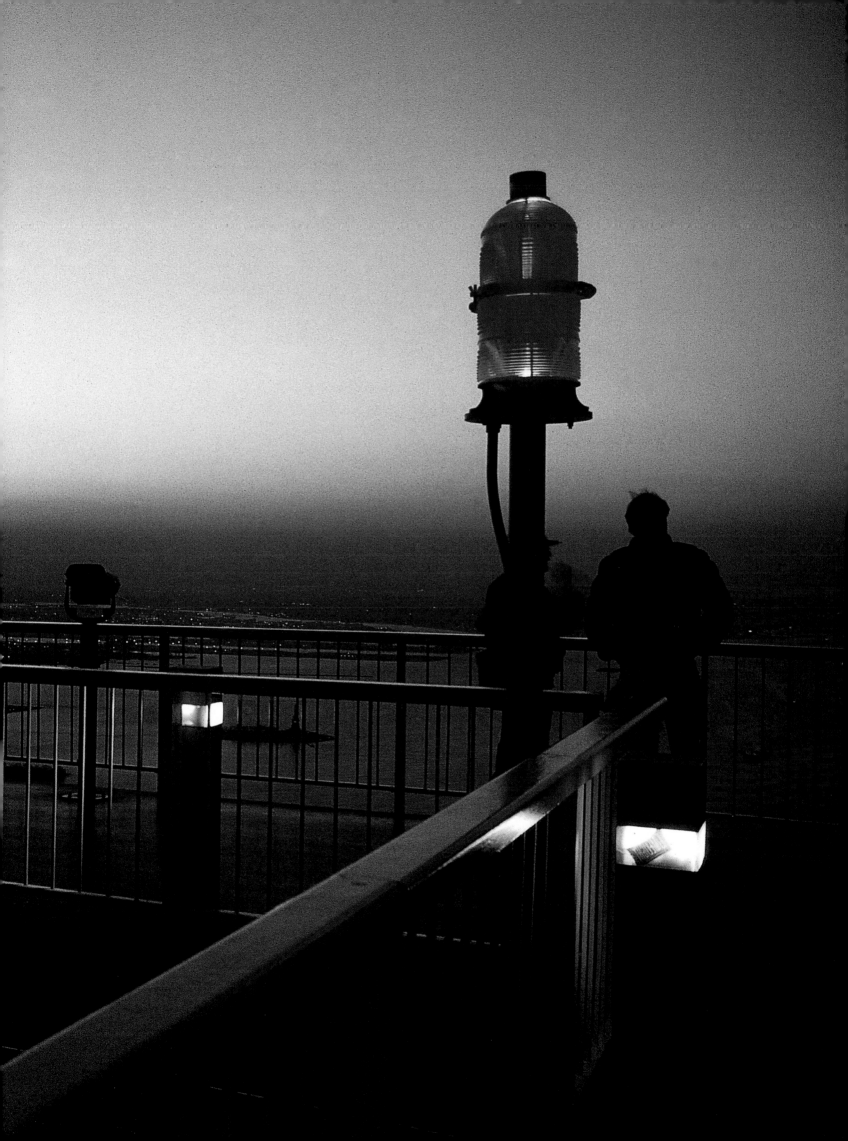

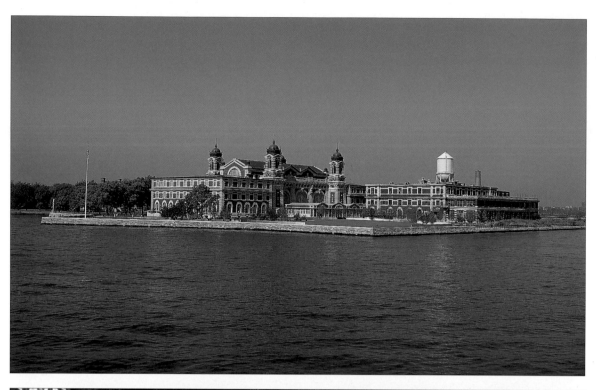

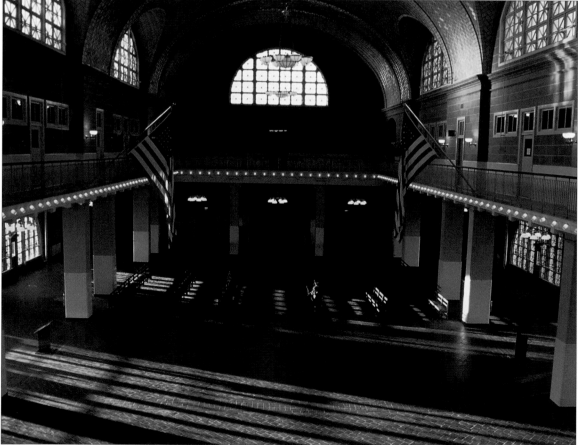

14 **(previous overleaf)** The New York harbor as seen from the promontory at the World Trade Center.

(above and right) Ellis Island interior and exterior.

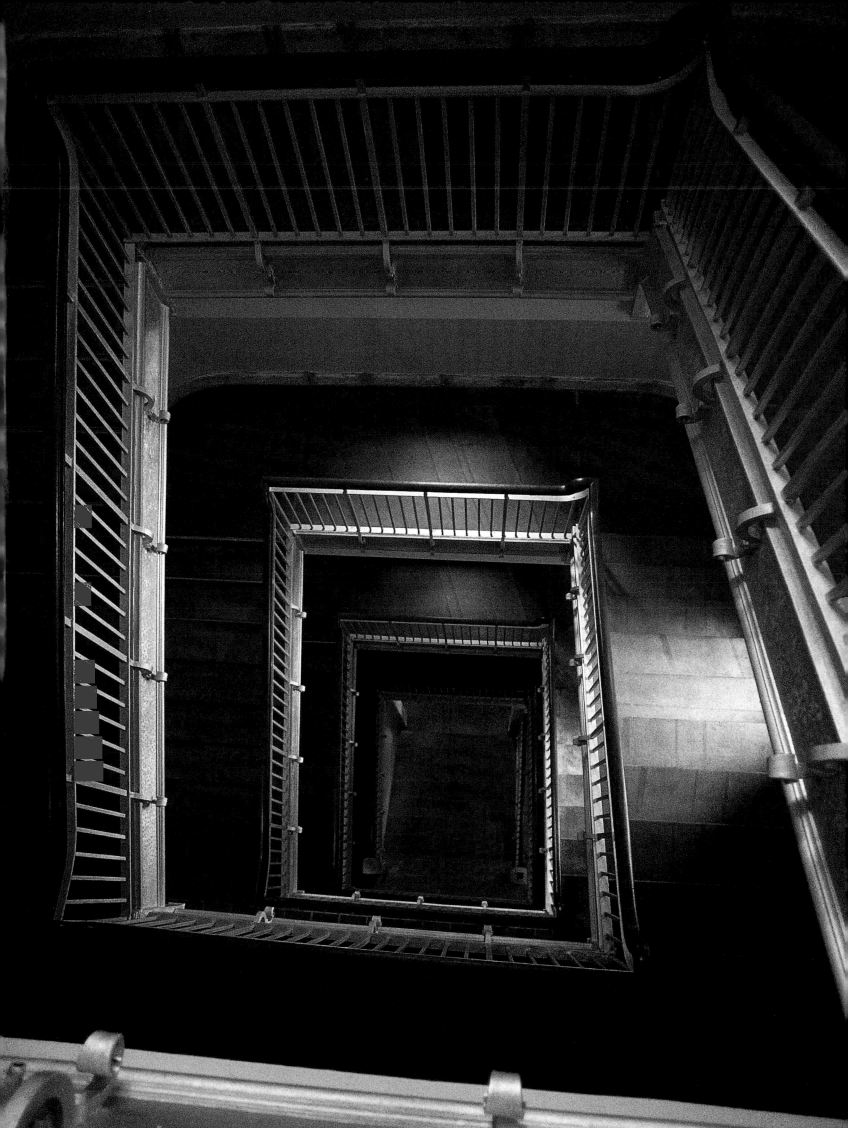

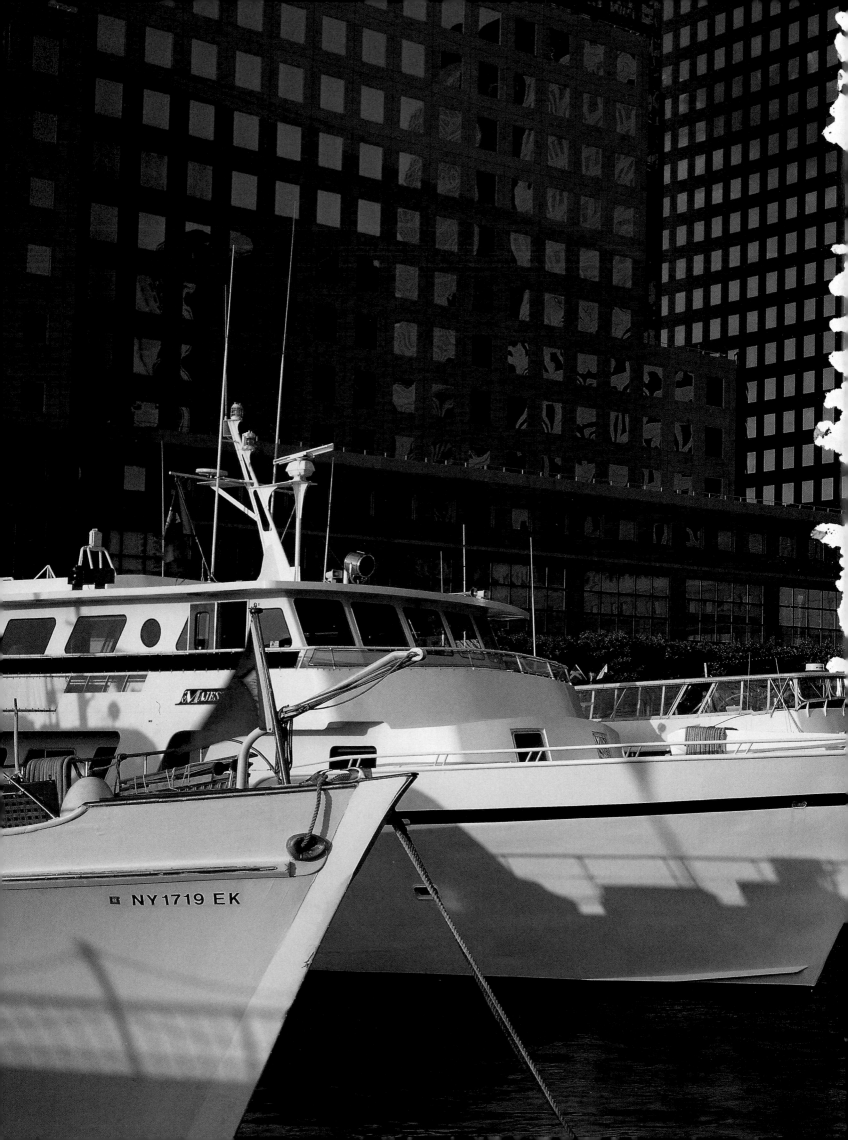

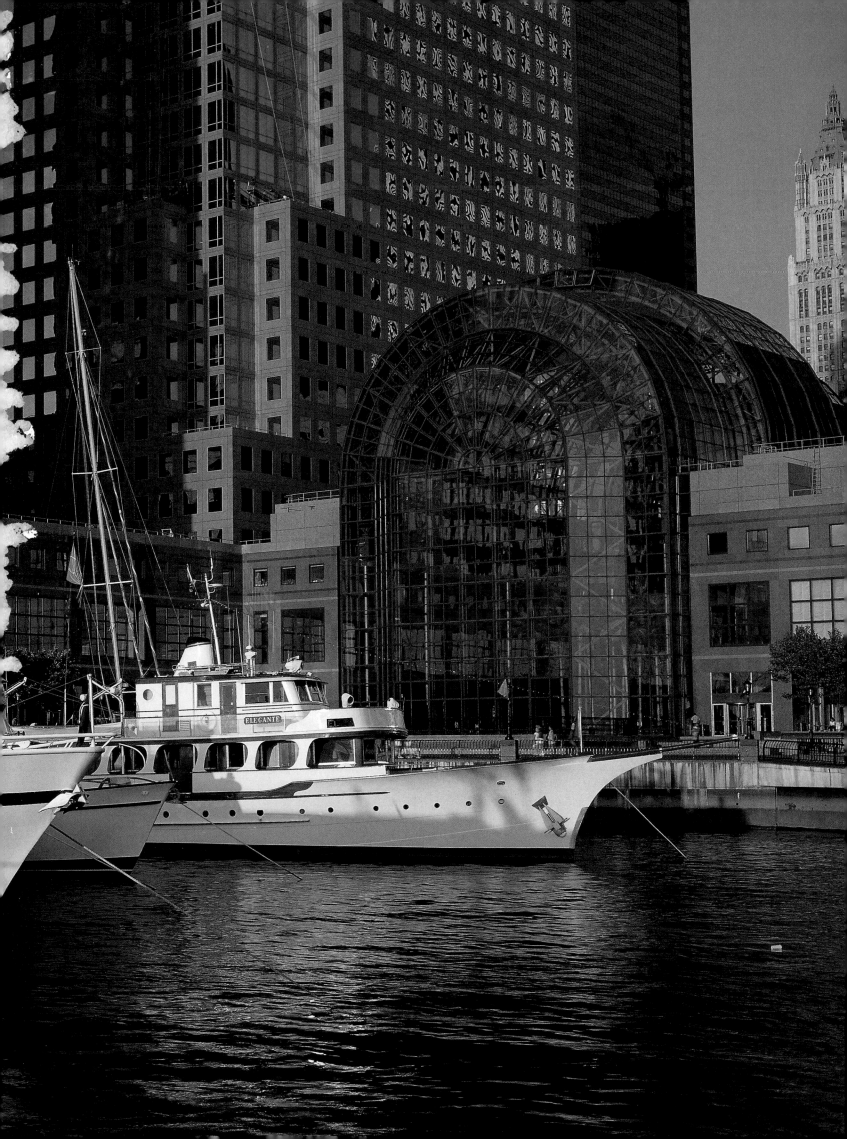

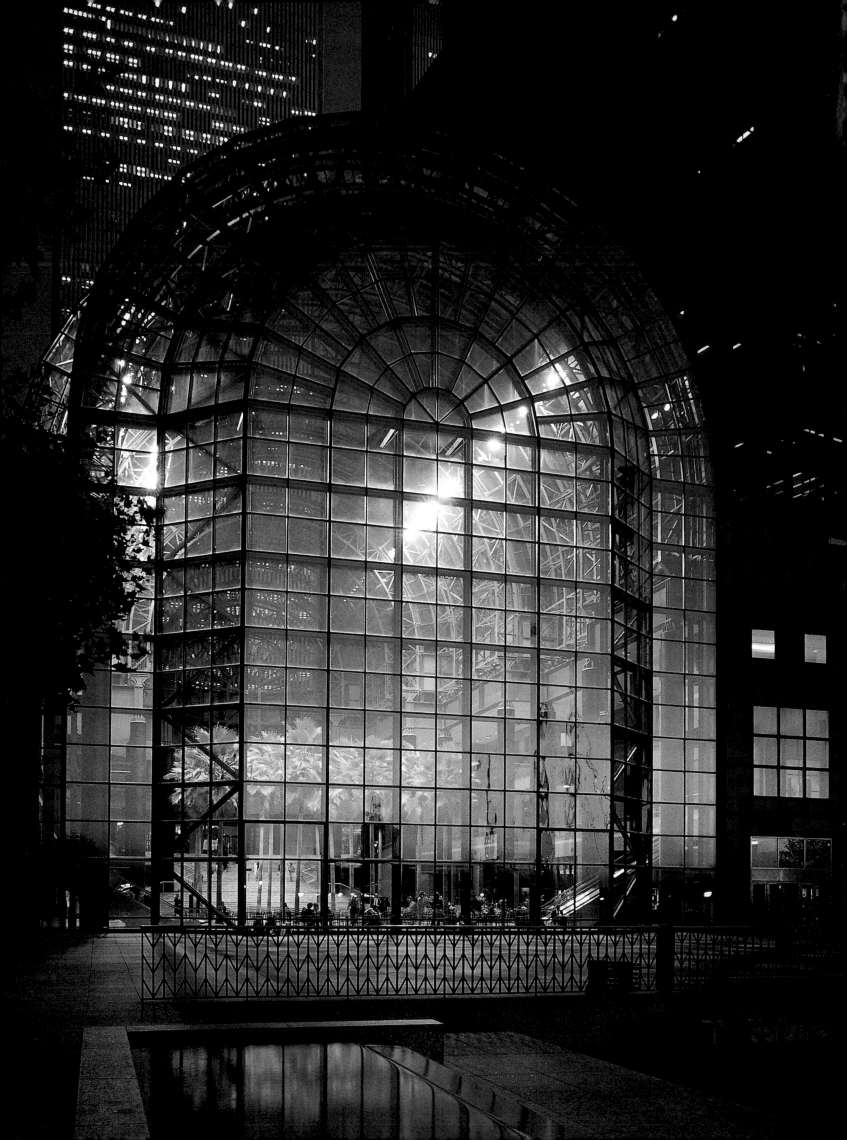

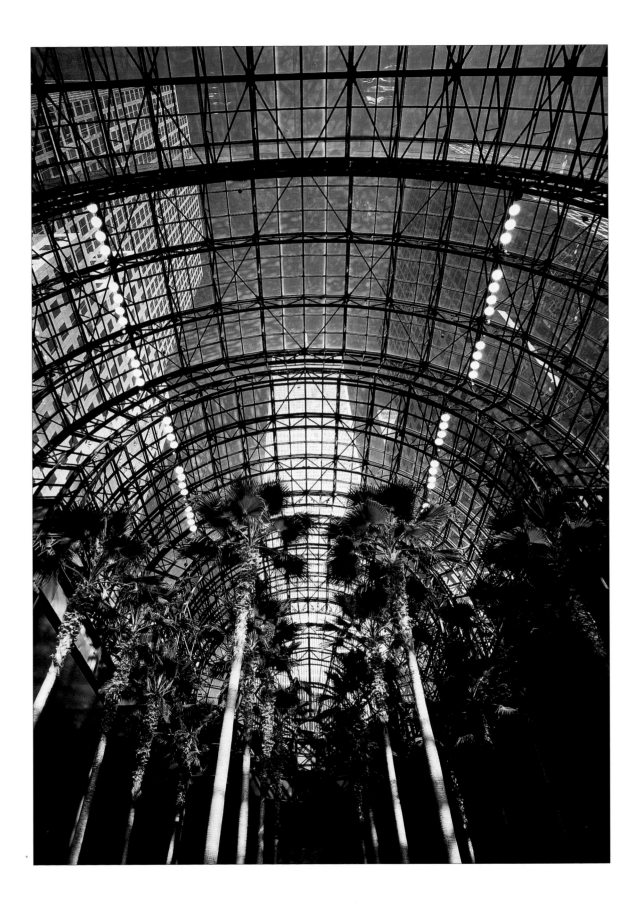

19 **(previous overleaf)** The World Financial Center as seen from the harbor.

(left) The World Financial Center. **(above)** The Winter Garden.

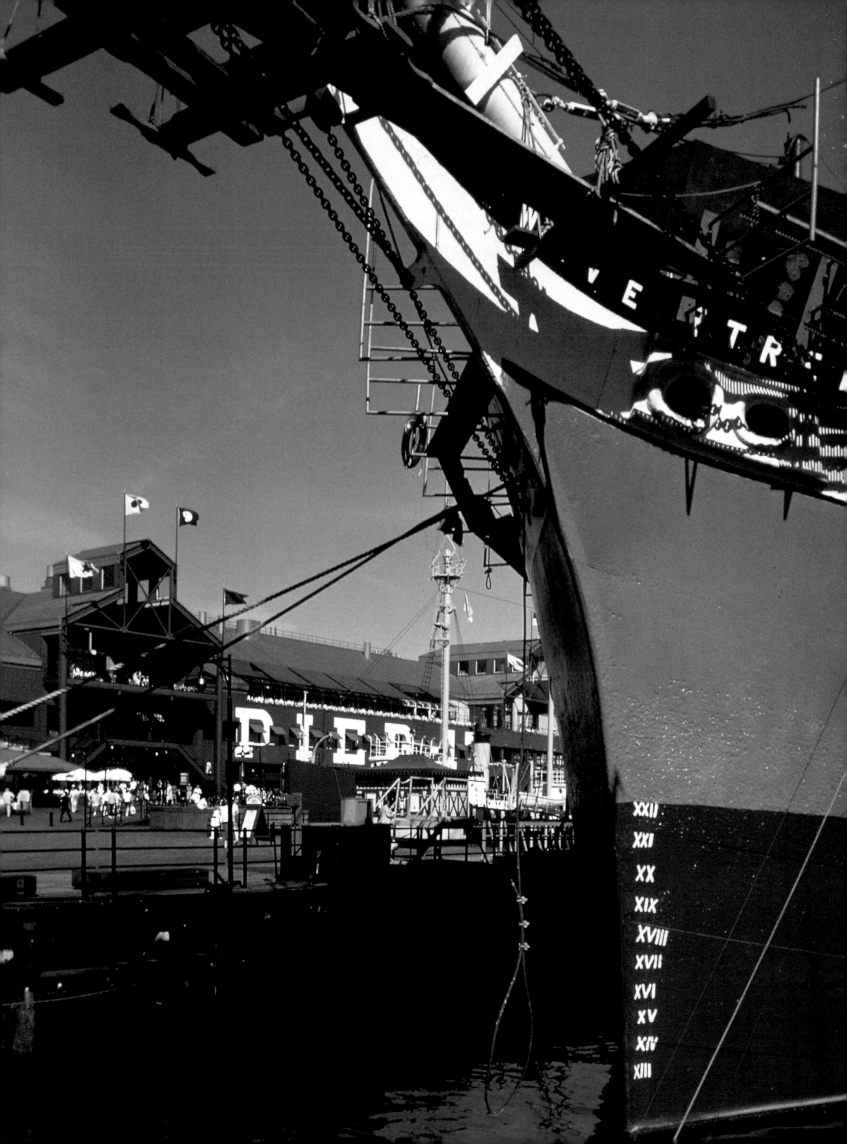

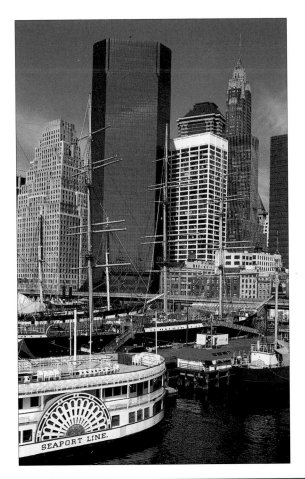

That enfabled rock, that ship of life, that swarming million-footed, tower-masted, and sky-soaring citadel that bears the magic name of the Island of Manhattan."

Thomas Wolfe (1900–1938)
American writer

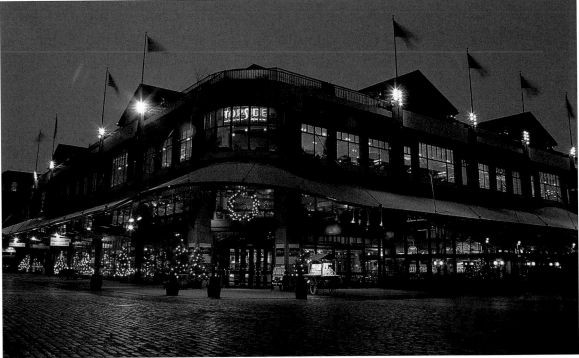

21 **(above and left)** The South Street Seaport. This former dockyard has been restored to an exterior period appearance. Restaurants and boutiques now take the place of the warehouses that stored fish, tea, rum, and spices in the nineteenth century.

(following two overleaves) The Brooklyn Bridge.

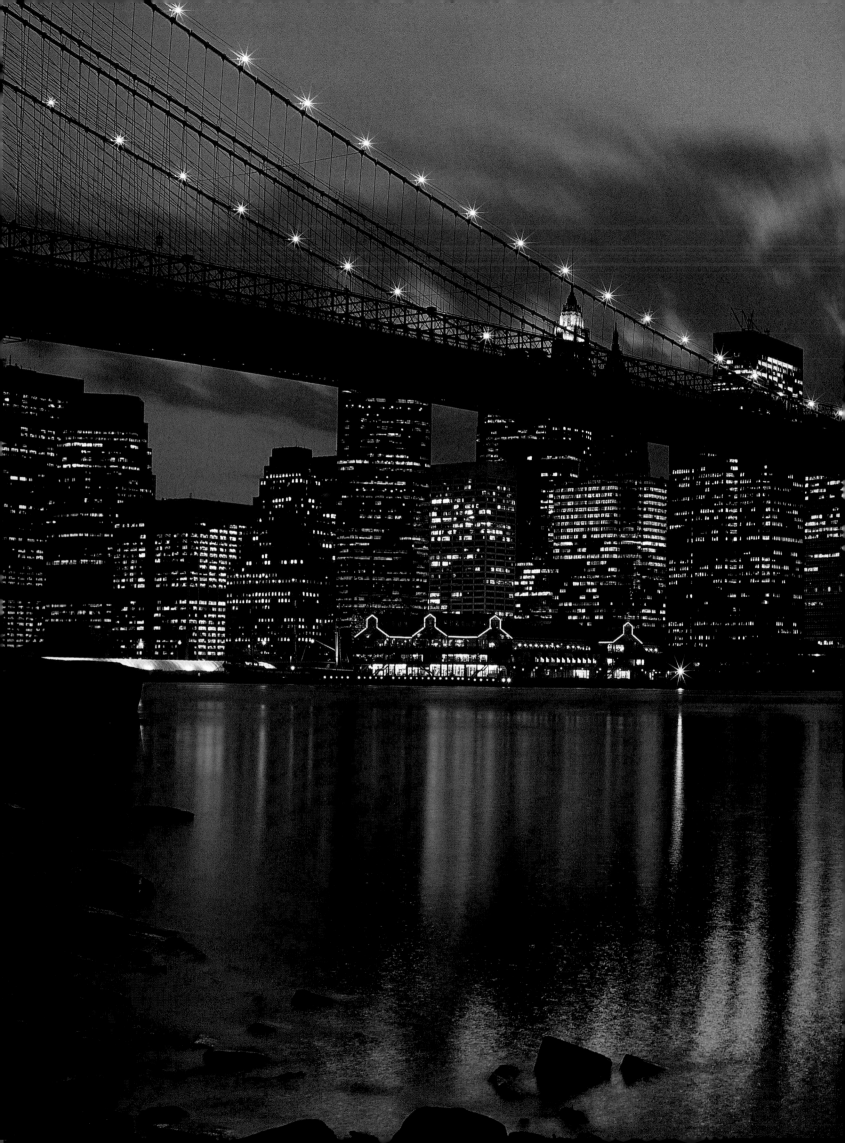

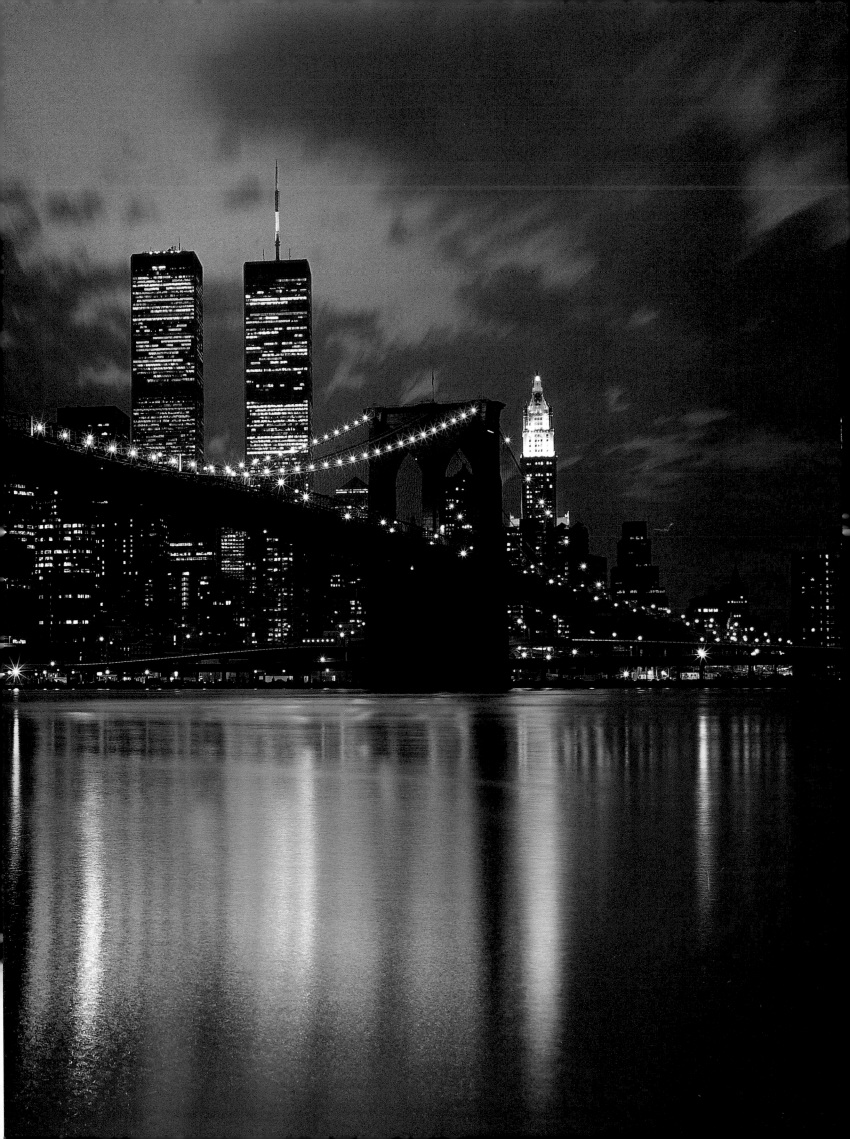

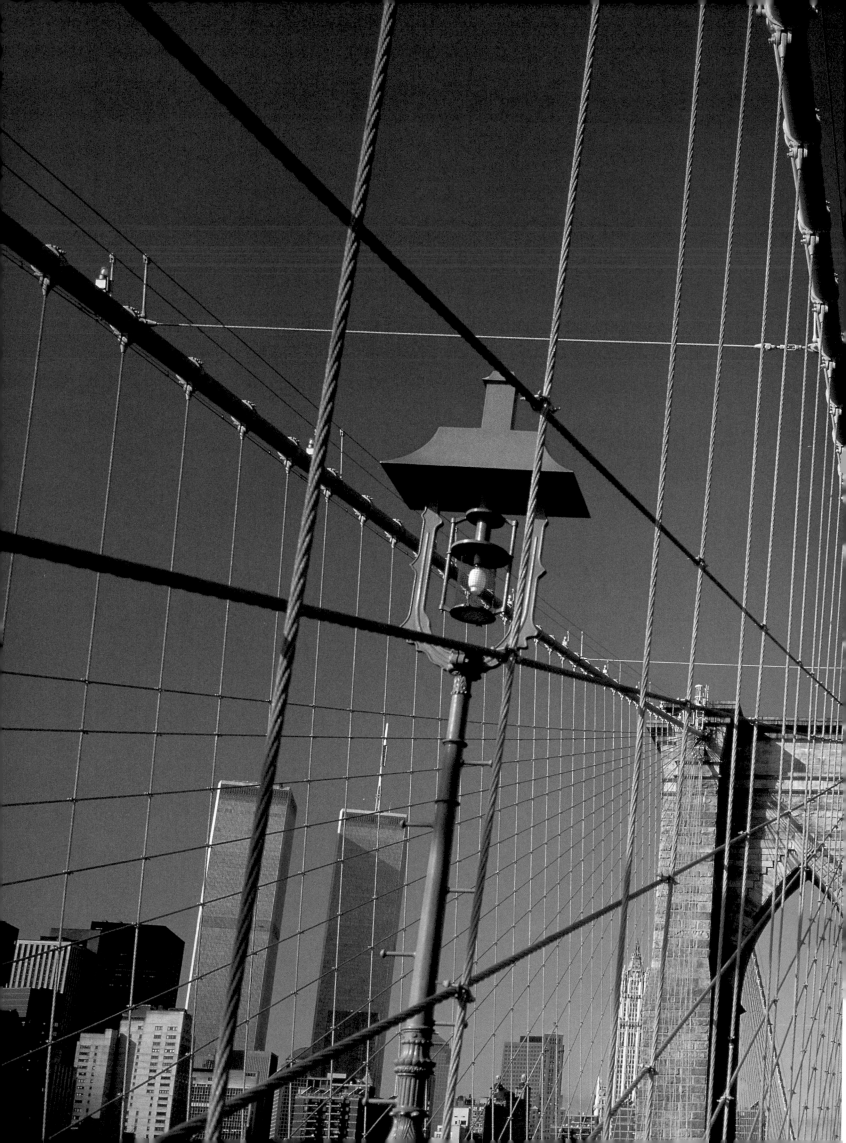

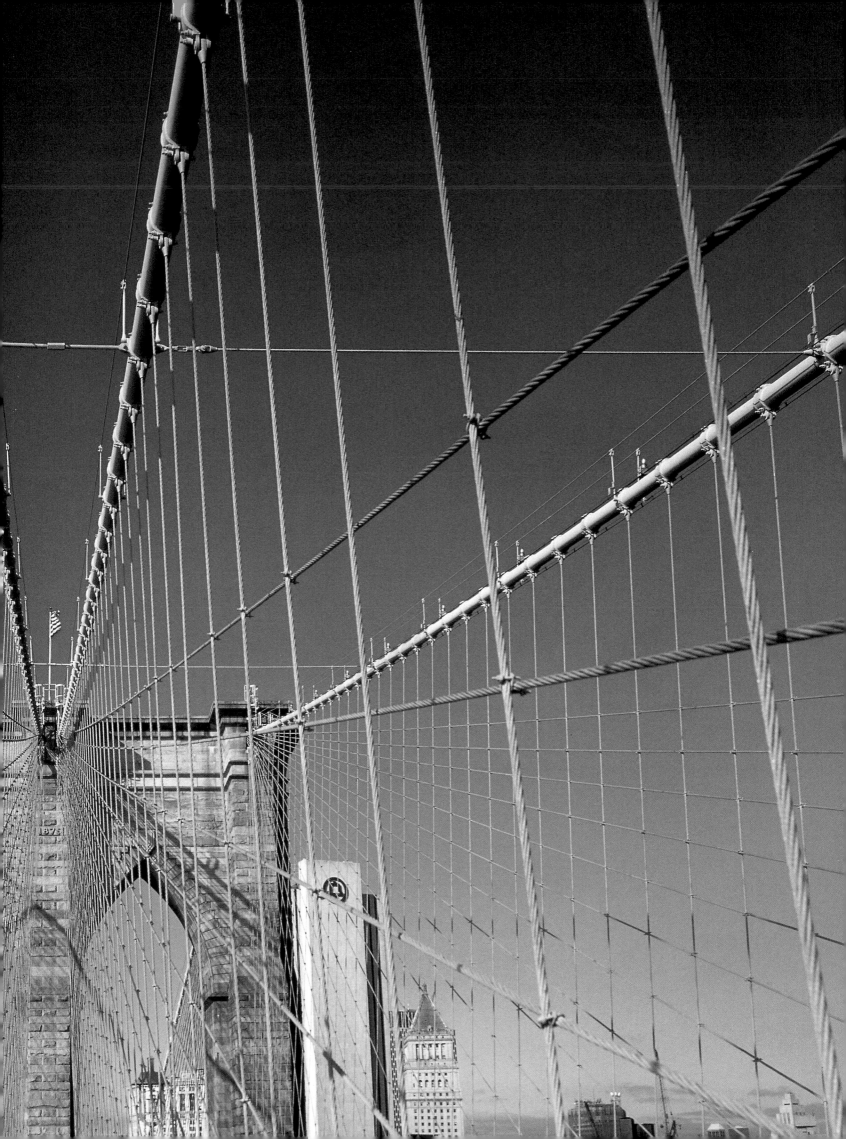

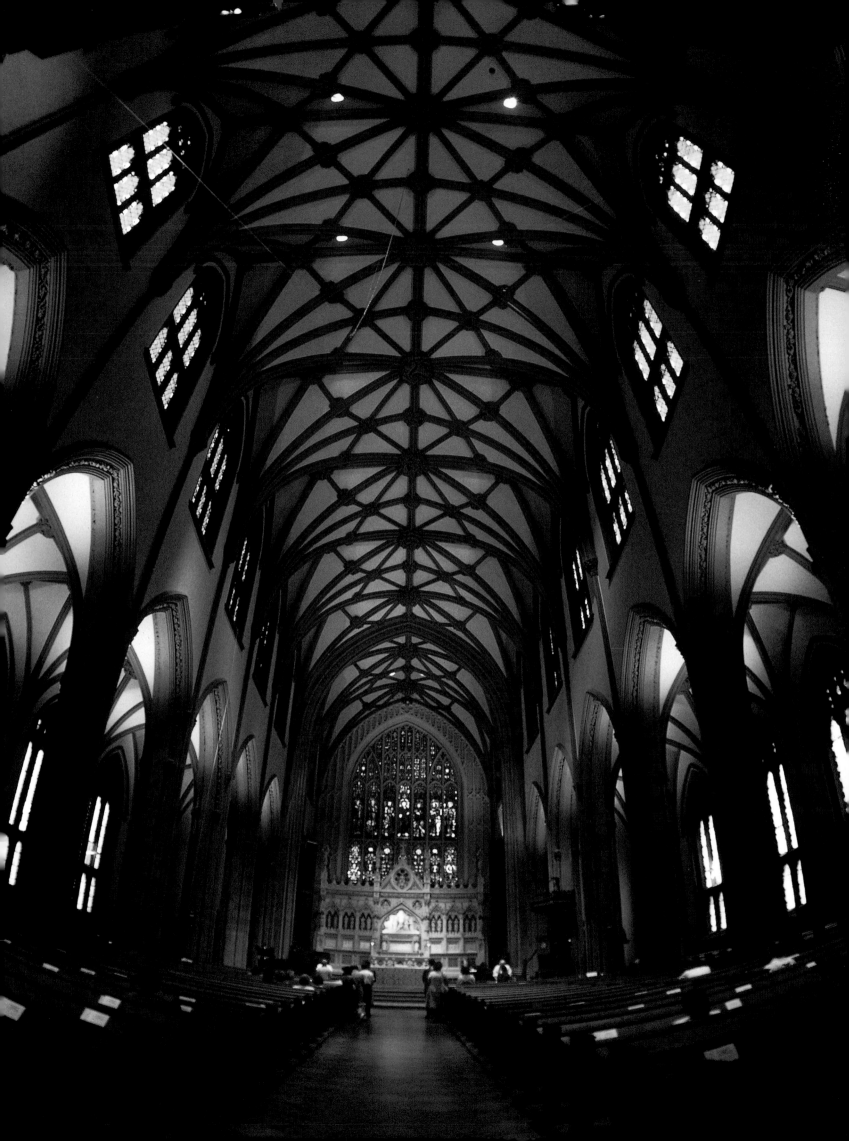

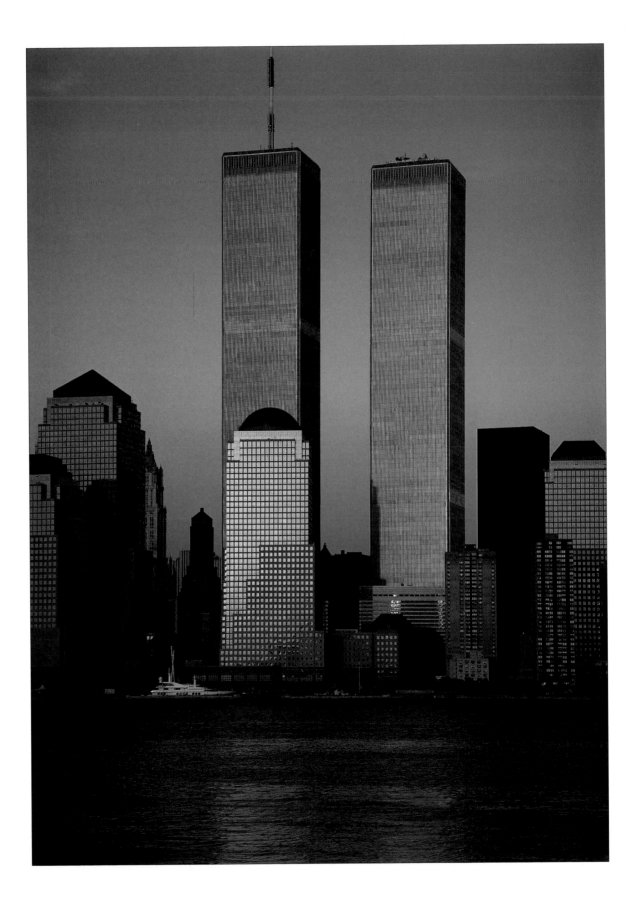

27 **(left)** The Trinity church. Vaulted ceilings echo the feeling of the downtown skyscrapers. **(above)** The *Twin Towers* is a nick-name for buildings I and II of the World Trade Centers.

(overleaf) The World Trade Center.

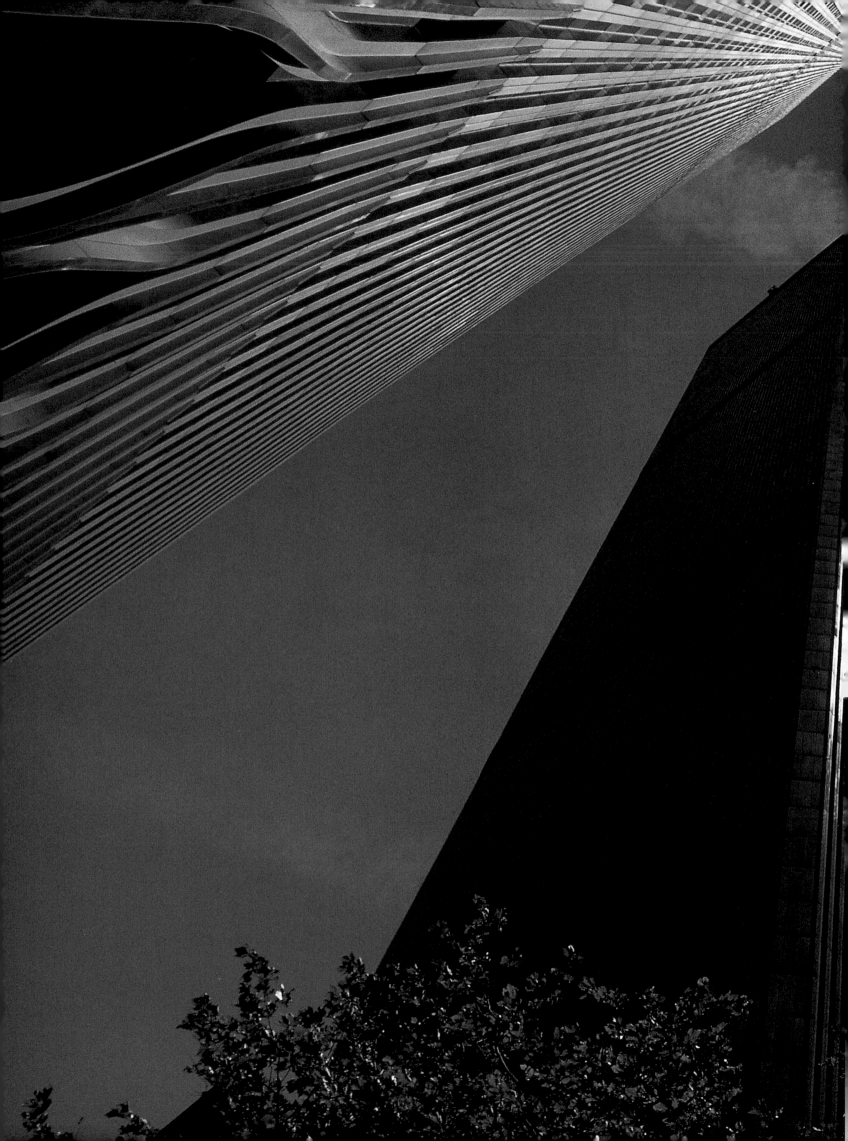

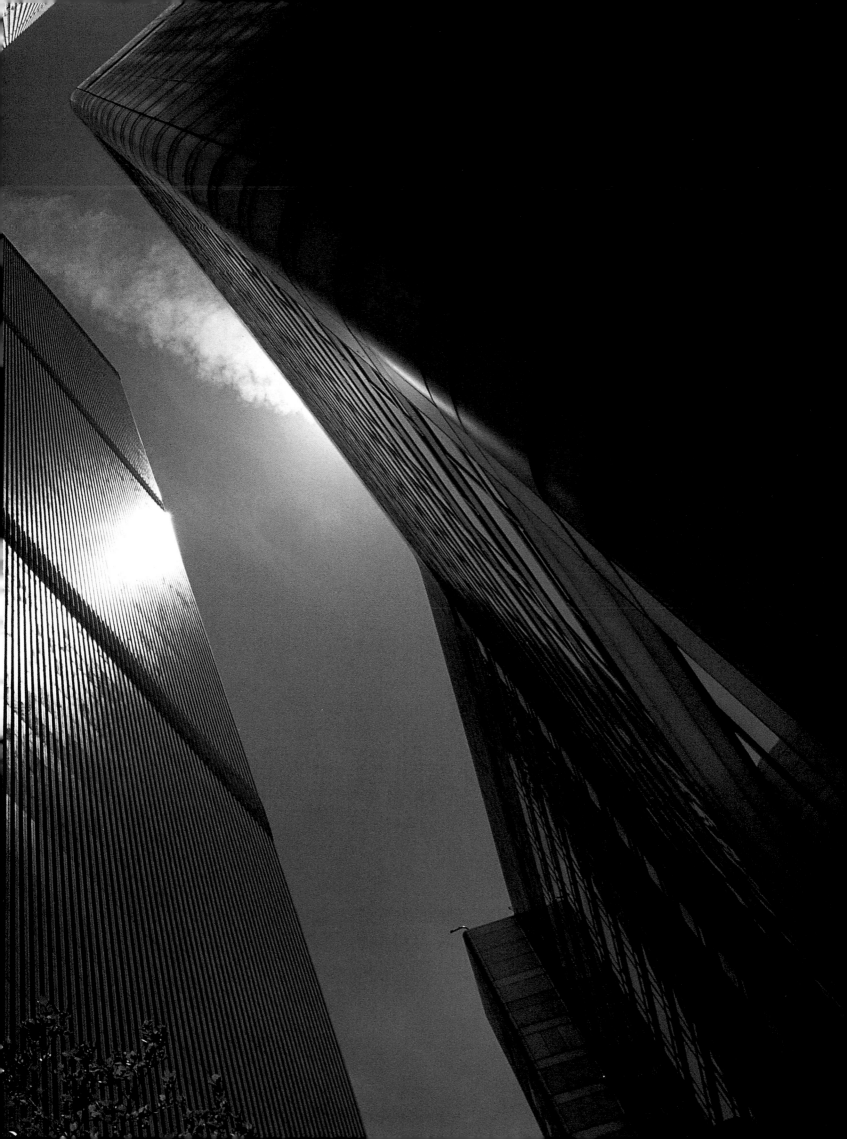

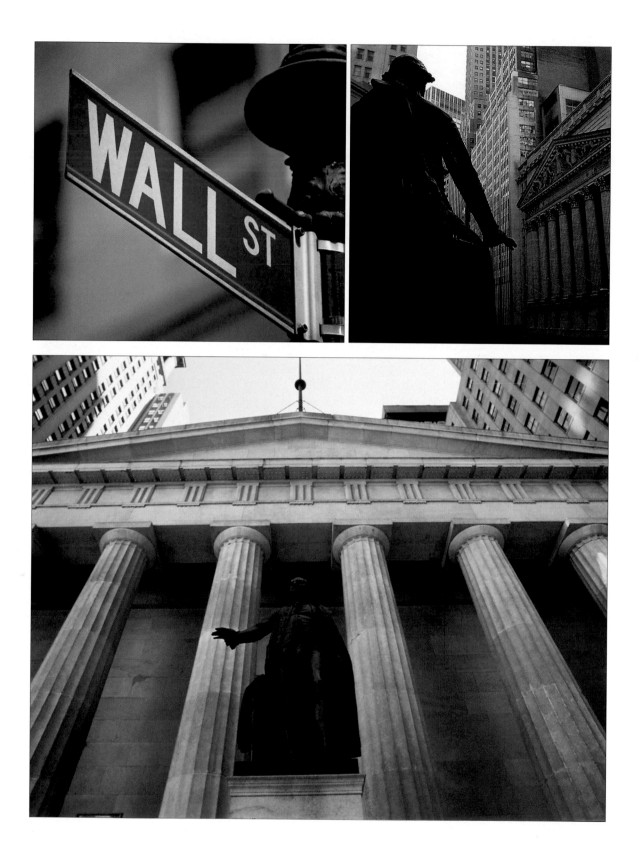

30 **(top left)** Wall Street. **(top right and bottom)** Statue of George Washington on Wall Street, across from the New York Stock Exchange.

(following overleaf) Detail of molding of the New York Stock Exchange.

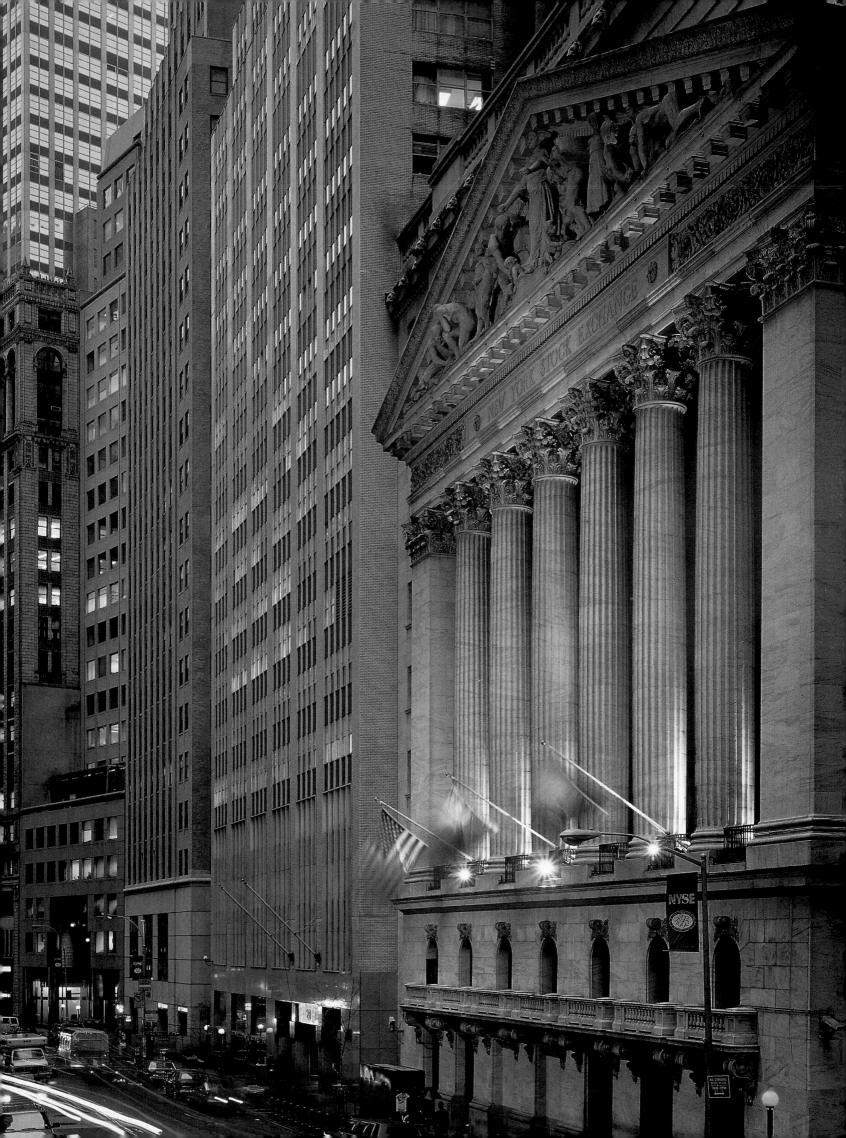

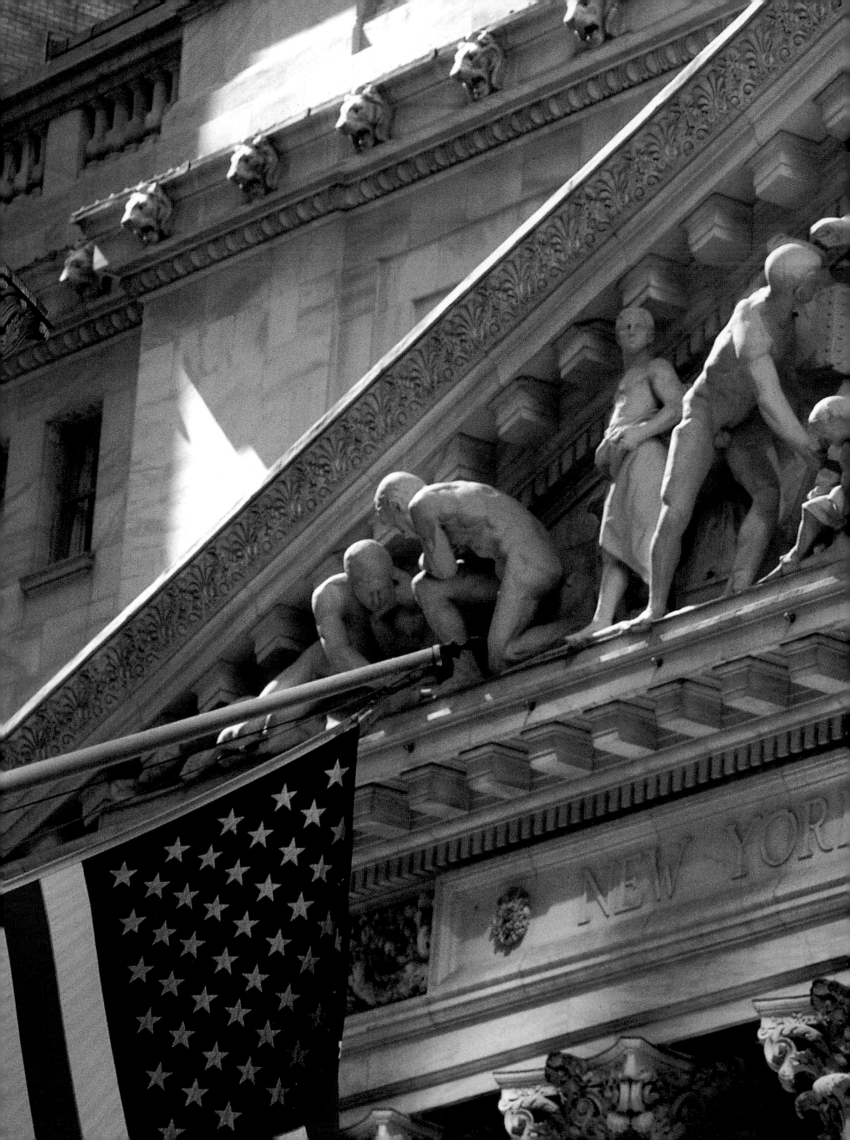

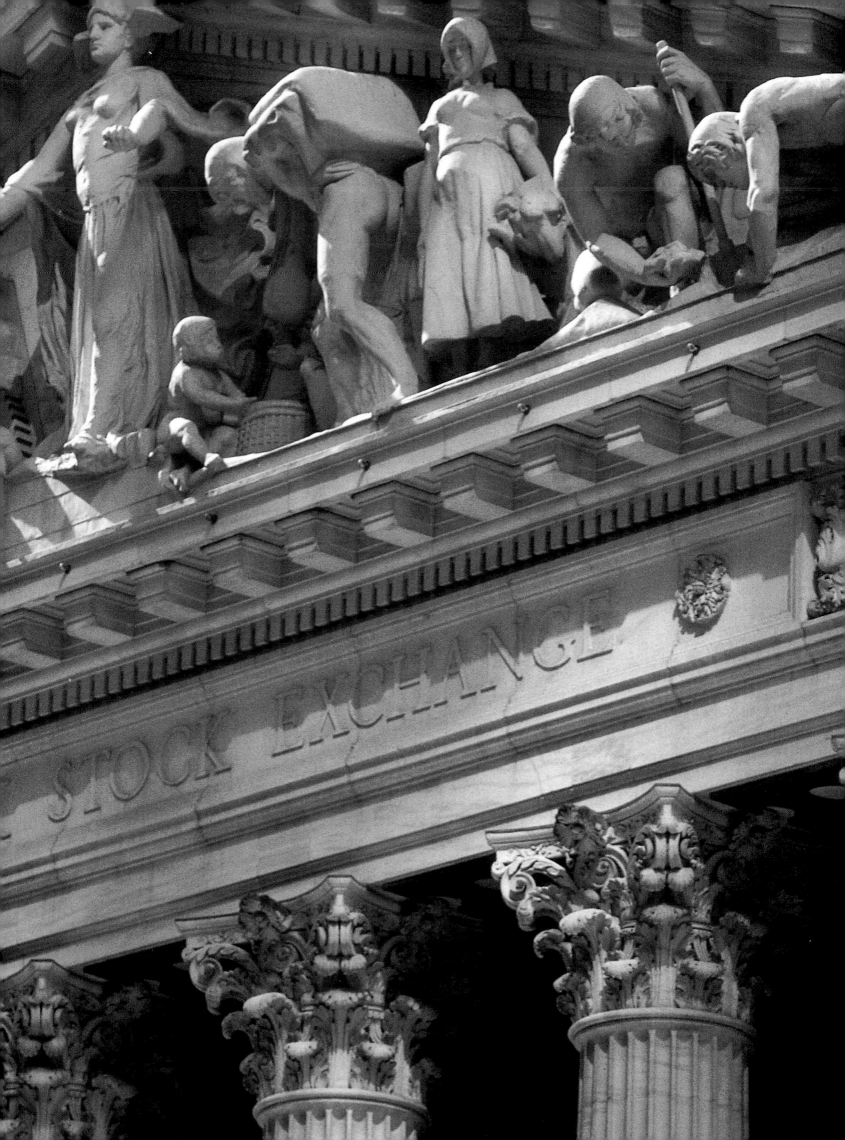

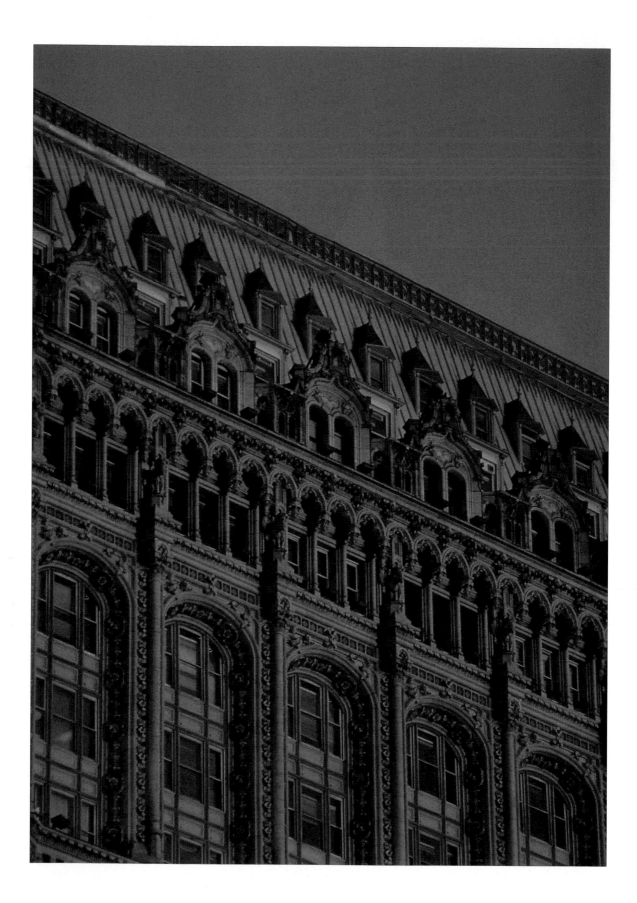

34 **(above and right)** Downtown architecture.

(overleaf) Chinatown.

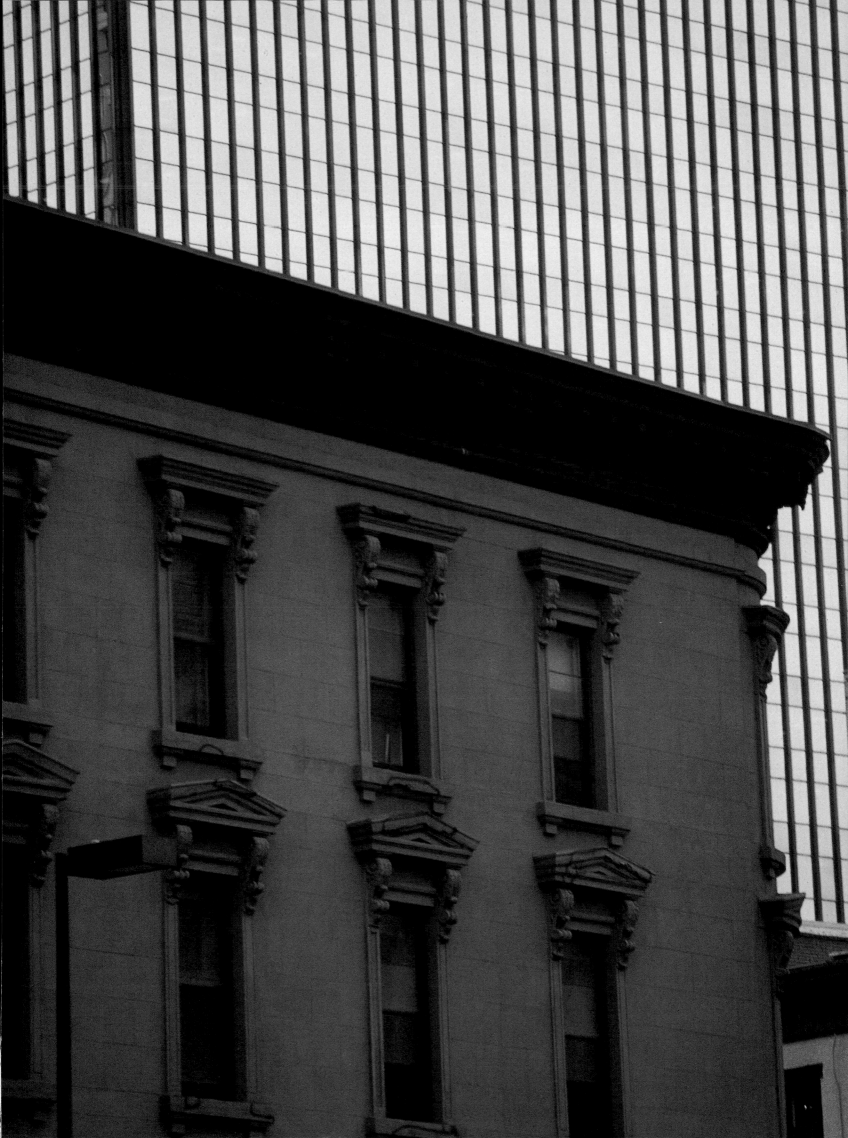

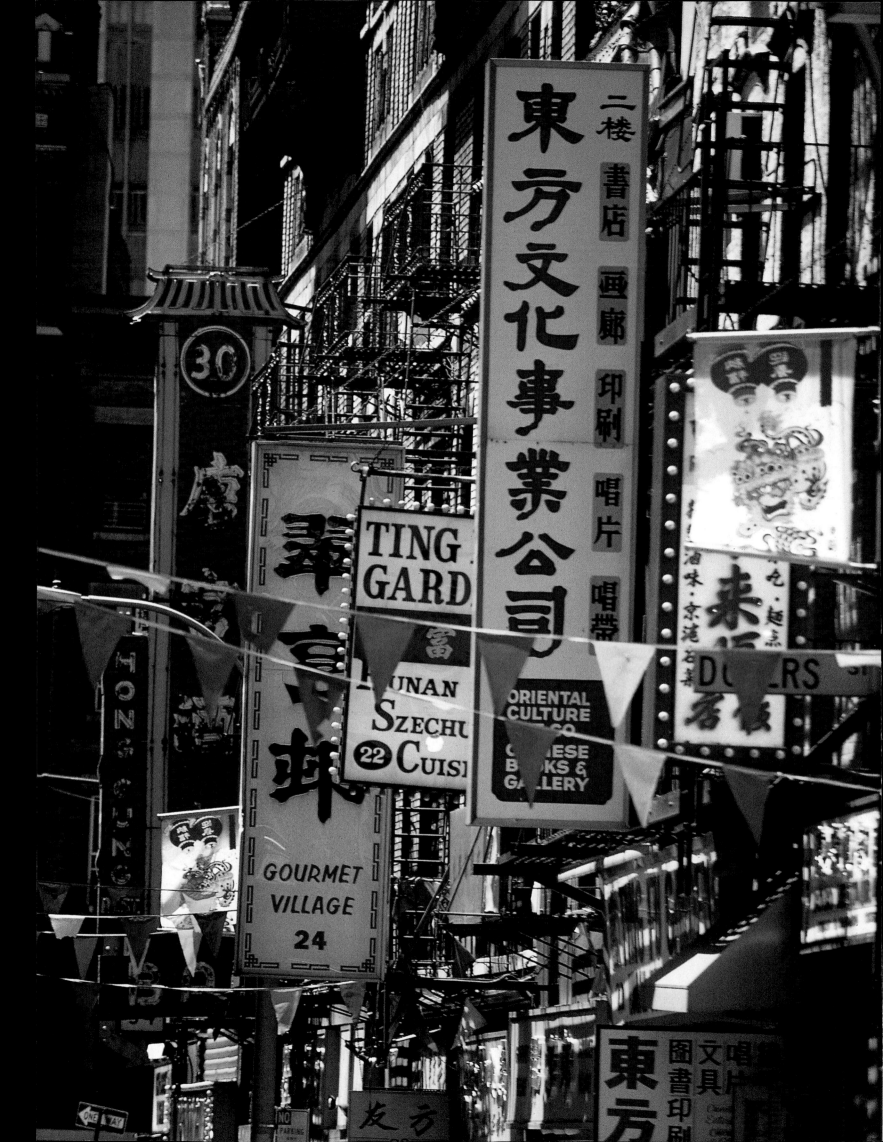

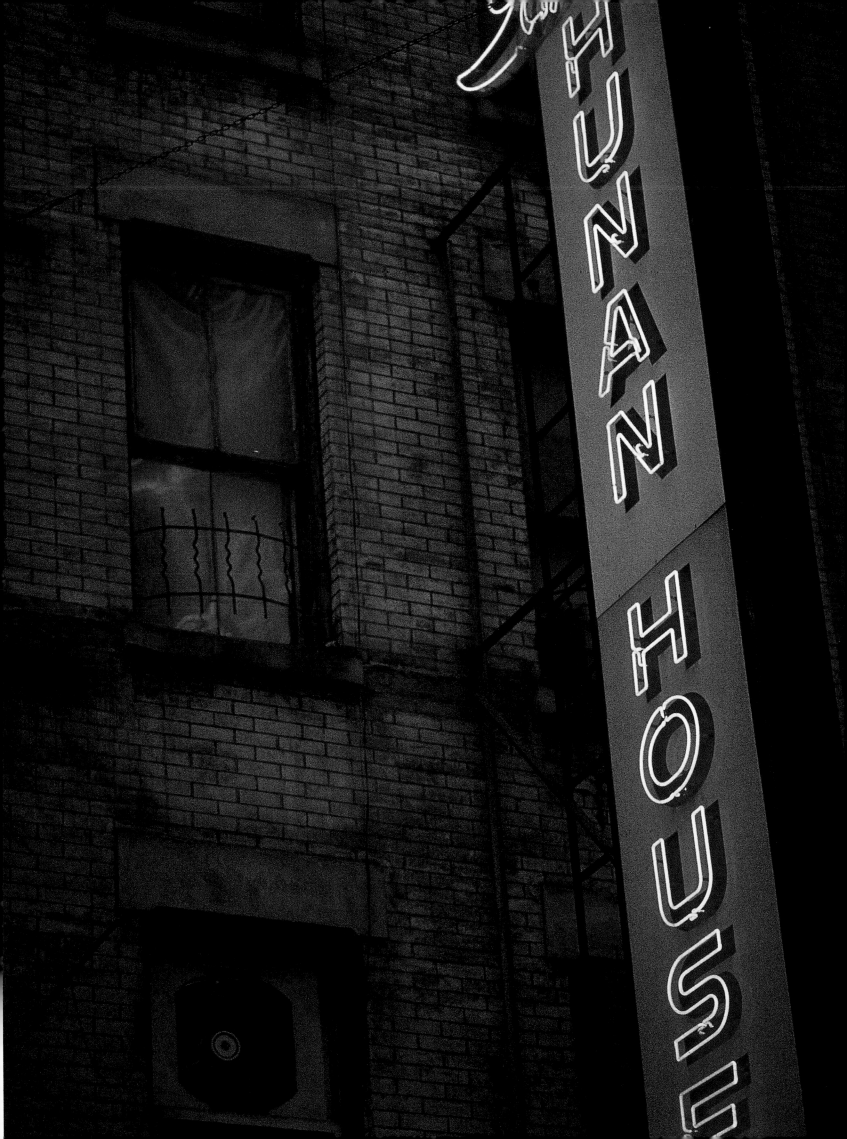

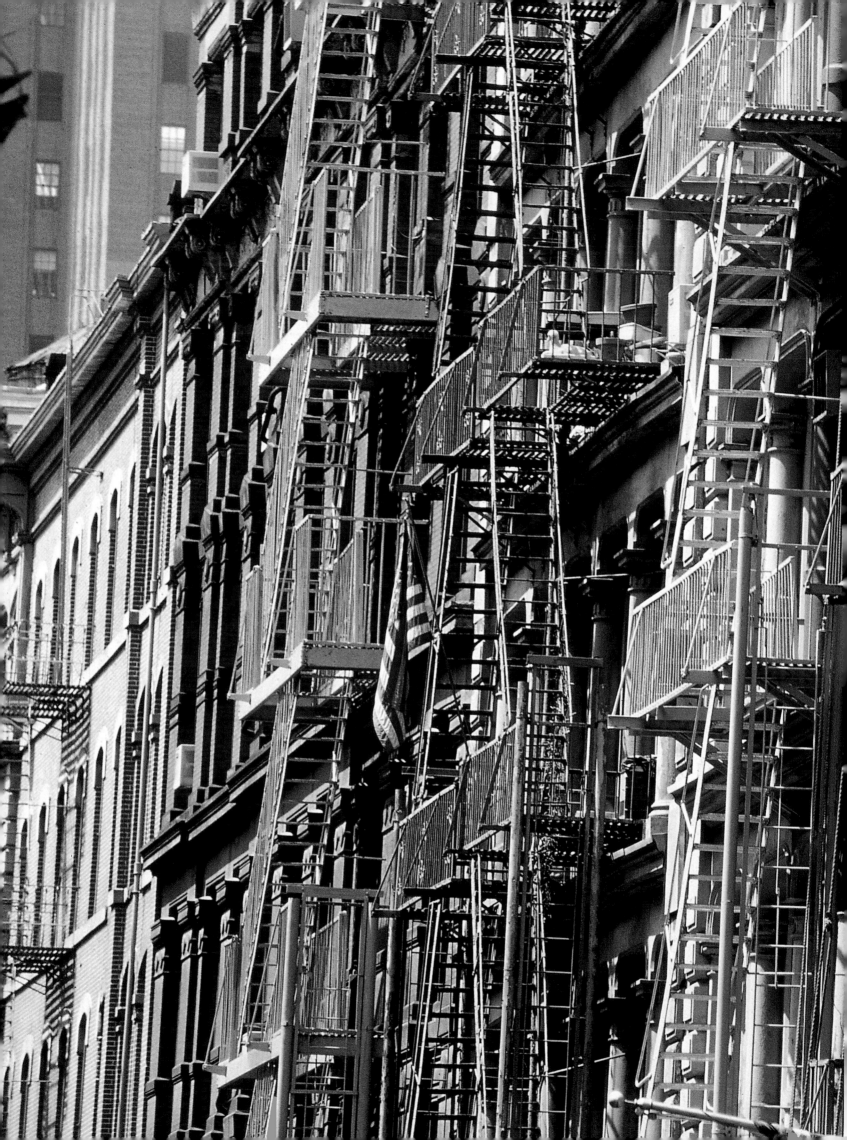

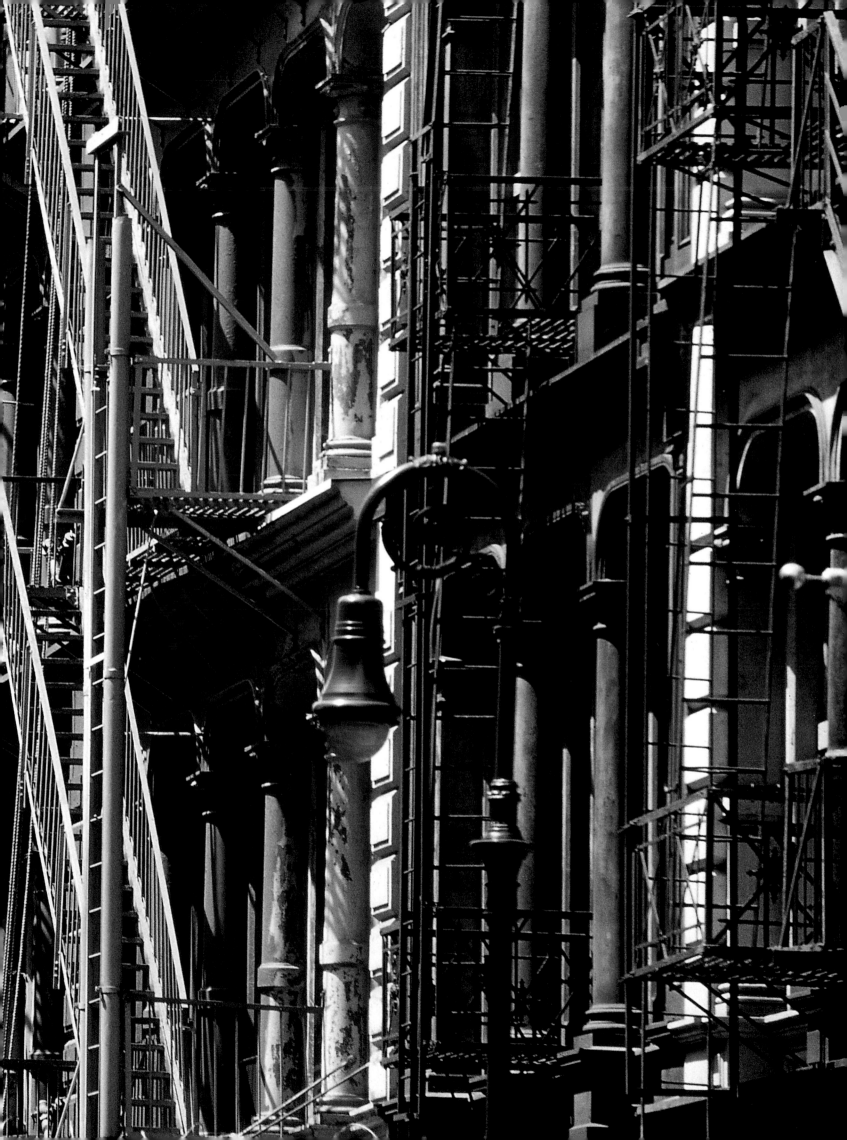

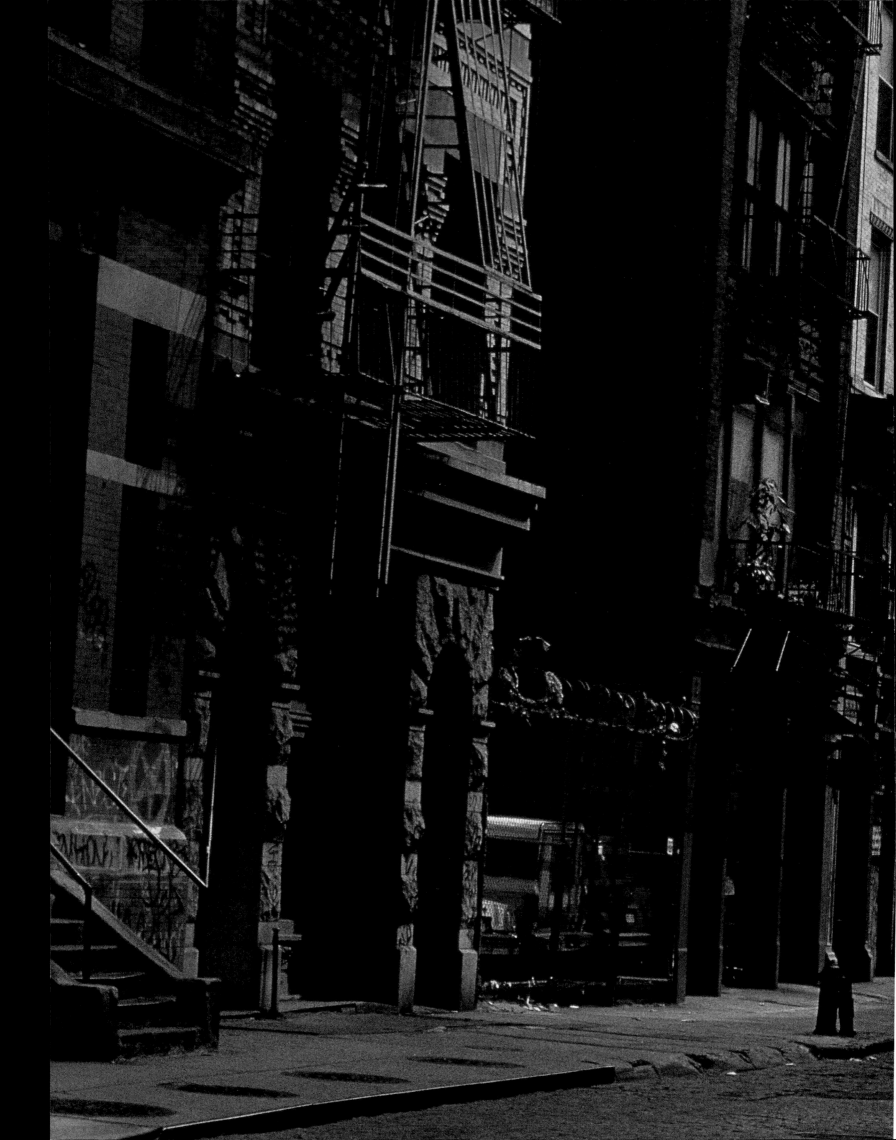

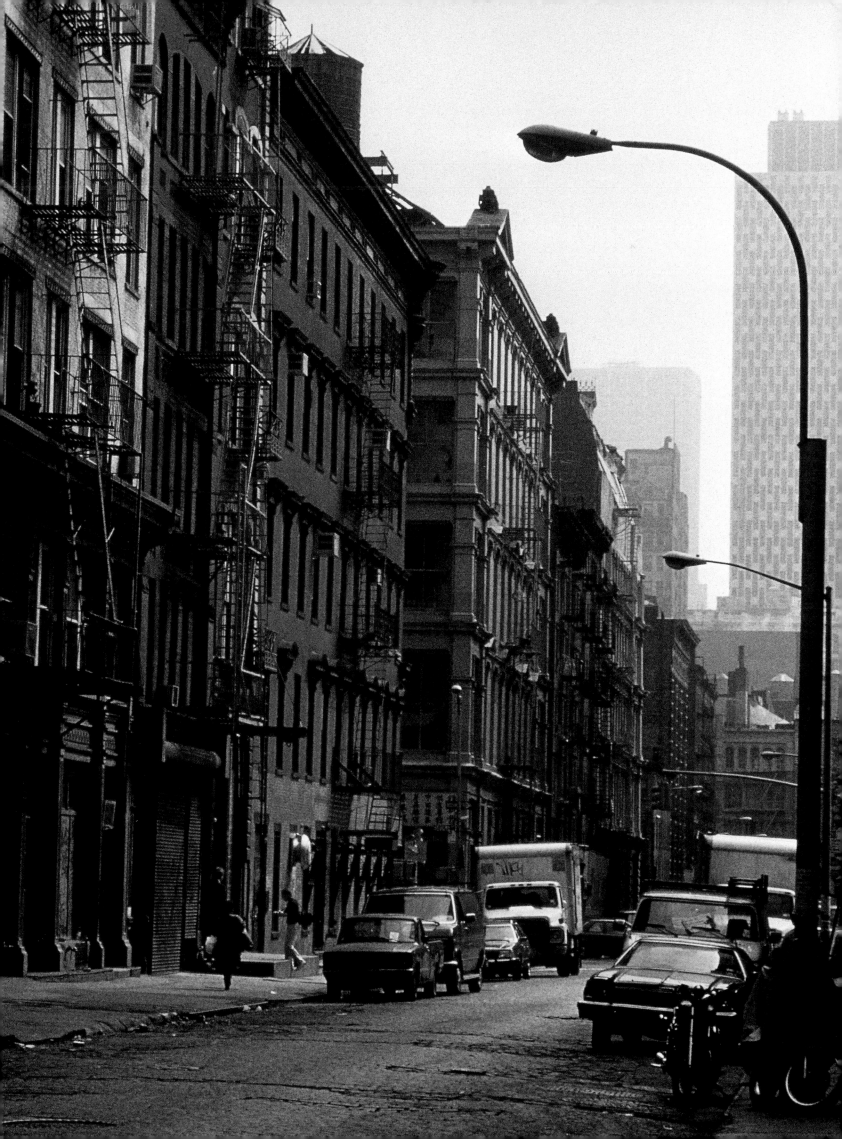

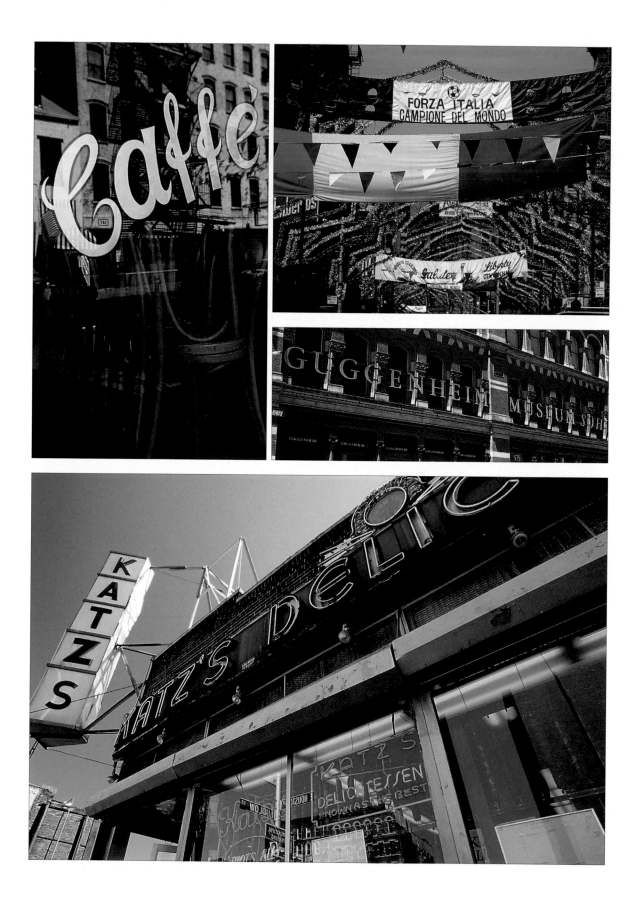

(previous two overleaves) Soho, which stands for SOuth of HOuston Street, is home to a characteristic building structure known as cast-iron architecture. Elaborate ornamental facades were cast in New York City foundries and then assembled on site.

(top right) Feast of San Gennaro. The Feast of San Gennaro is held in Little Italy every September to honor St. Januarius, the patron saint of Napoli. New Yorkers from every neighborhood join in the feast. **(top left)** A cafe in Little Italy. **(middle)** The Guggenhiem in Soho. **(bottom)** Katz's Deli.

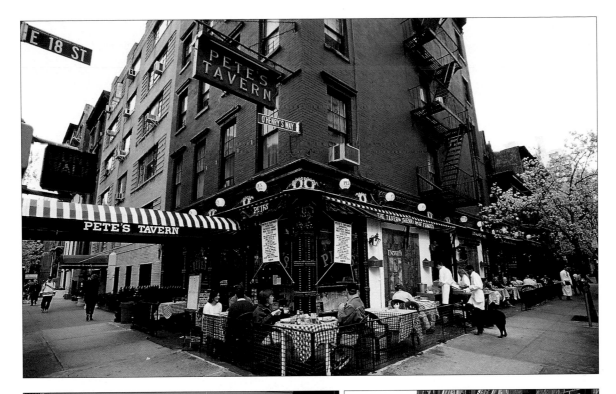

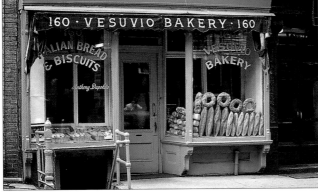

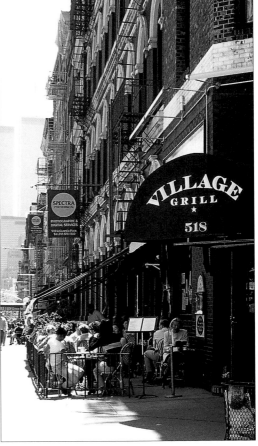

M any a New Yorker spends a lifetime within the confines of an area smaller than a country village. Let him walk two blocks from his corner and he is in a strange land and will feel uneasy till he gets back."

E. B. White (1899–1985)
American writer

(top) Pete's Tavern. Since 1864, Pete's Tavern has catered many different crowds from the Tammany Hall mob to a more literary crowd. O. Henry is said to have written many of his stories at Pete's Tavern while enjoying a beer. **(bottom left)** Vesuvio Bakery. **(bottom right)** Village Grill.

(overleaf) Brownstone homes in Greenwich Village.

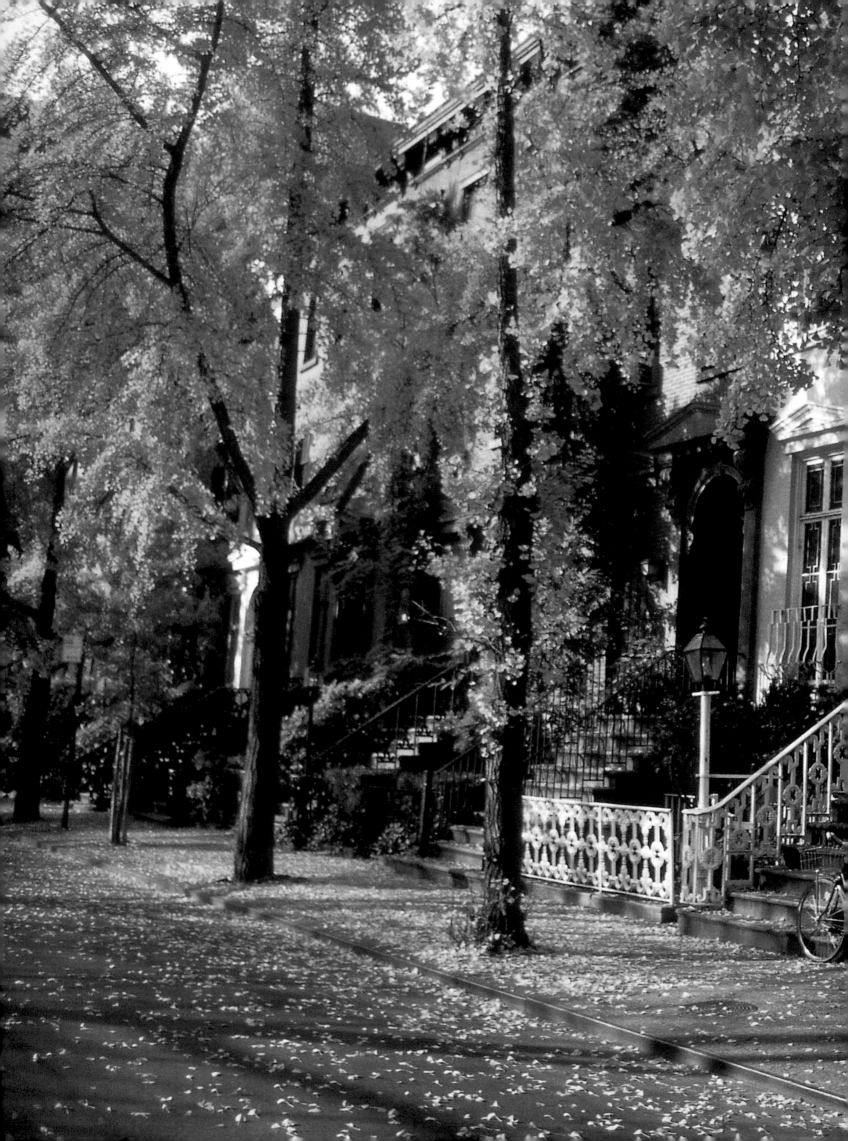

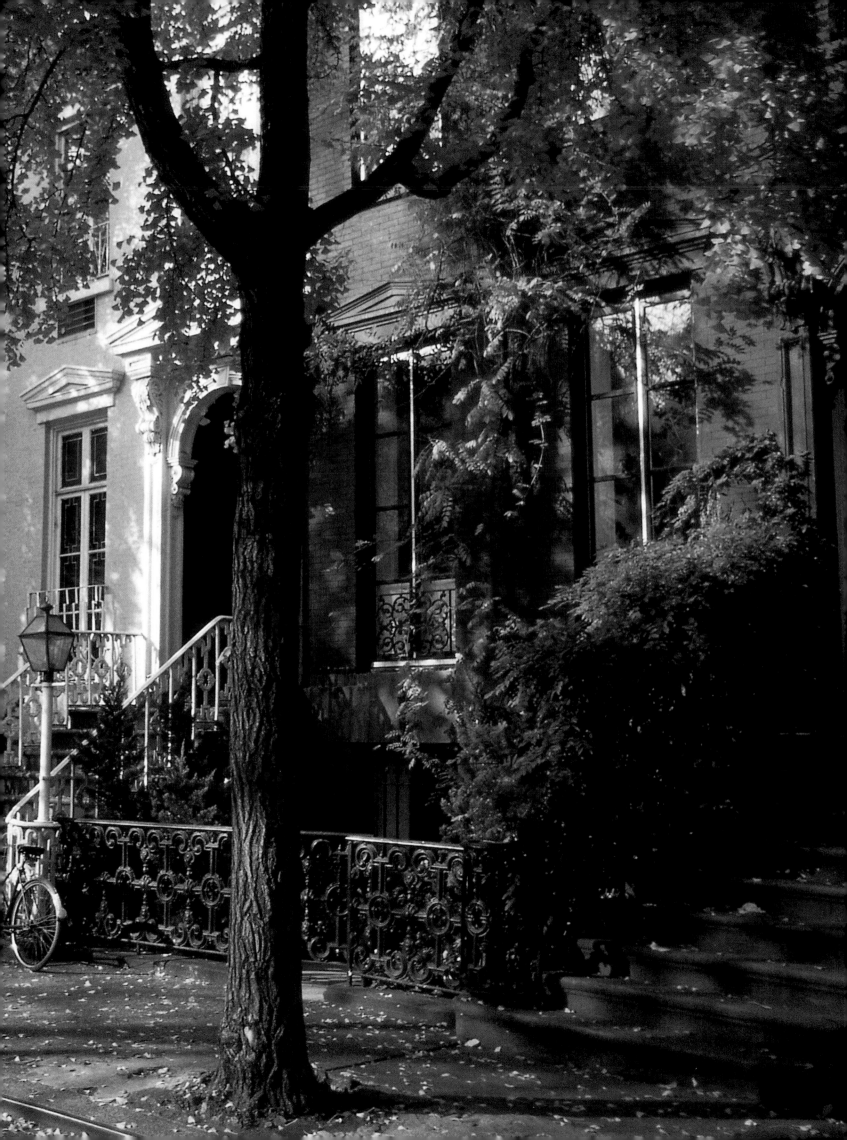

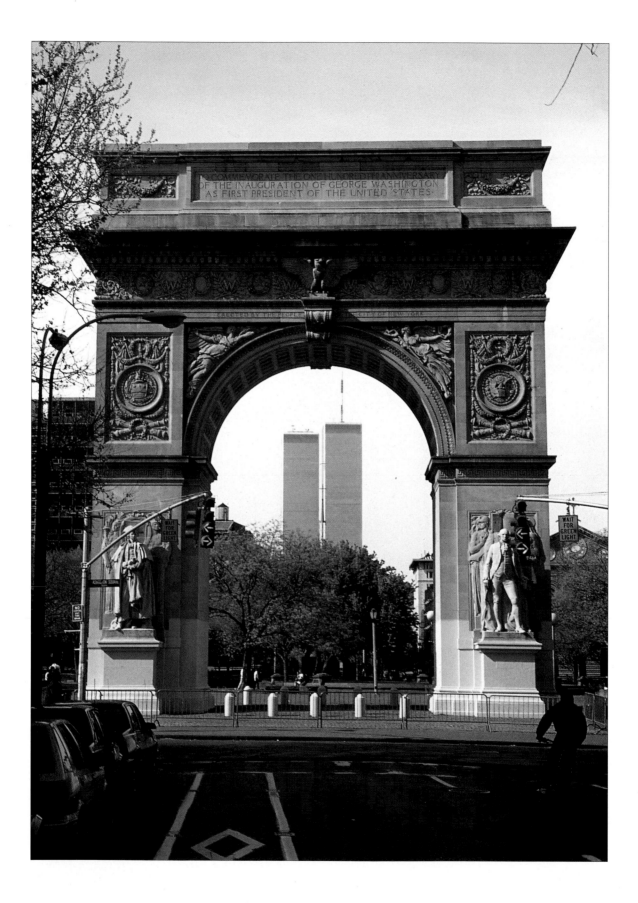

46 **(above and right)** Triumphal Arch.

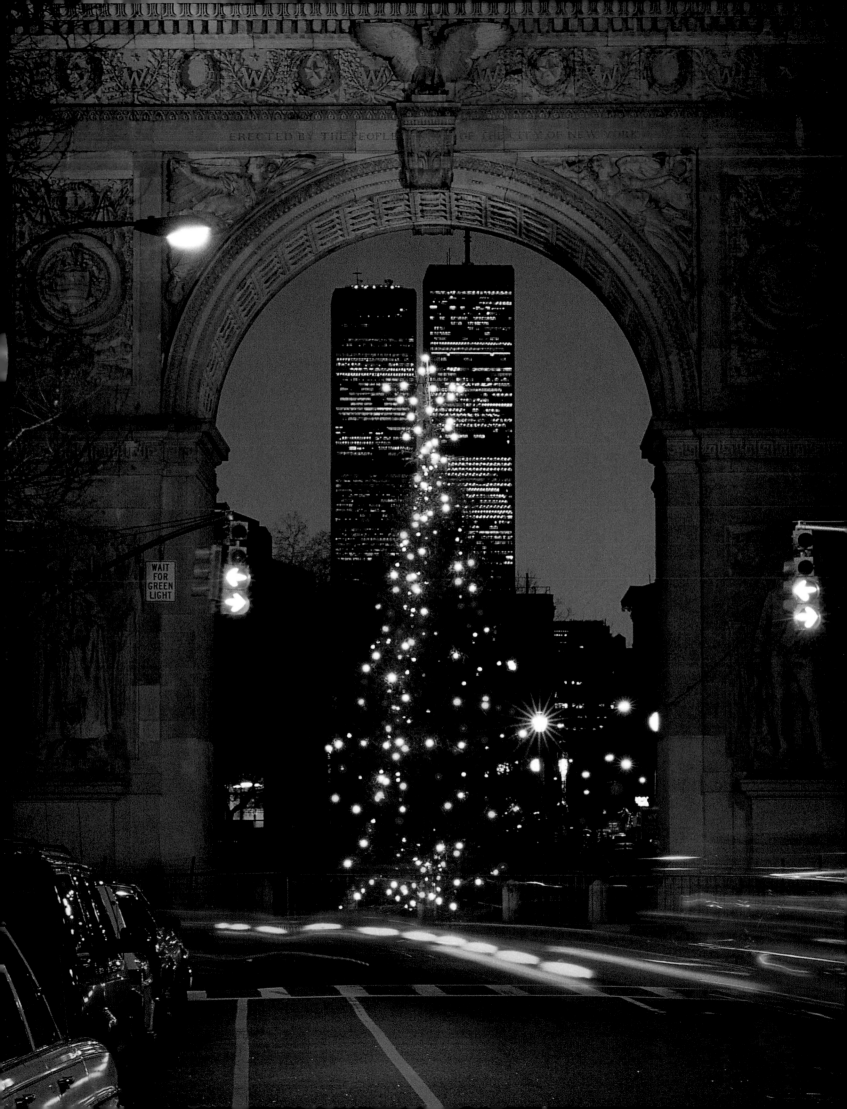

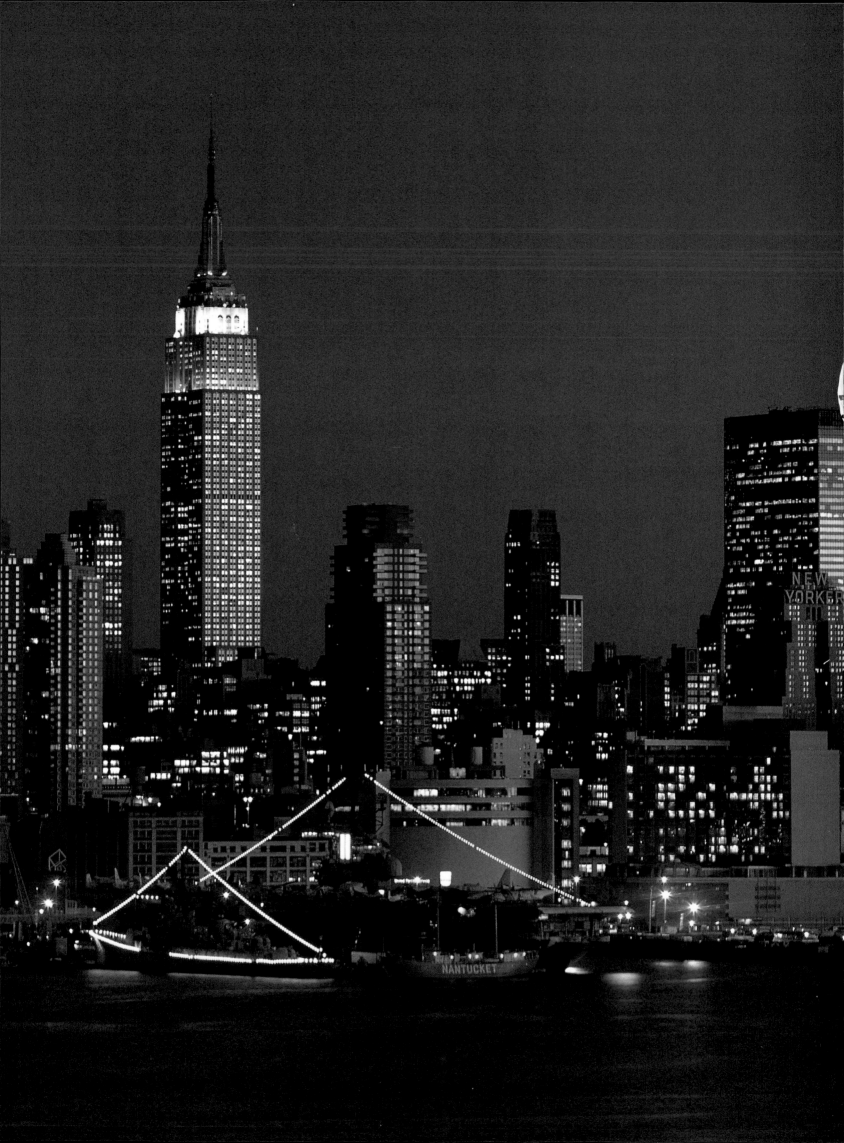

M I D T O W N

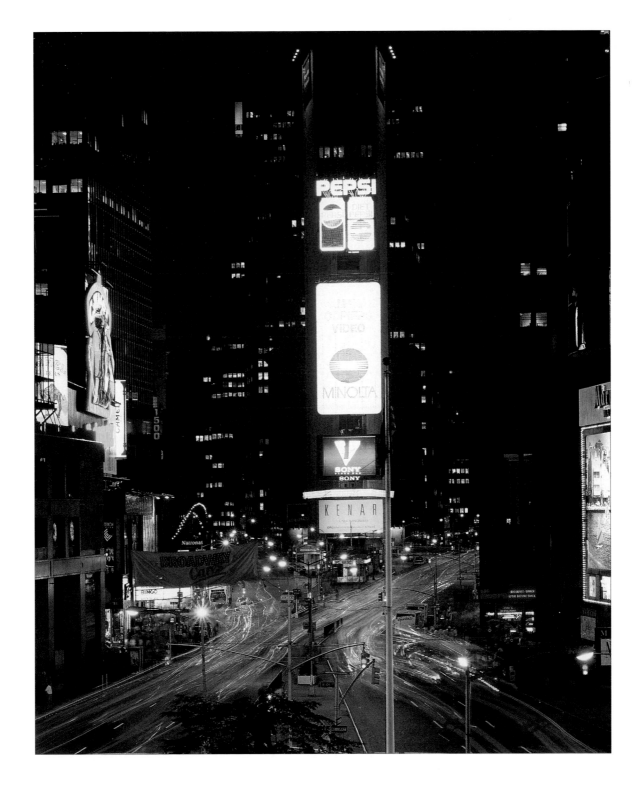

49 **(left)** Midtown Manhattan as seen from the harbor. **(above)** Midtown at night.

(overleaf) Midtown as seen from New Jersey.

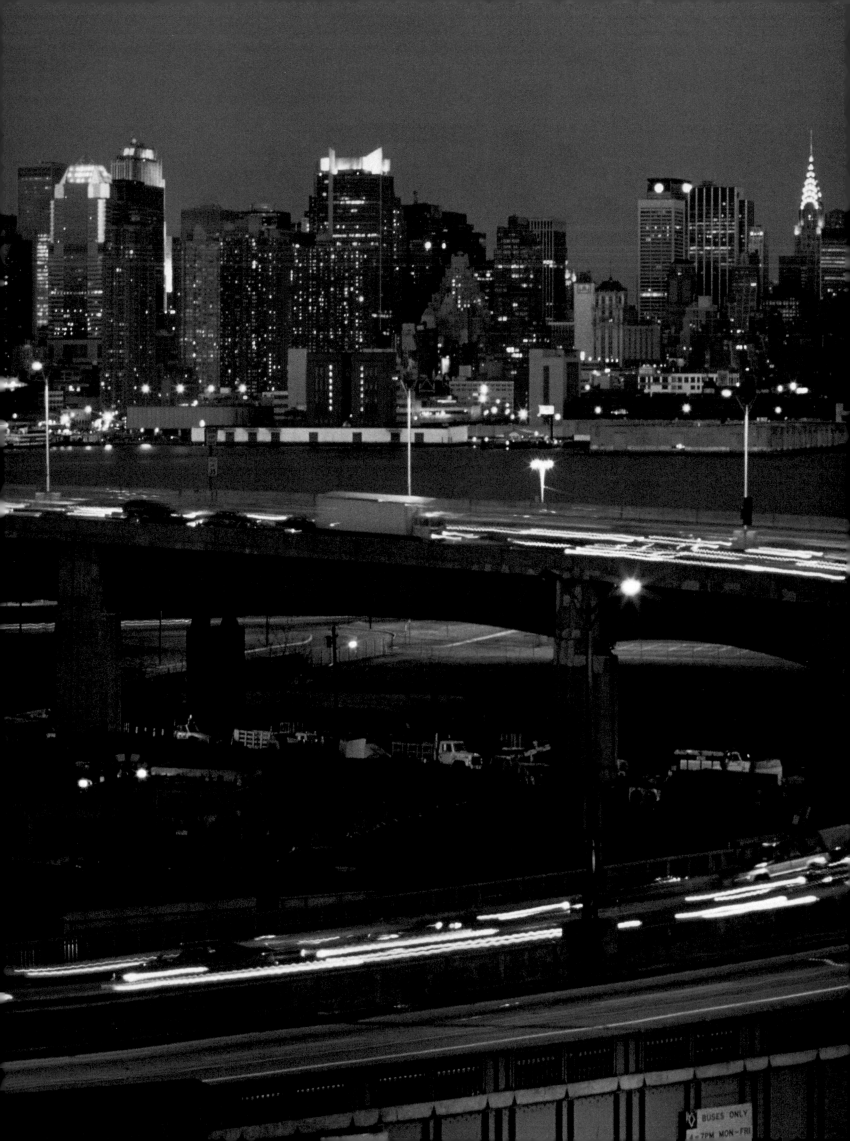

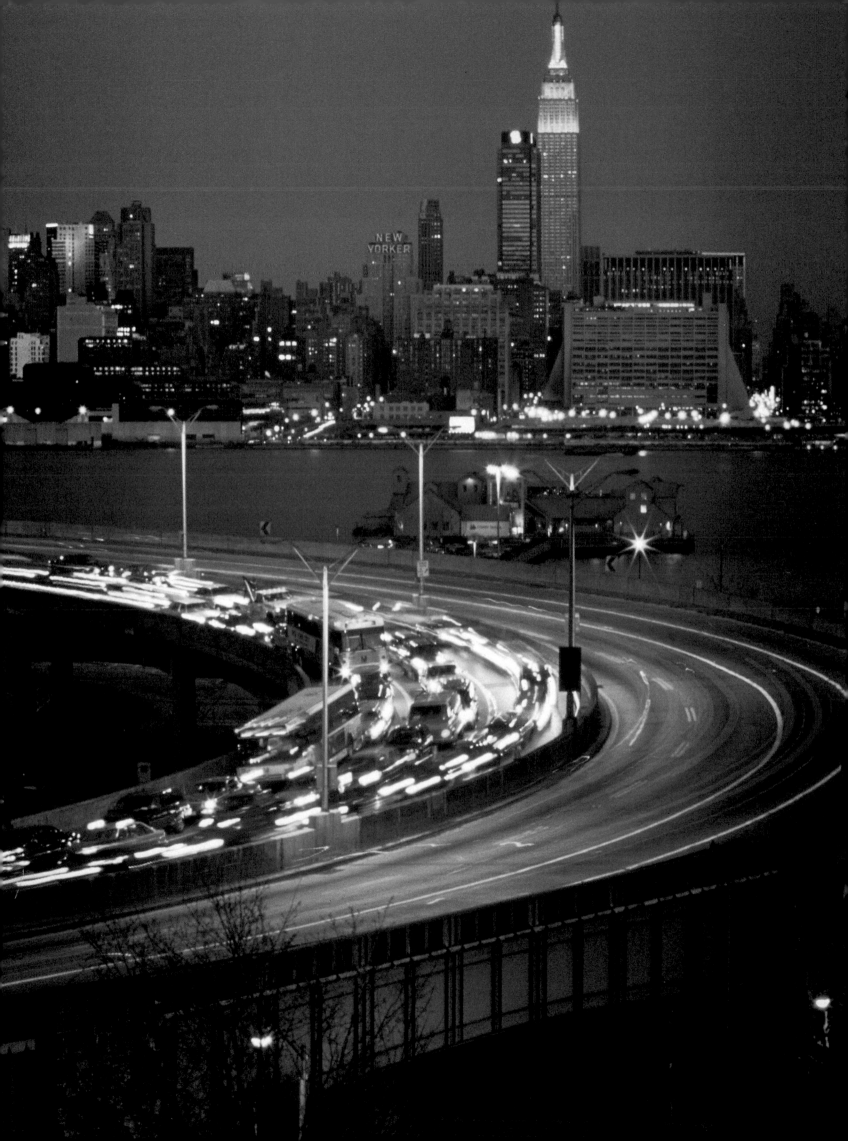

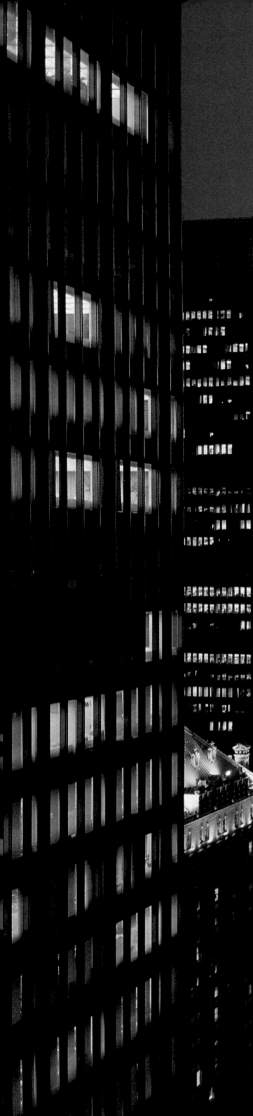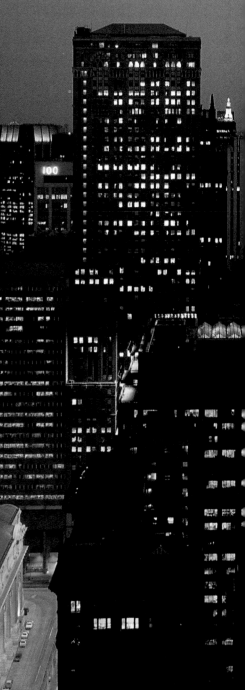

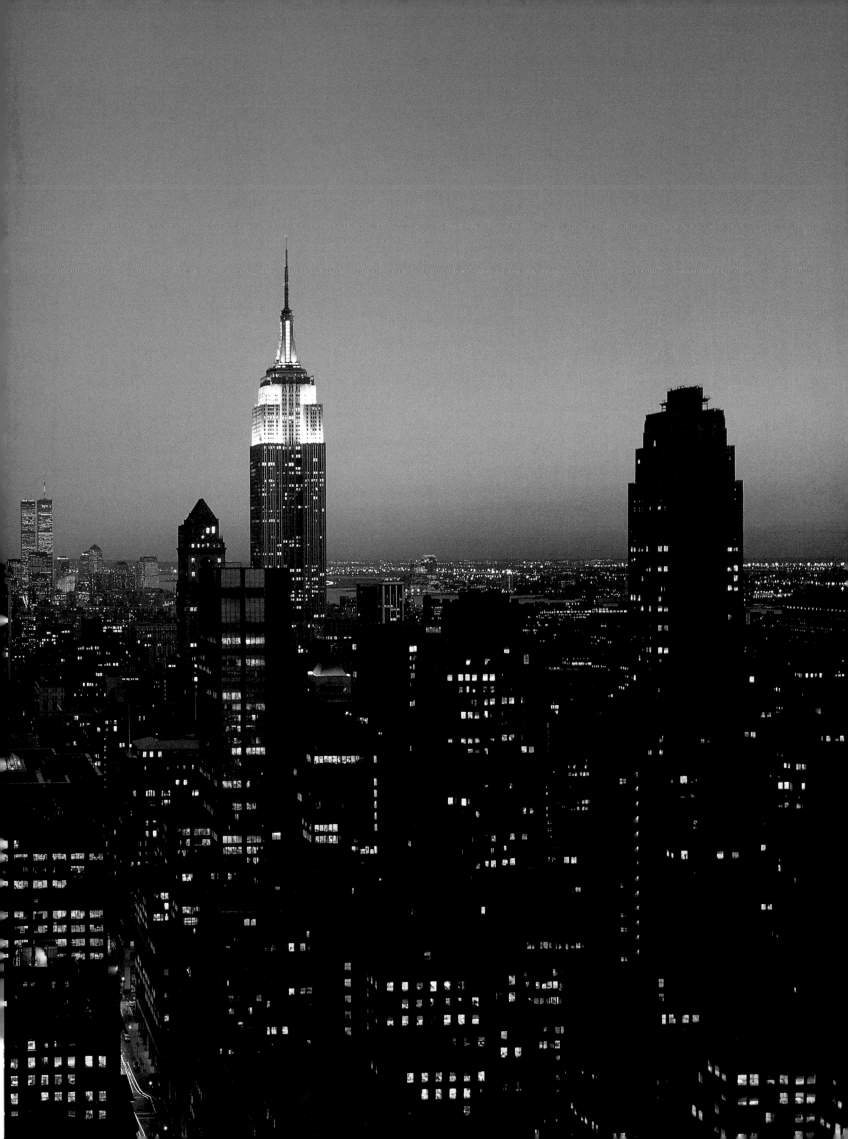

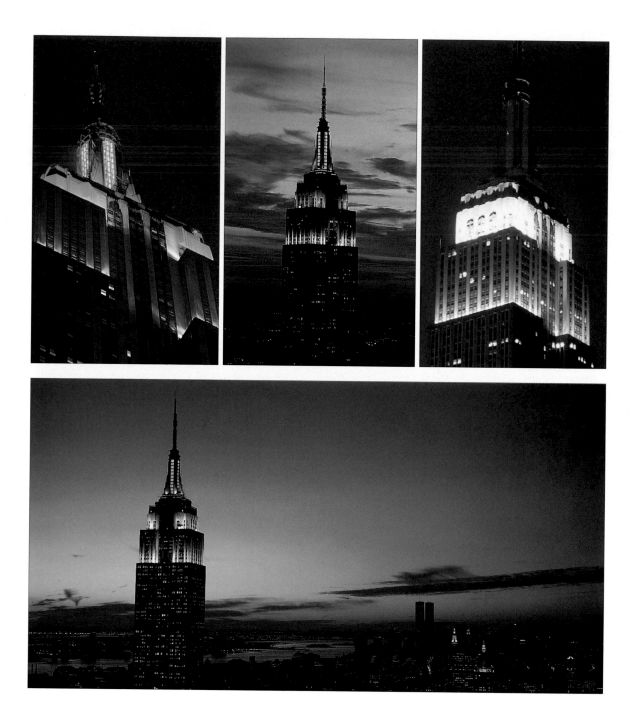

I n New York, you have to remember to look Up."

Helene Hanff
20th-century American writer

(previous overleaf) The Empire State Building.

(above and right) Empire State Building. Red and green floodlights illuminate the Empire State Building during the Christmas season. Other colors—like orange at Halloween and red, white and blue on the fourth of July—are used to celebrate other holidays throughout the year.

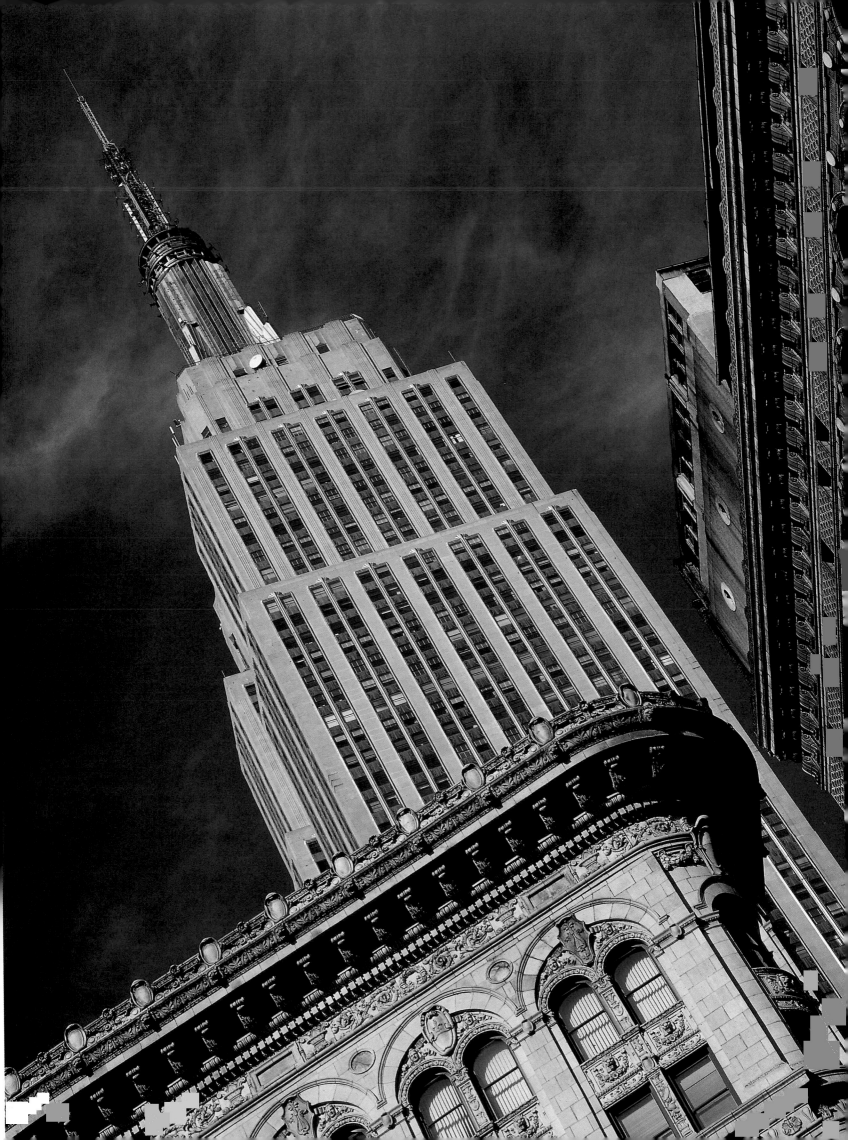

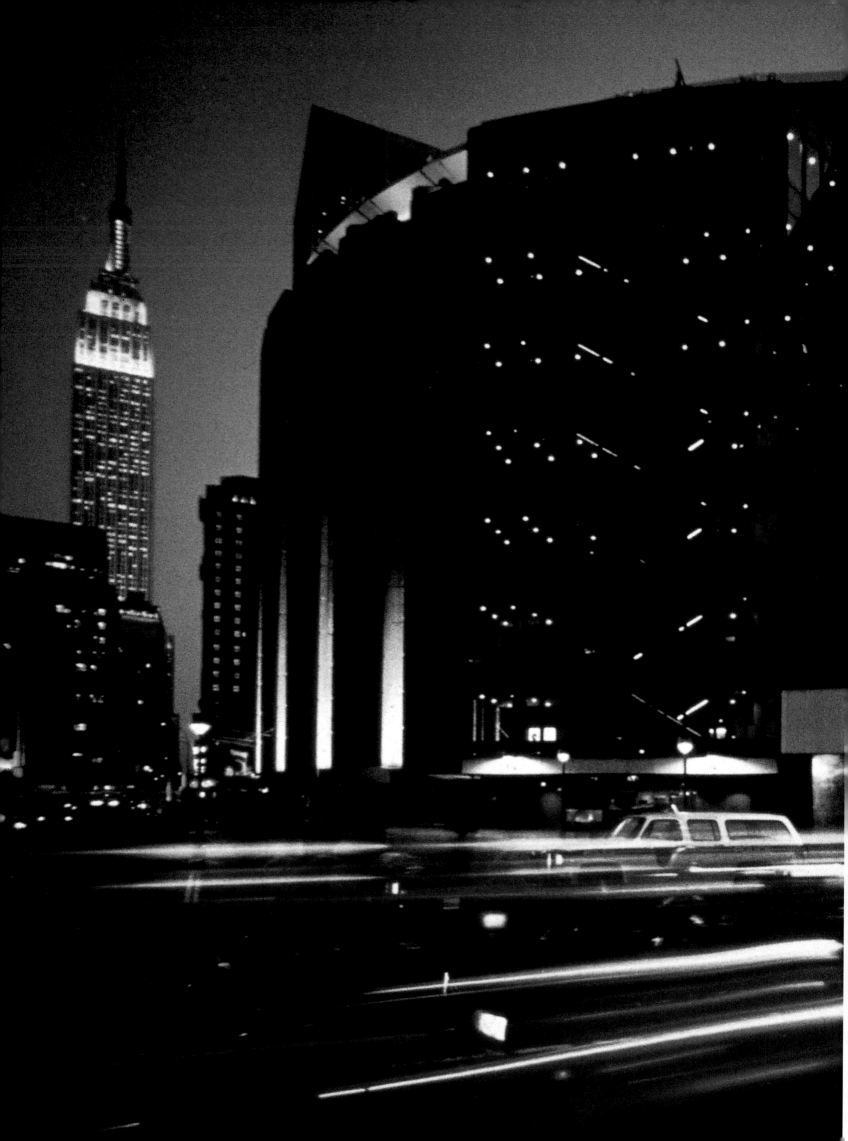

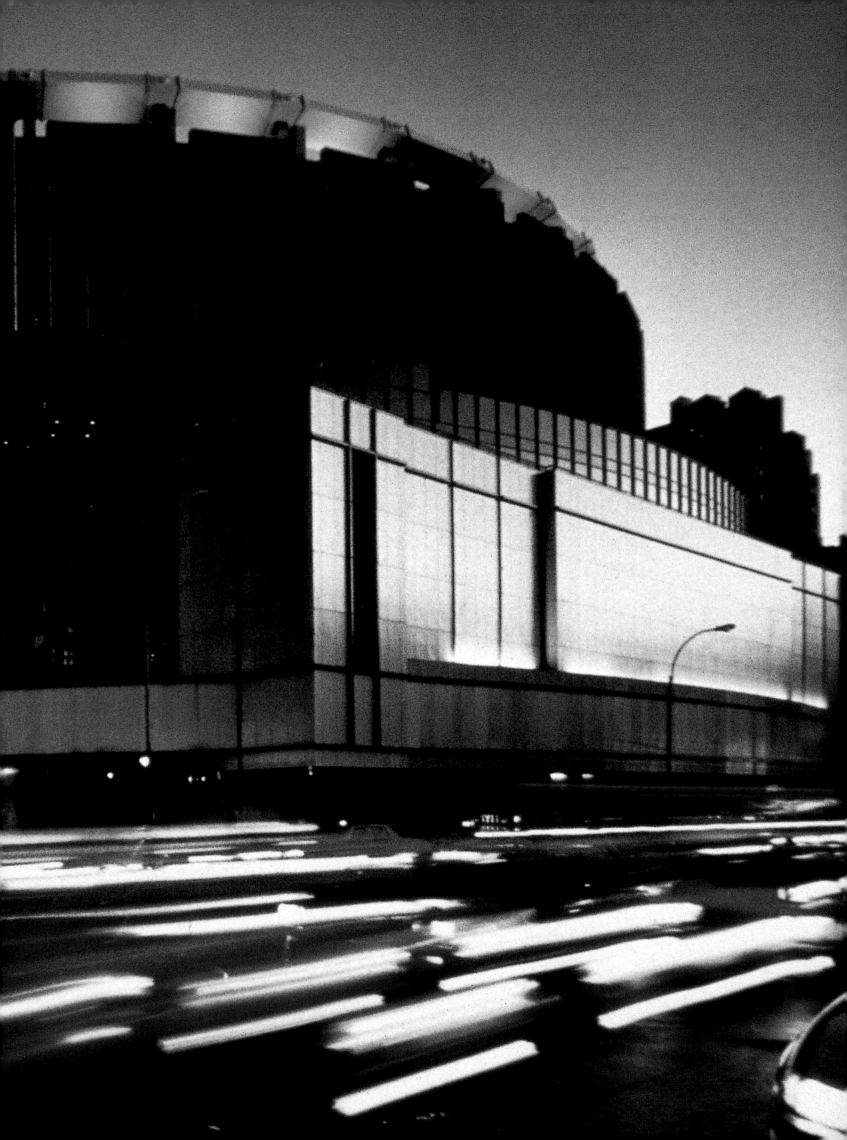

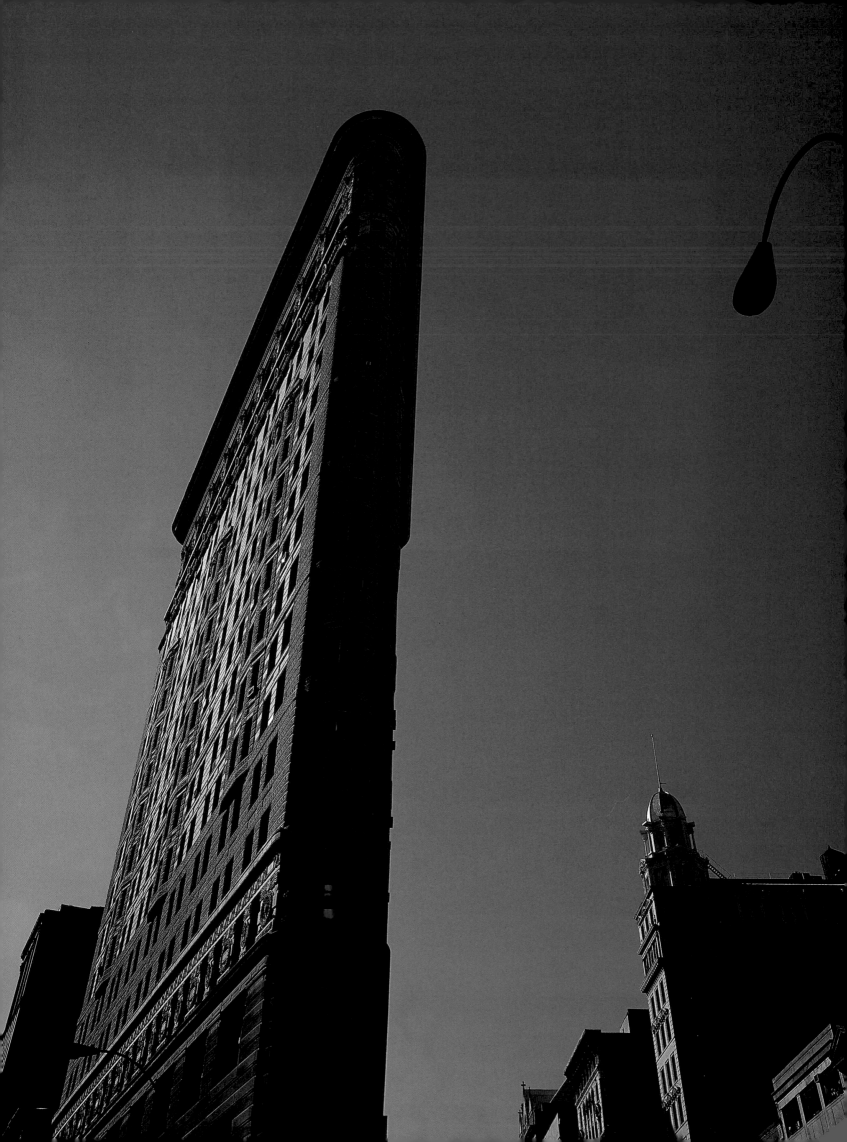

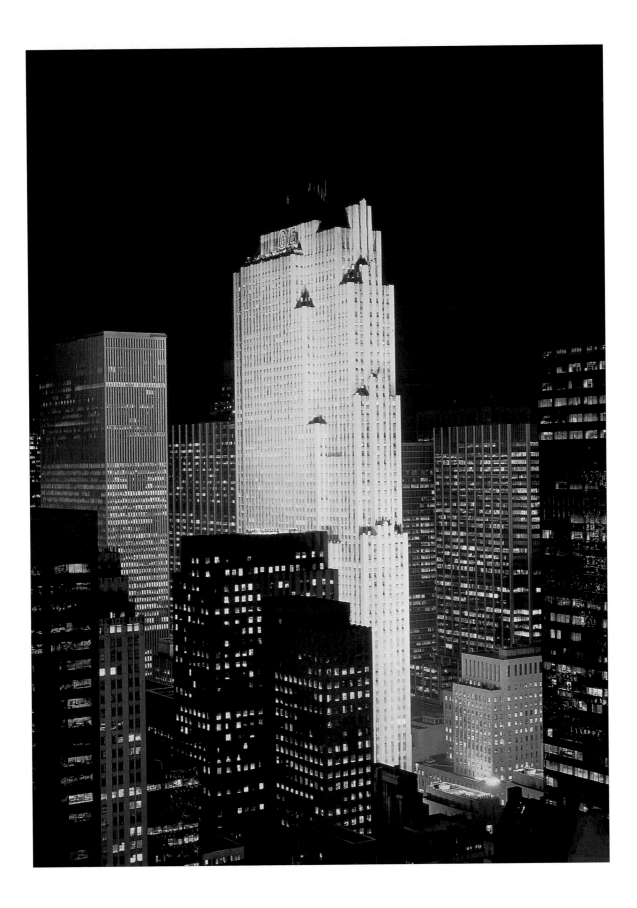

59 **(previous overleaf)** Madison Square Garden.

(left) The Flat Iron Building. **(above)** The RCA Building.

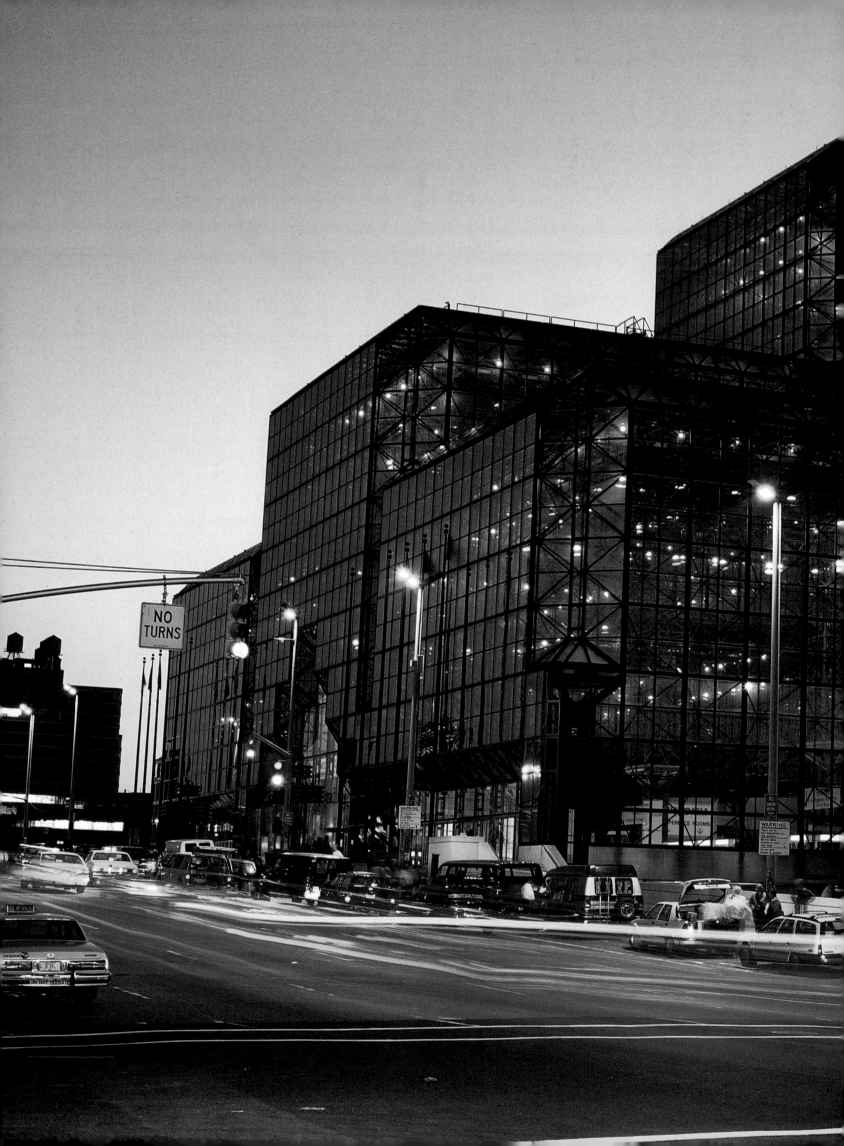

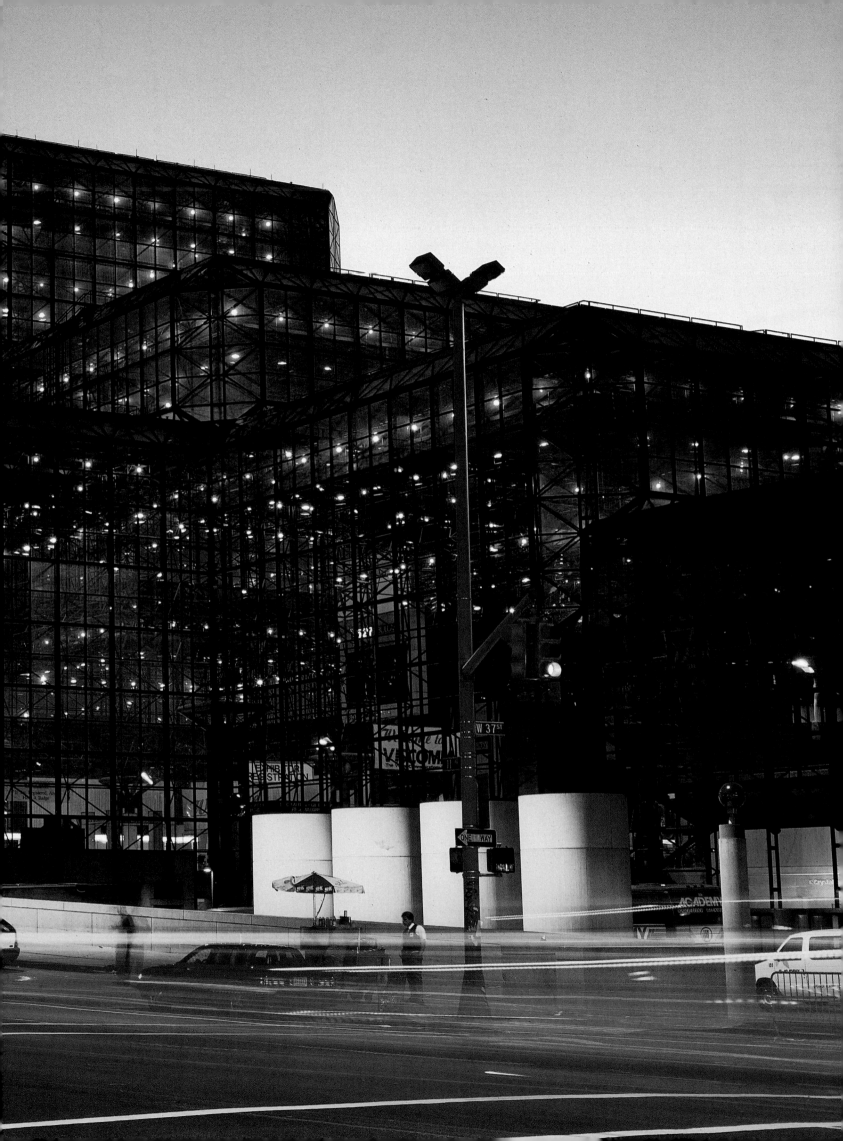

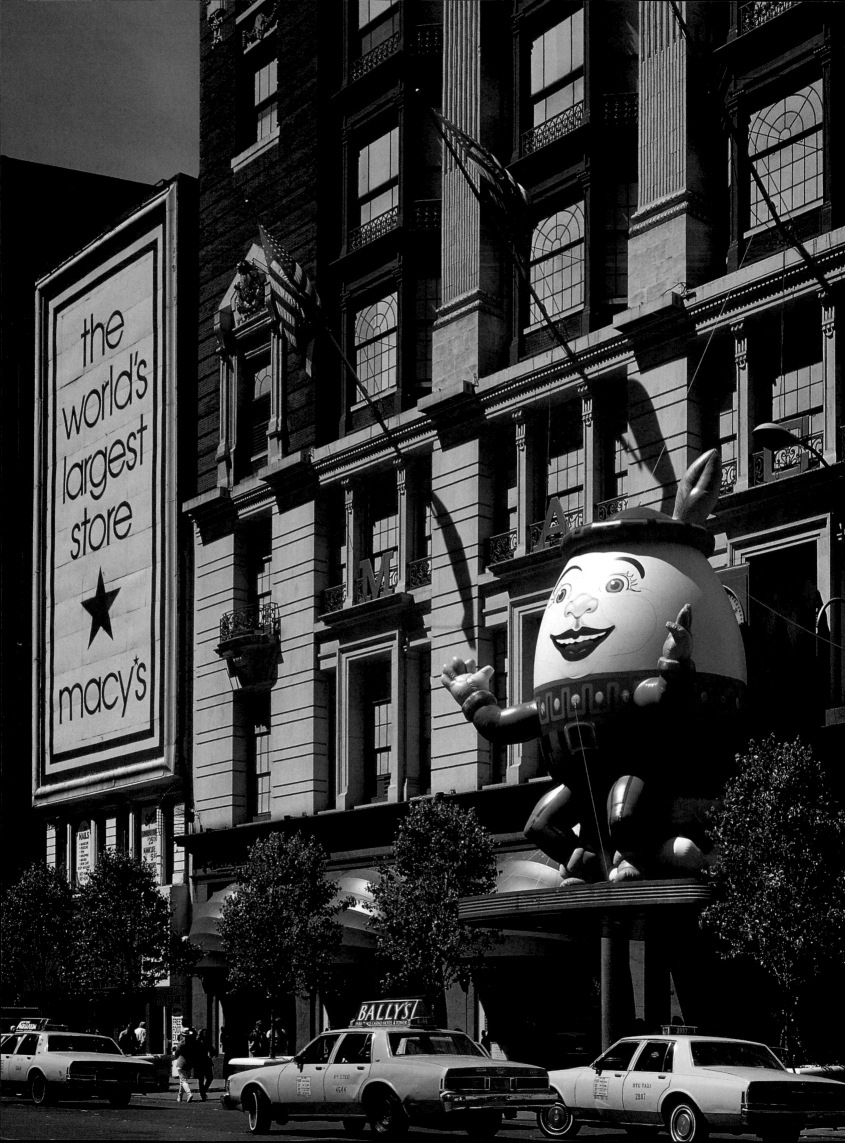

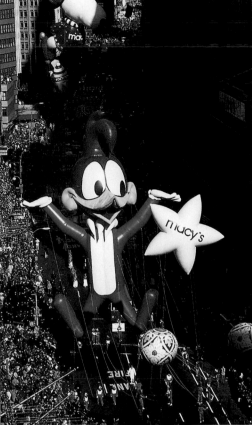

hether they're newly immigrated cabbies or megalomaniac financiers like Donald Trump, New Yorkers seem to possess a real whoop-de-do enthusiasm for living here."

David Brown
20th-century American writer

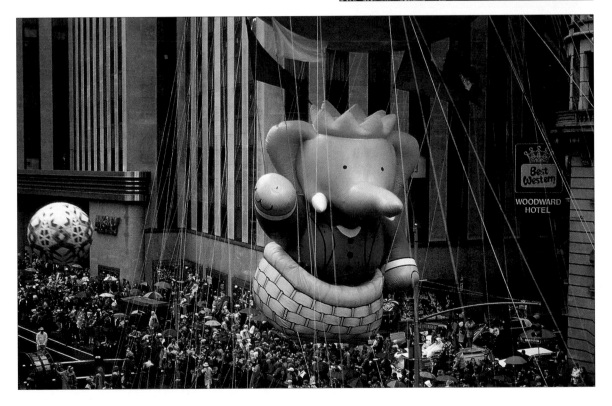

(previous overleaf) Jacob Javits Convention Center.

(left) Macy's Department Store. **(above and overleaf)** Macy's Thanksgiving Day parade.

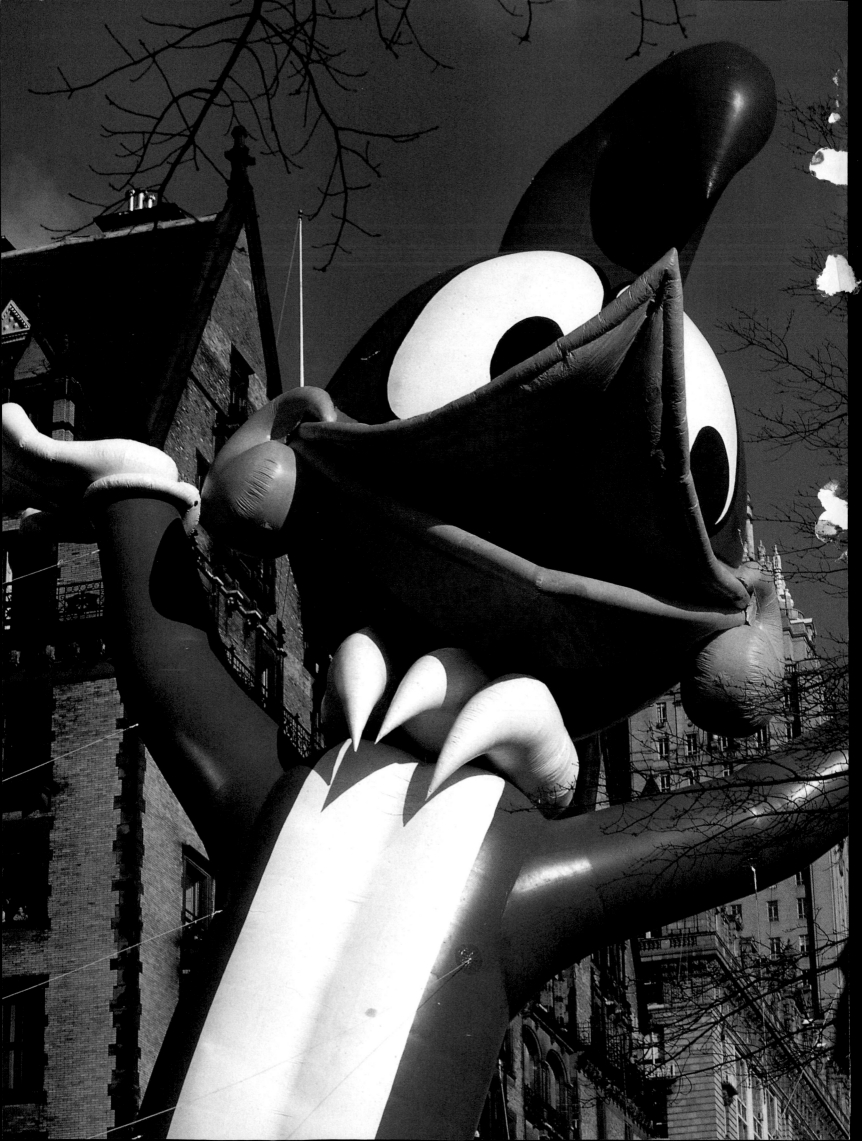

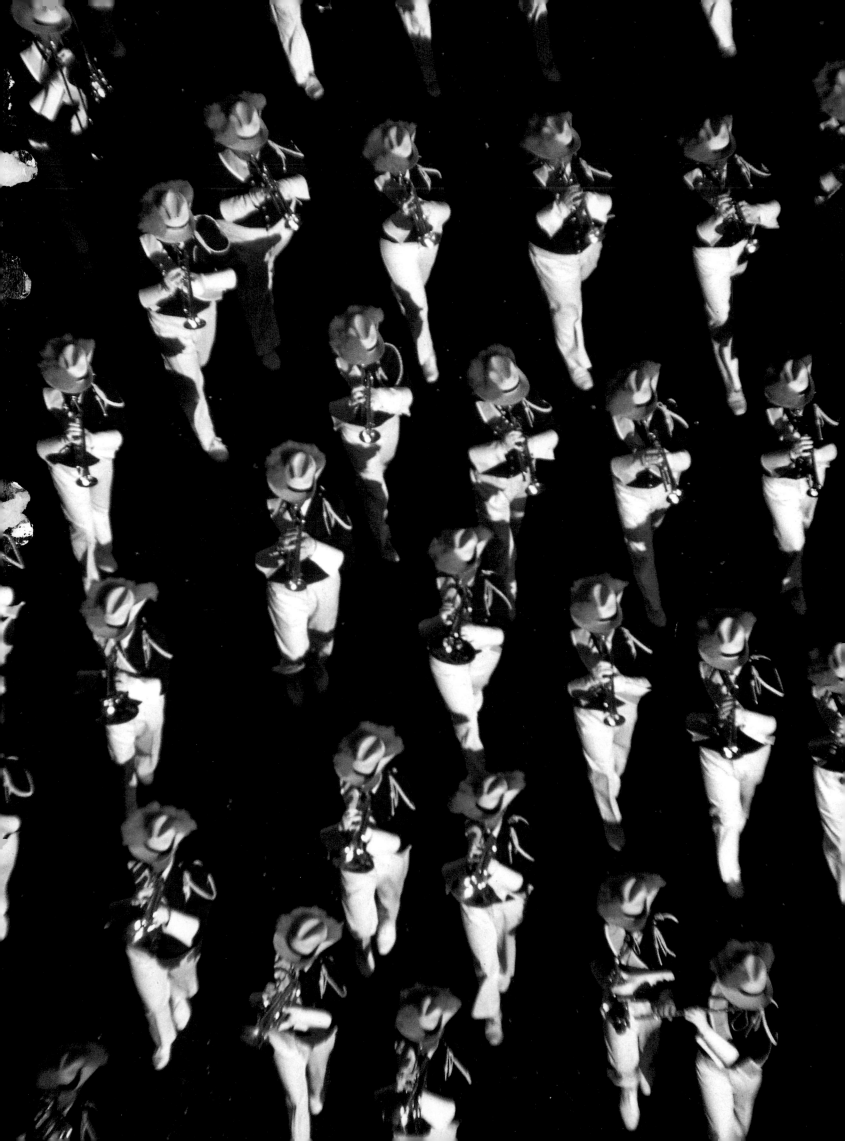

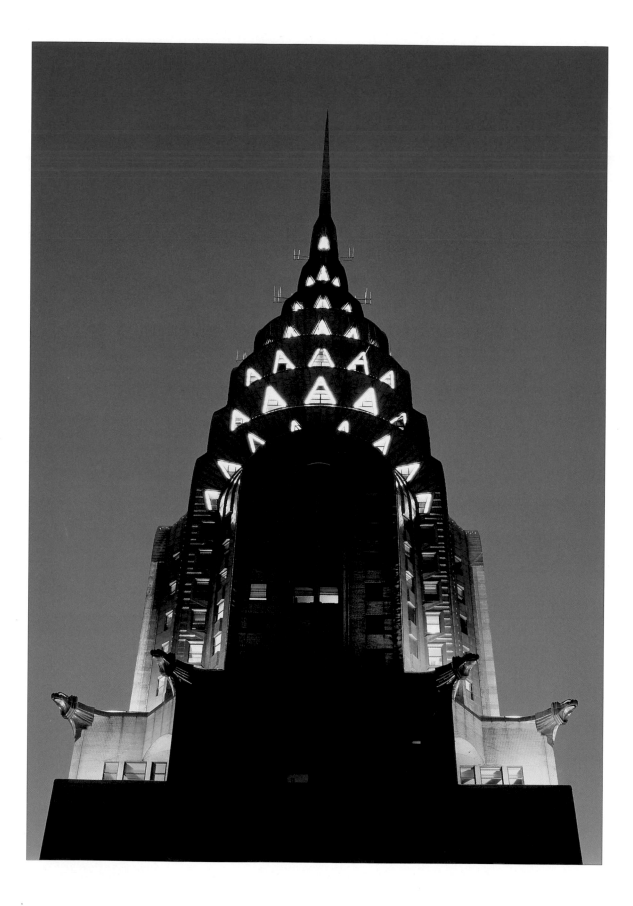

66 **(above and right)** The Chrysler Building. The Chrysler Building has stainless steel gargoyles and typifies the Art Deco style of skyscraper; its stunning spire was hidden until a dramatic unveiling at its installation.

(overleaf) The Helmsley Building (left) and the Citicorp Building (right).

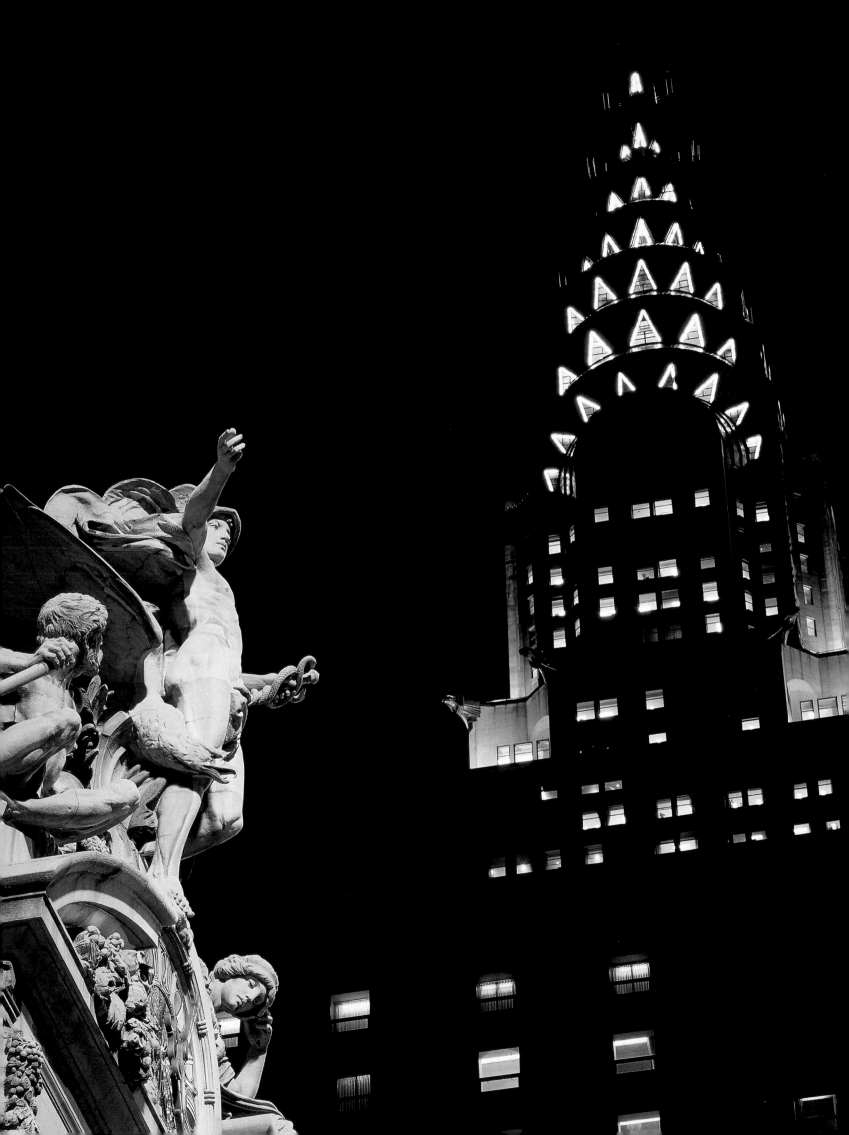

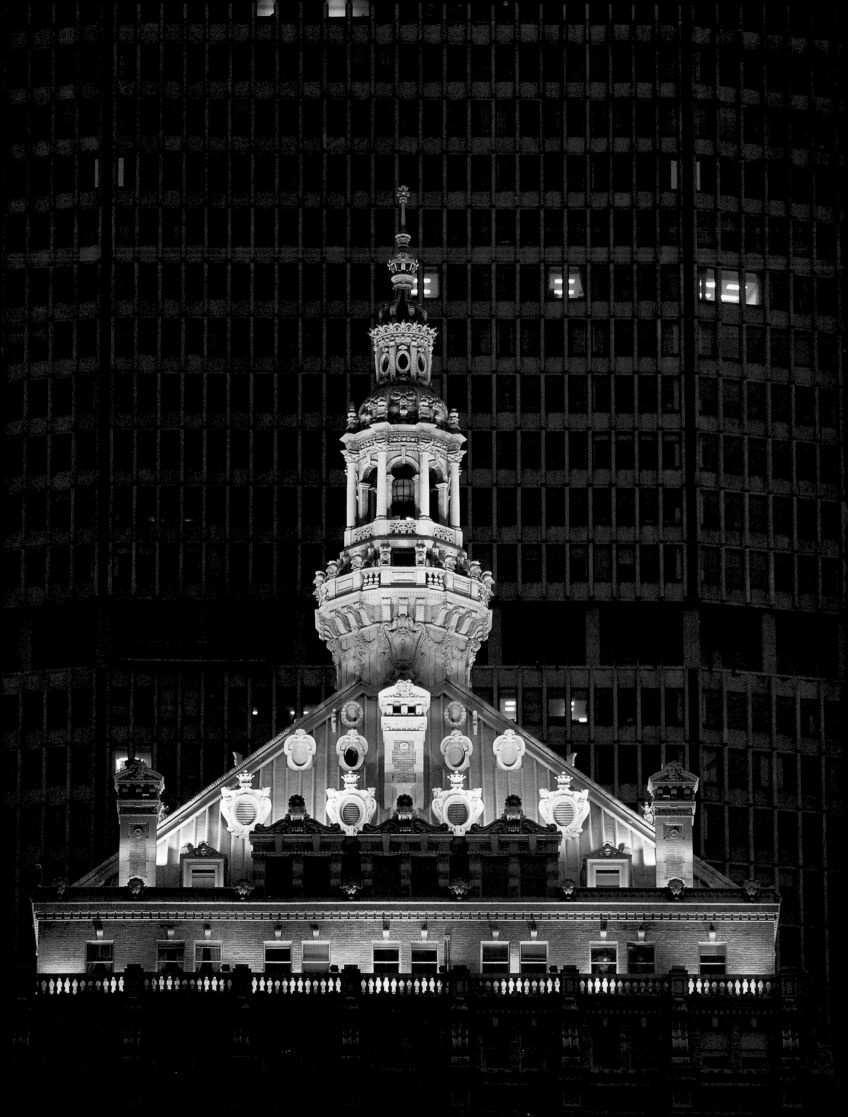

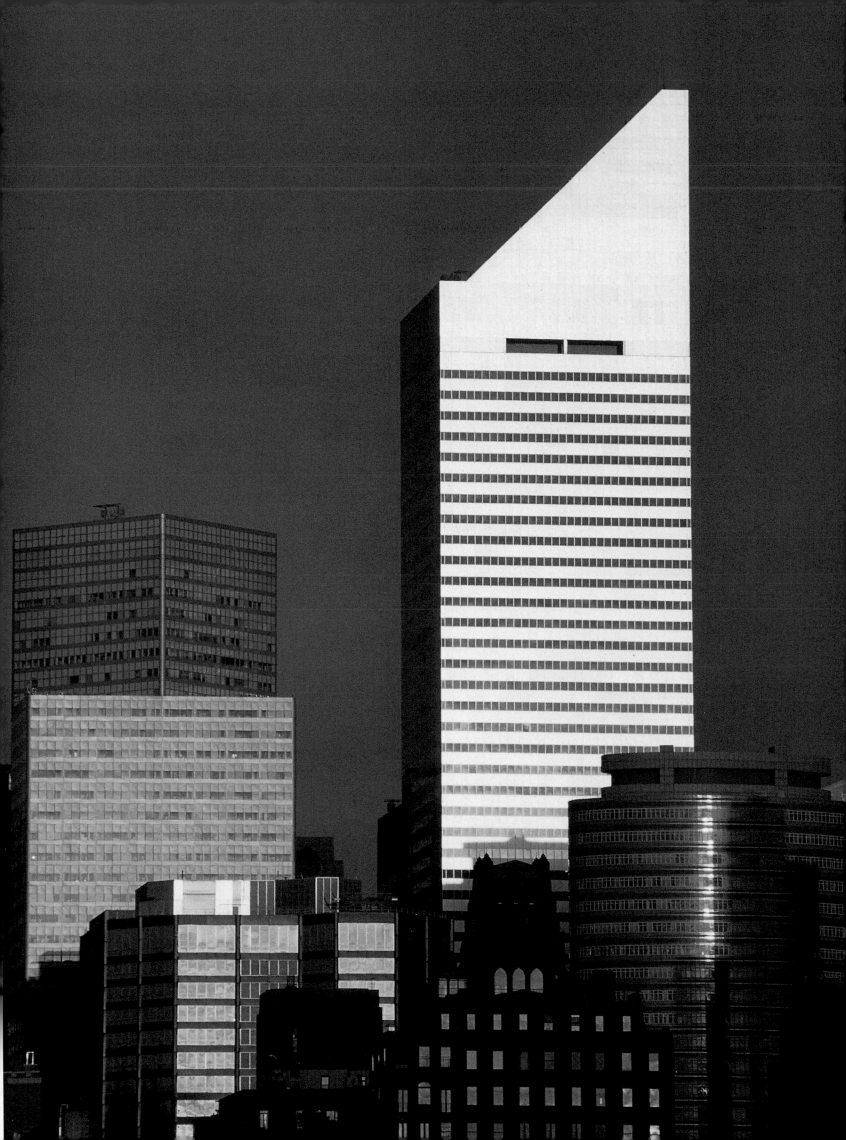

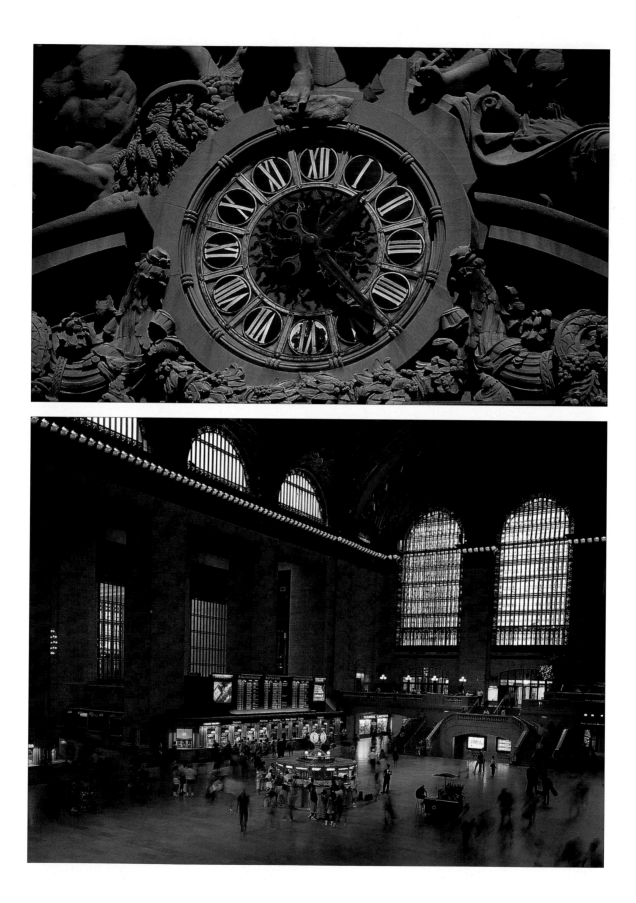

70 **(above and right)** Grand Central Station. Restored in the early nineties, Grand Central Station shows the grandeur of the Art Deco period. The clock in center of the terminal is one of the most popular meeting places in midtown Manhattan.

(overleaf) New York Public Library. The New York Public Library was established in 1895 by combining private collections of prominent New York citizens and now contains more than 30 million catalogued items. Regal, stone lions stand sentry at the main entrance to the library.

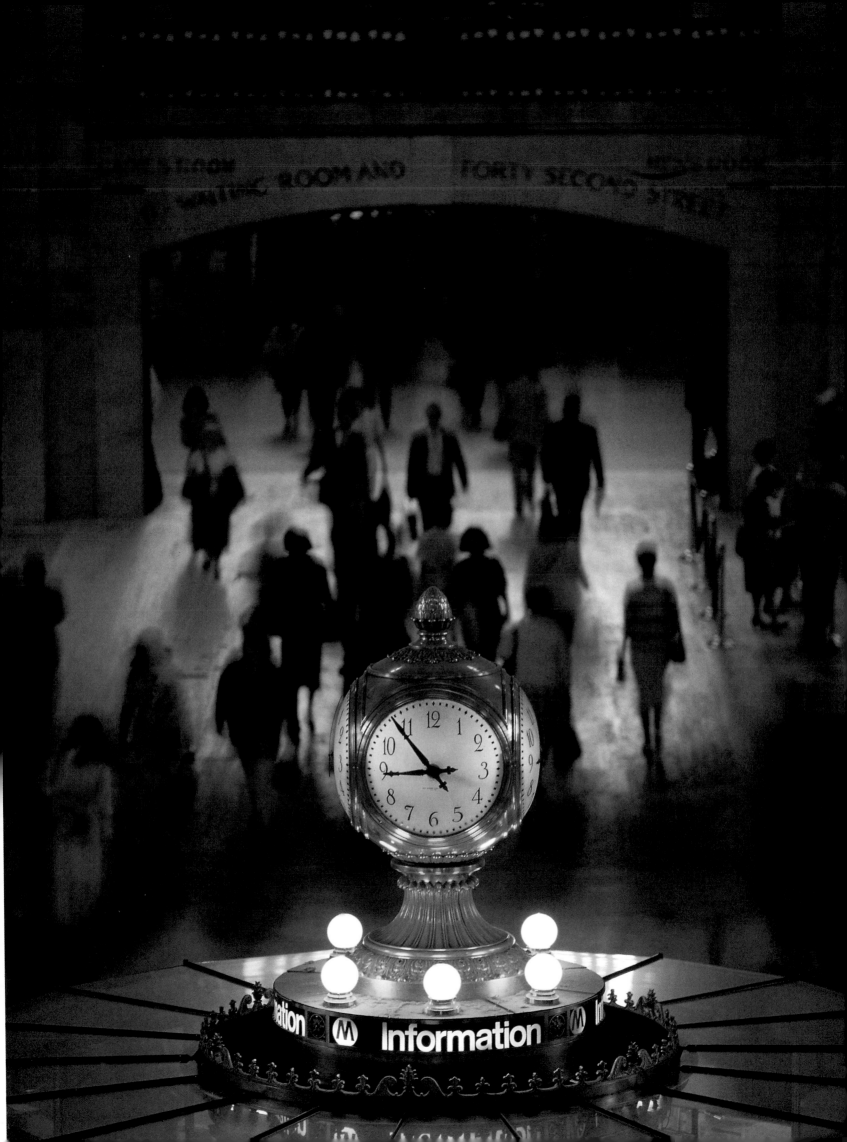

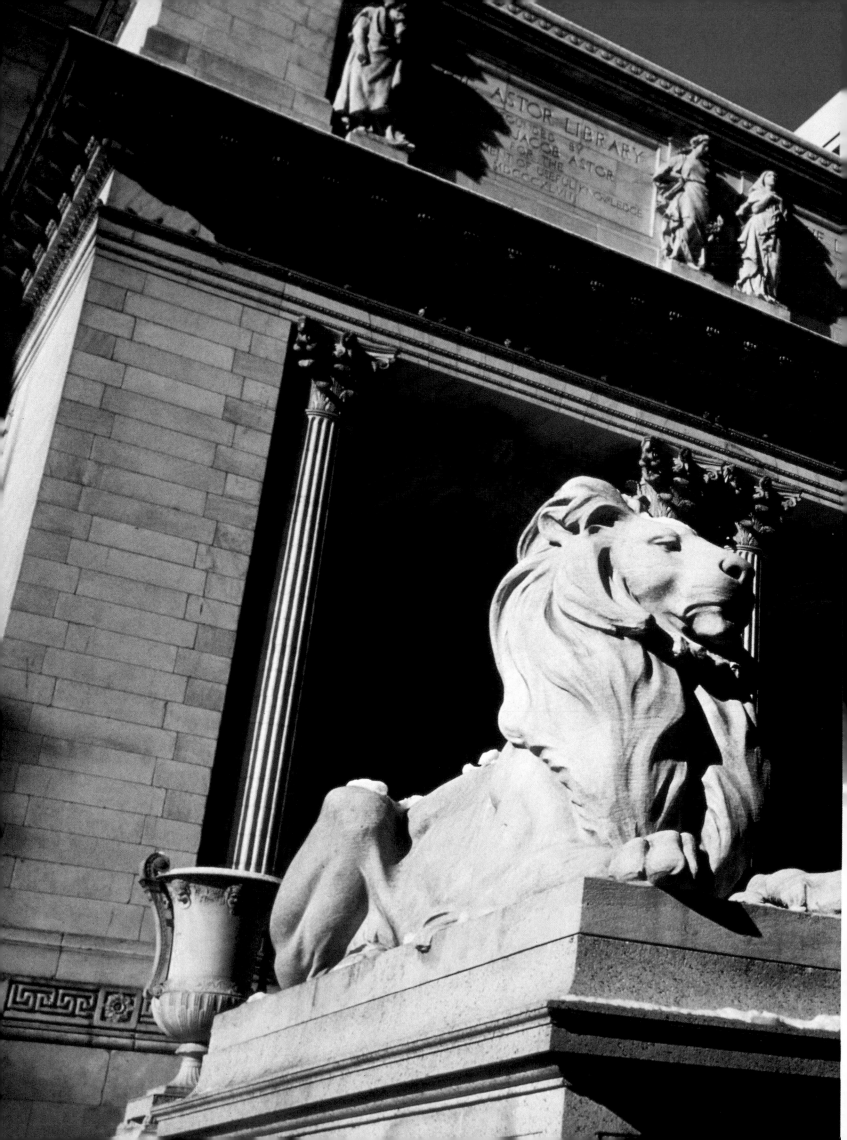

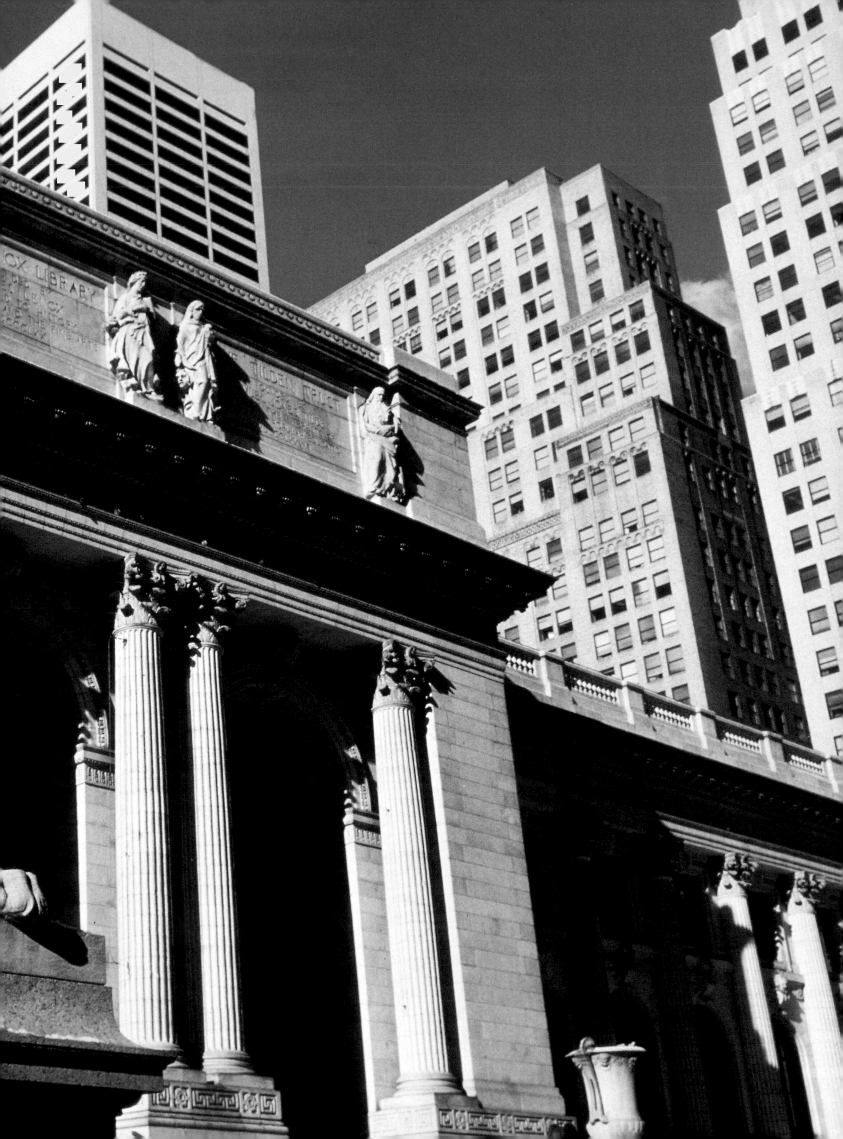

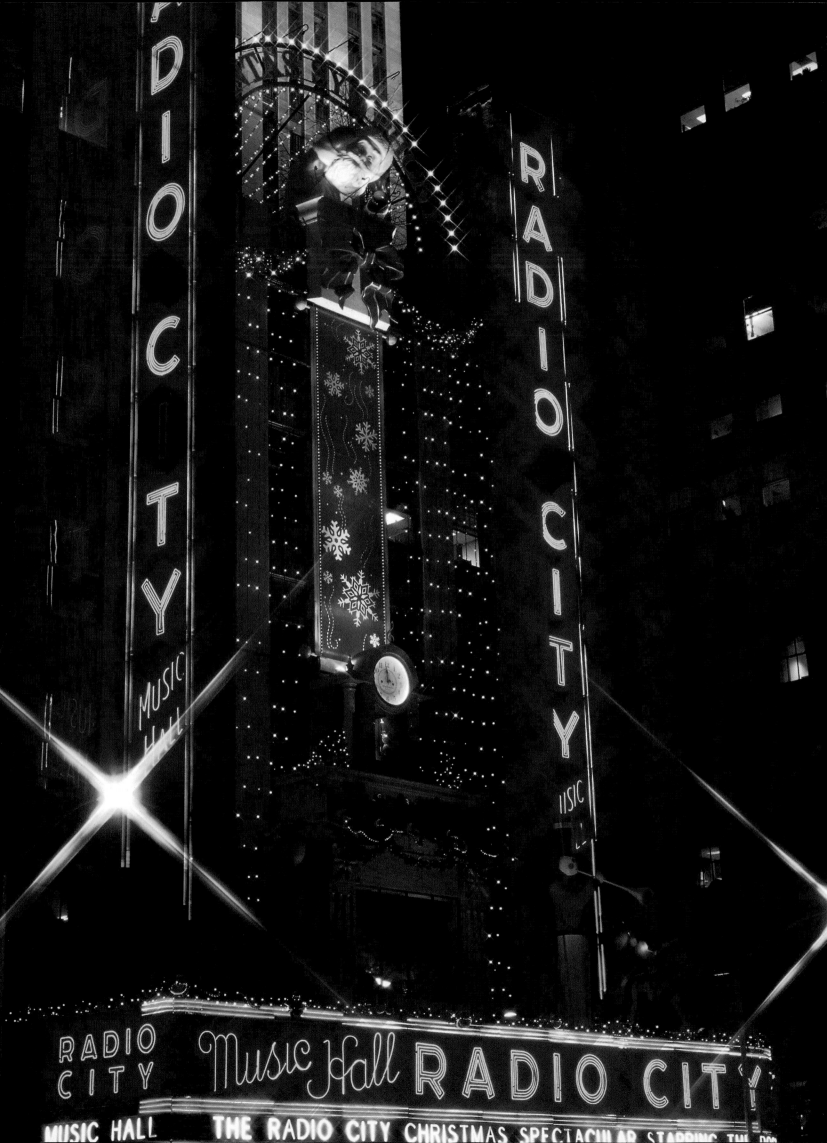

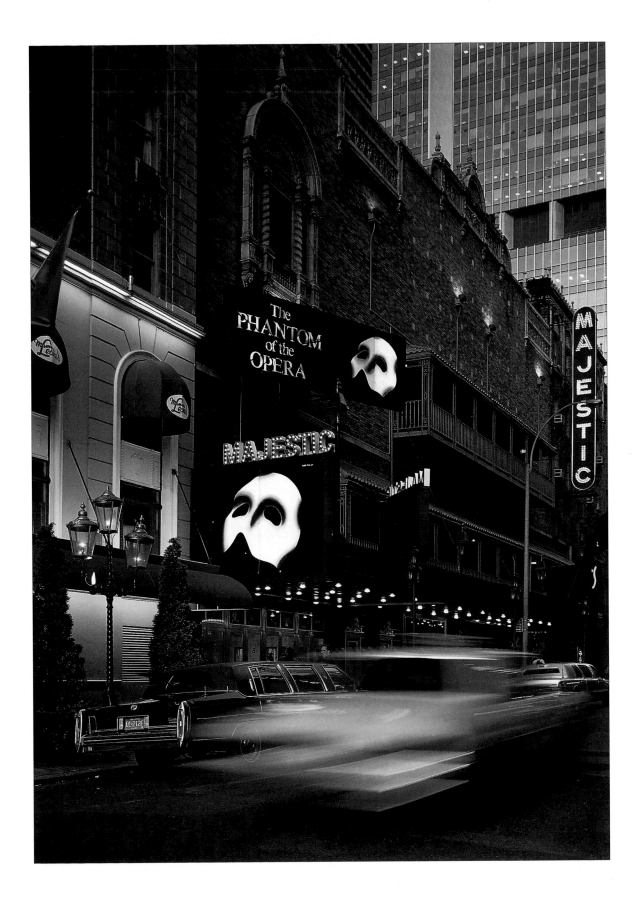

(left) The Radio City Music Hall. **(above)** *Phantom of the Opera* at the Majestic Theater.

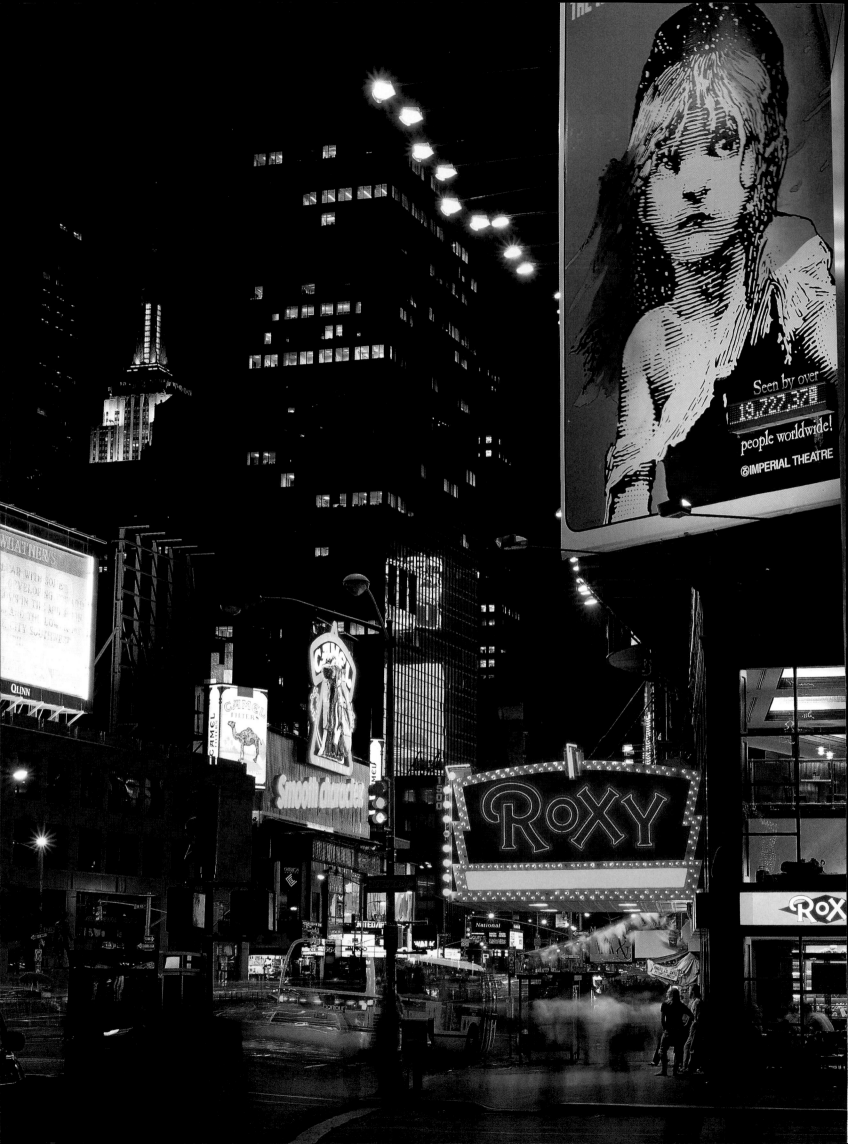

n Broadway it was still bright afternoon and the great, great crowd,

the inexhaustible current of millions of every race and kind pouring out, pressing round,

of every age, of every genius, possessors of every human secret,

antique and future, in every face the refinement of one particular motive or essence."

Saul Bellow (b. 1915)
Canadian novelist

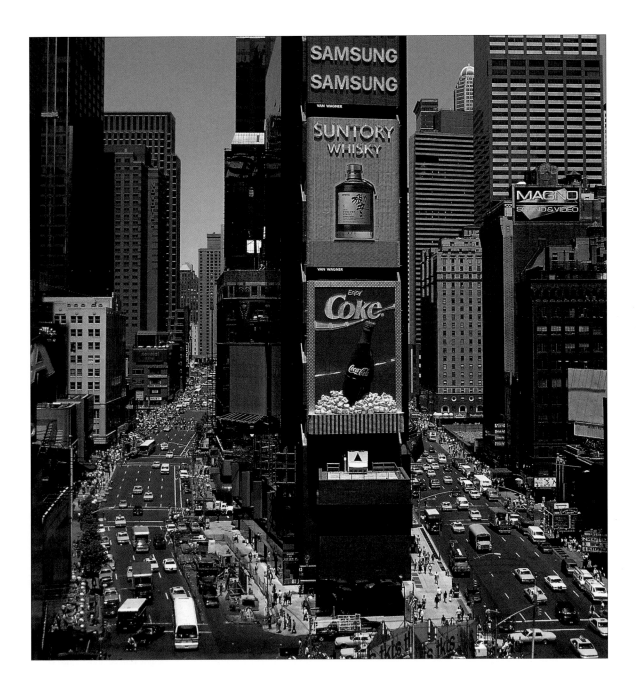

(left) Broadway at night. **(above)** Times Square.

(following two overleaves) Times Square and yellow cabs.

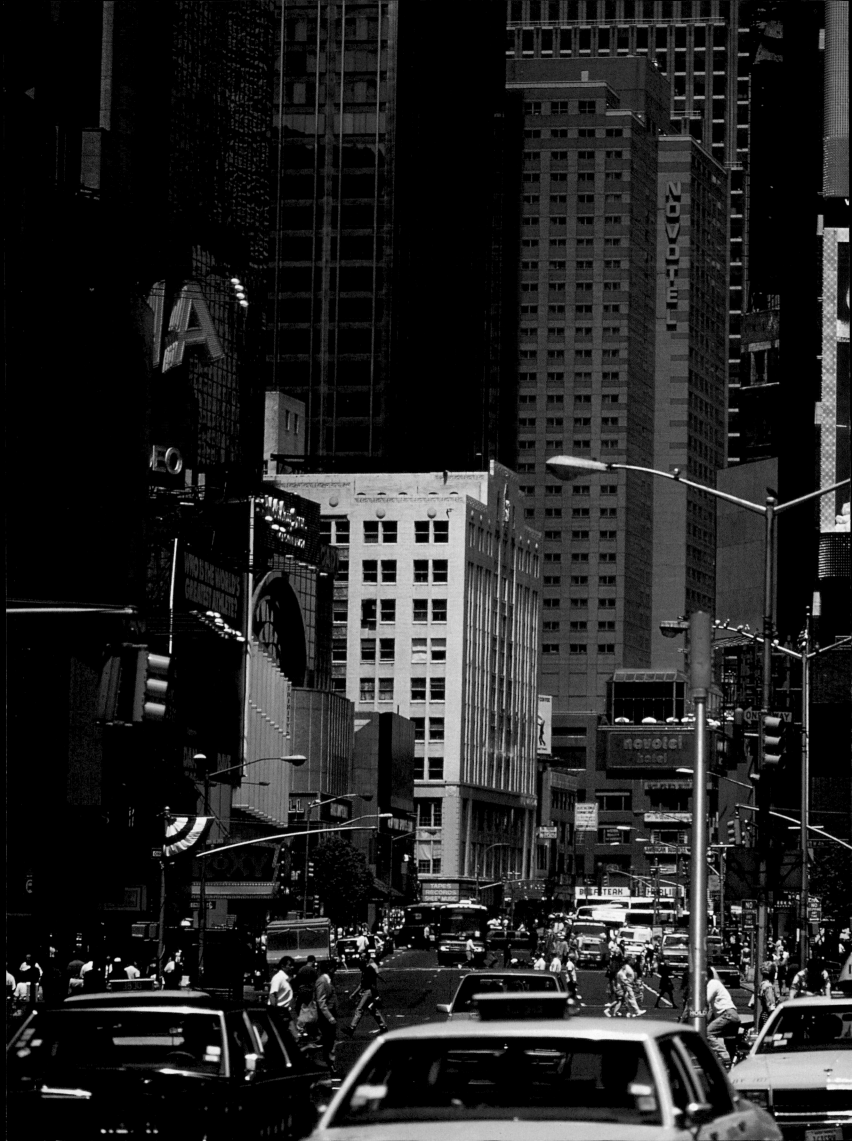

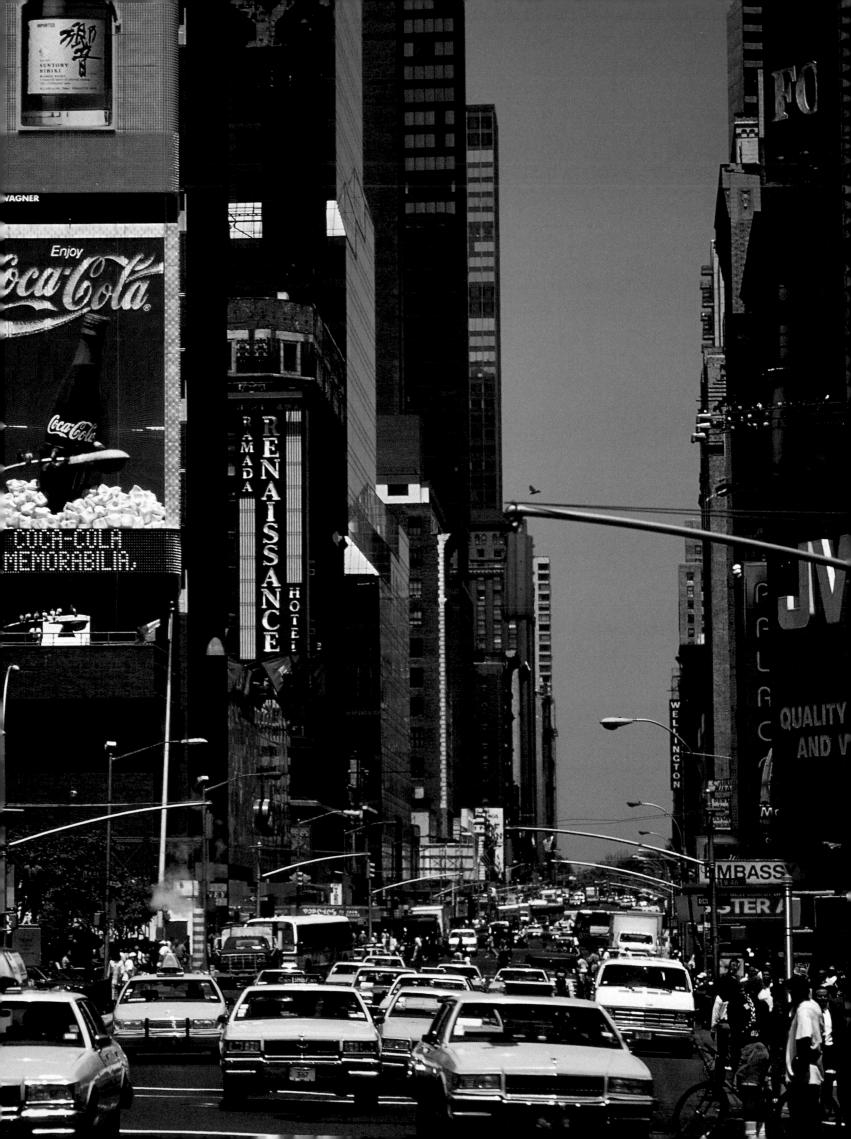

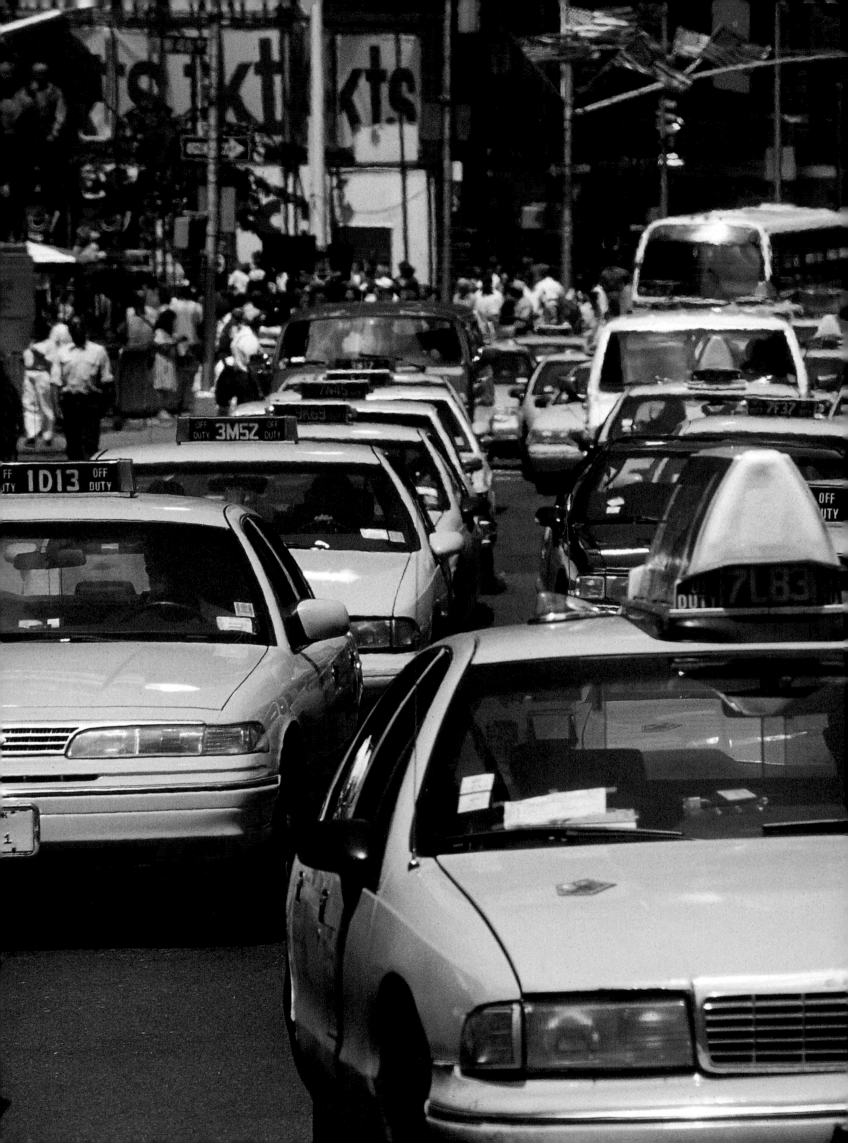

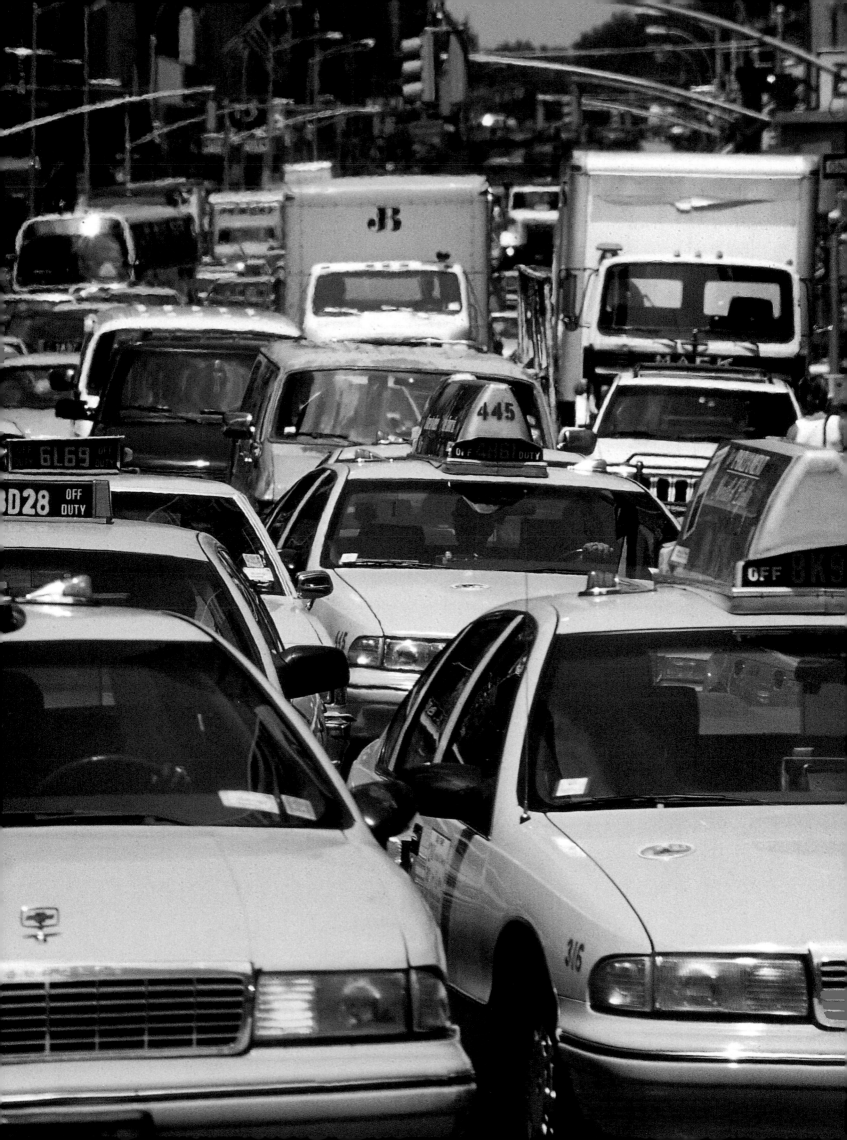

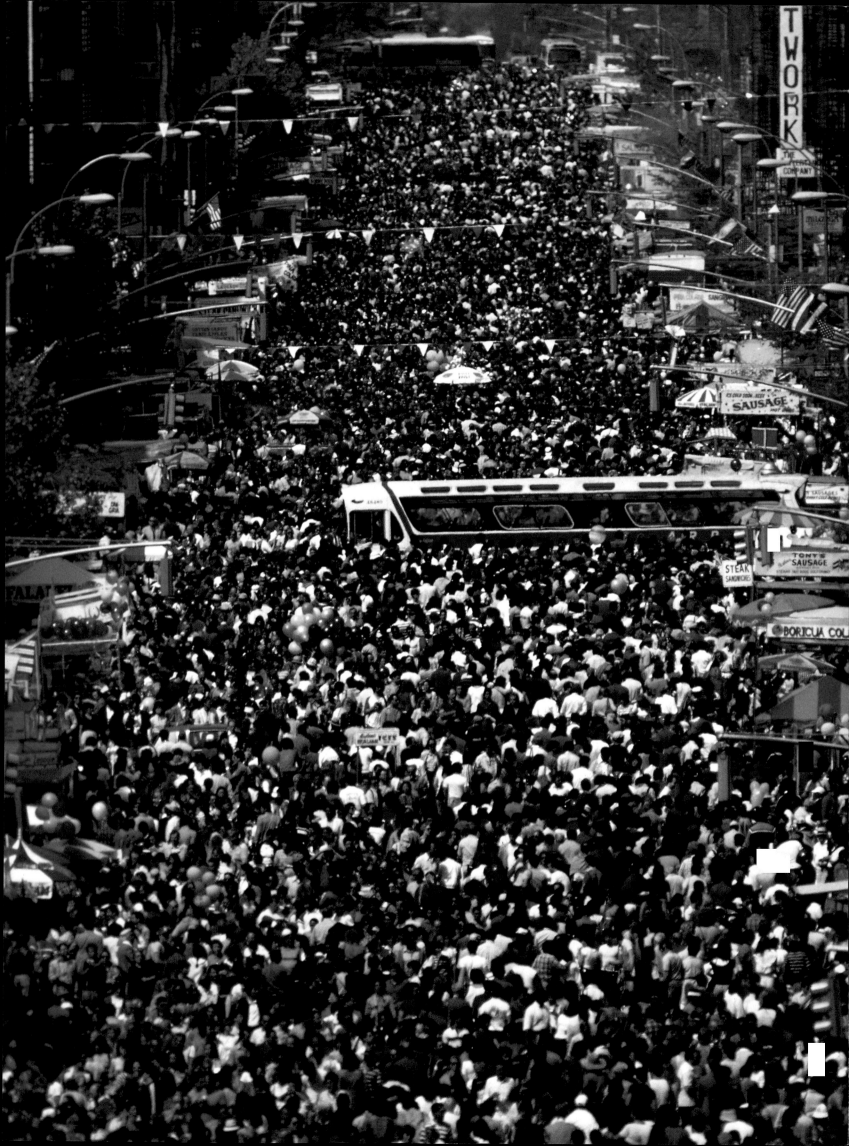

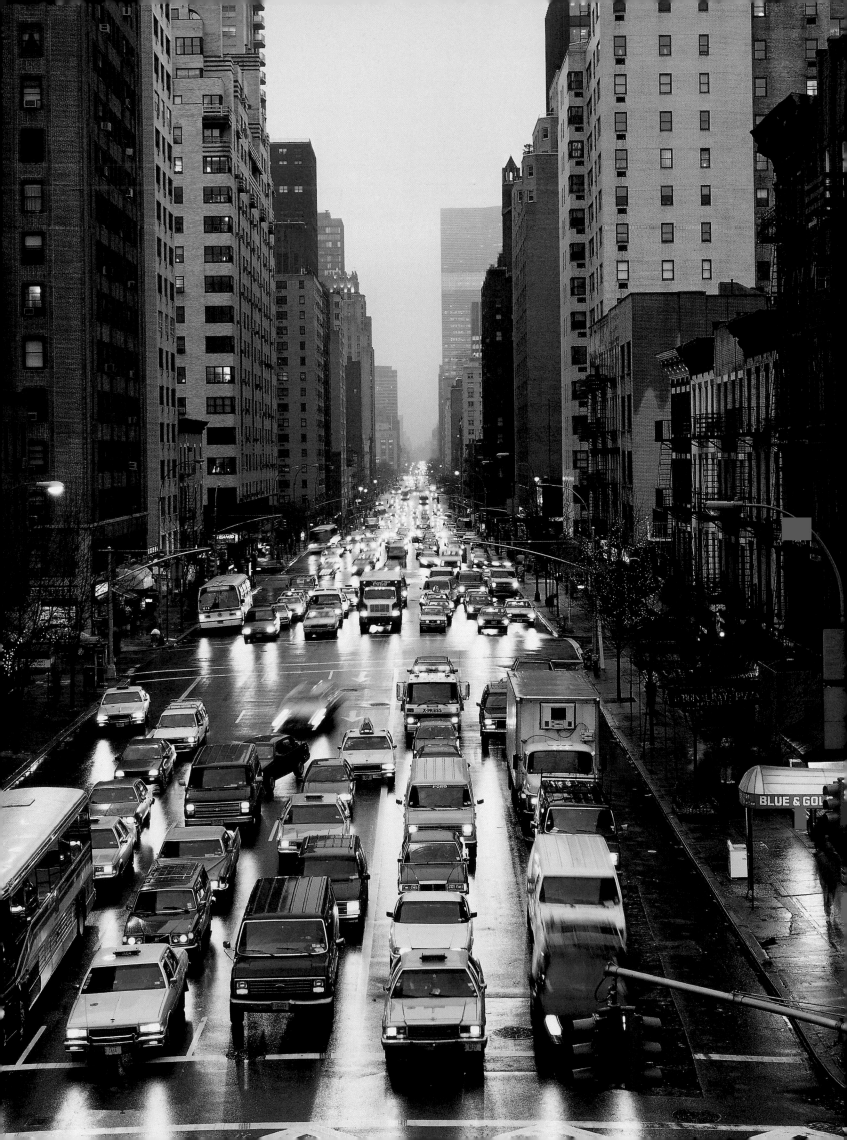

84 (previous overleaf) 9th Avenue food festival (left) and First Avenue (right).

(above) The fountain at Rockerfeller Center. (right) The Atlas statue at Rockerfeller Center.

(following two overleaves) Rockerfeller Center at Christmas. Every year at Rockefeller Center, a Christmas tree is decorated and lit in a ceremony that has become a classic New York tradition.

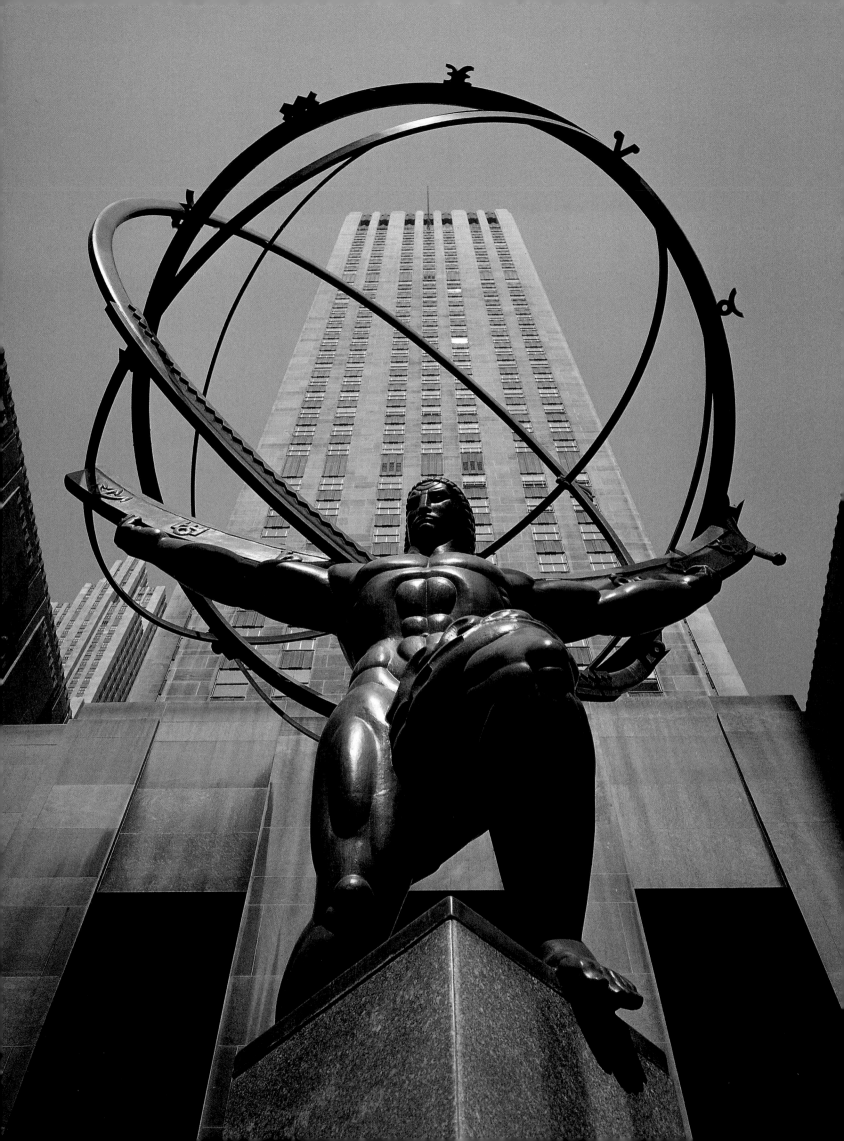

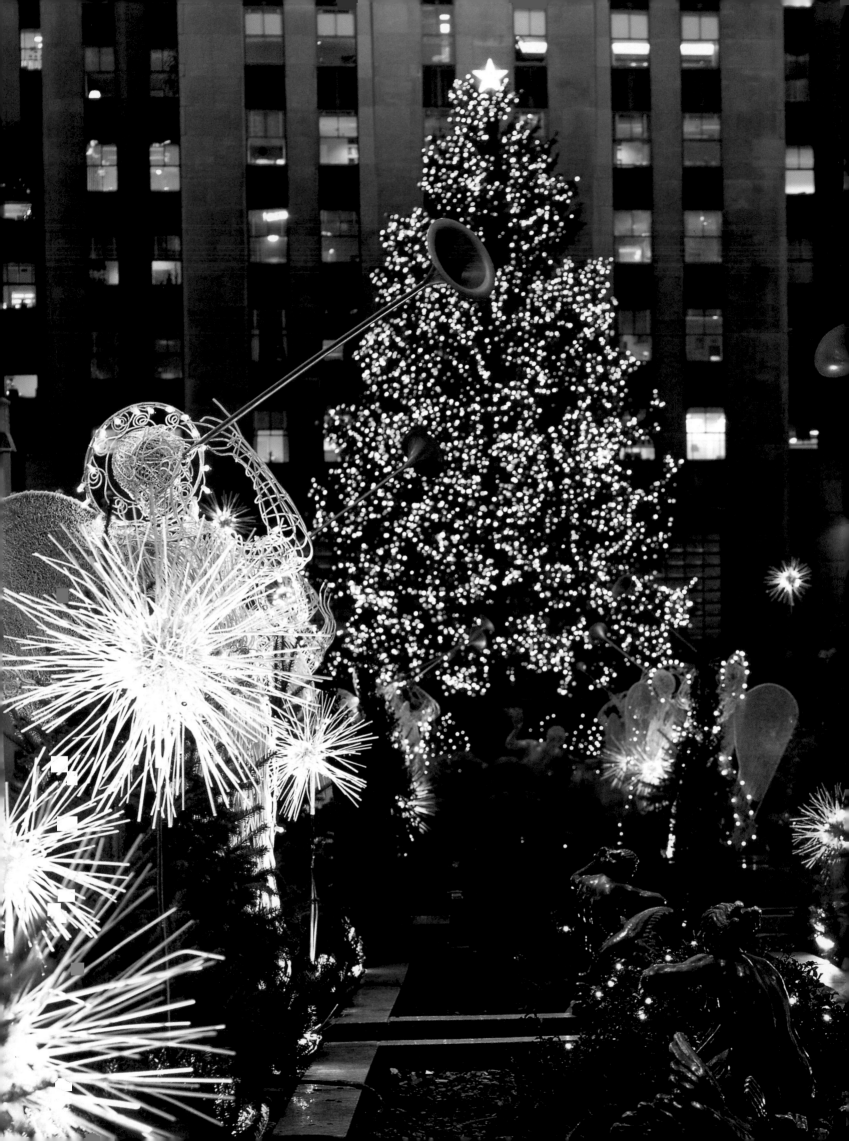

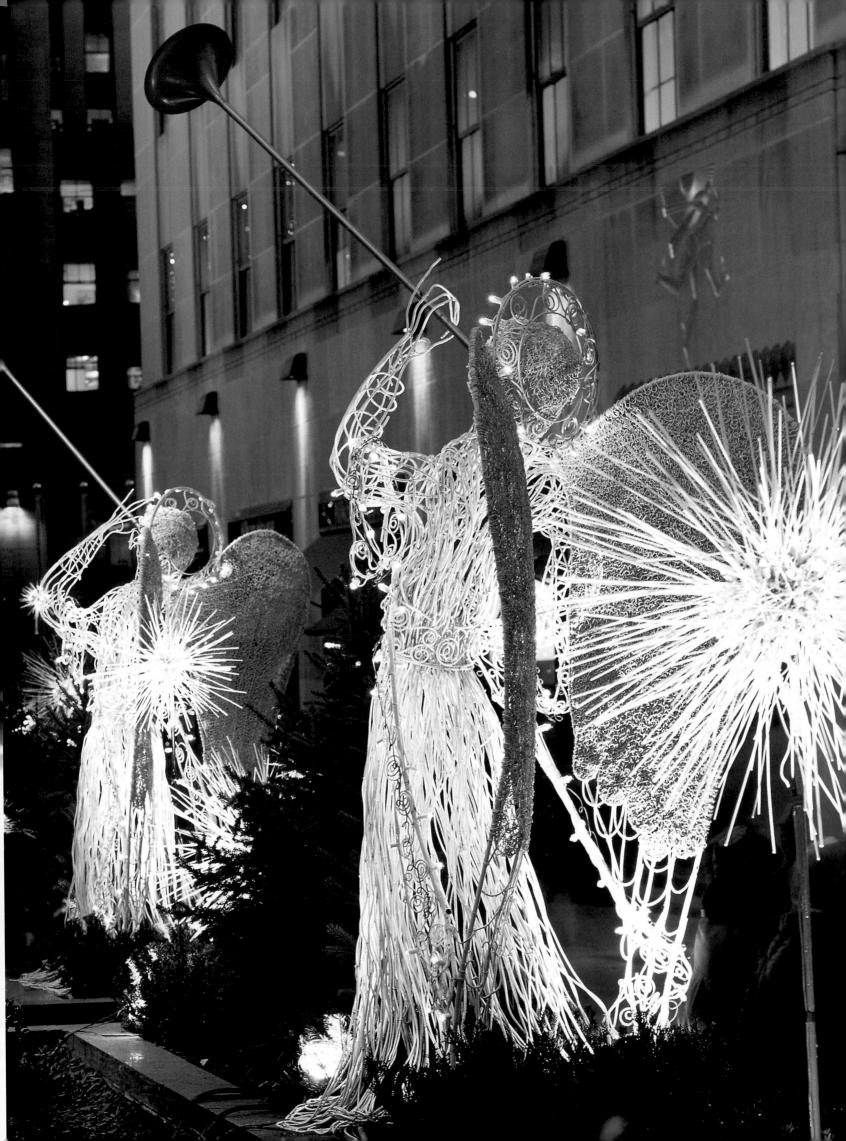

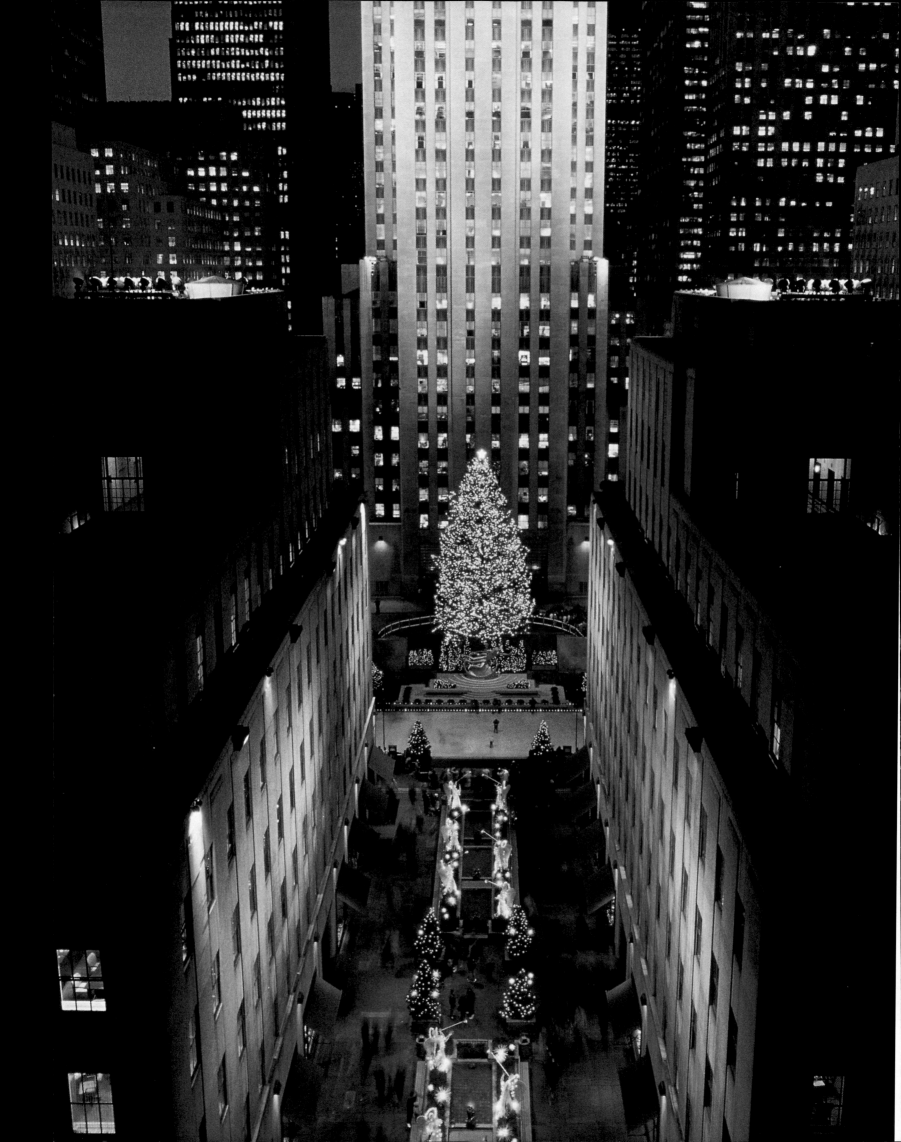

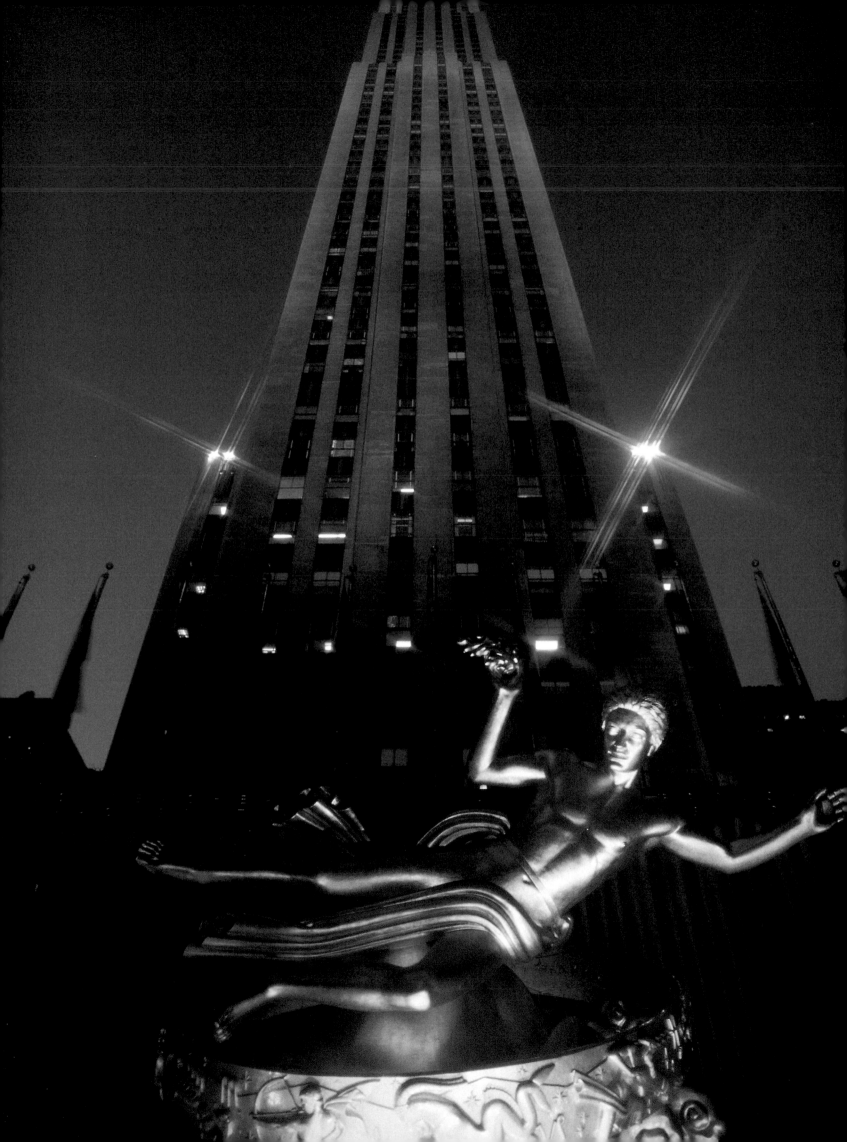

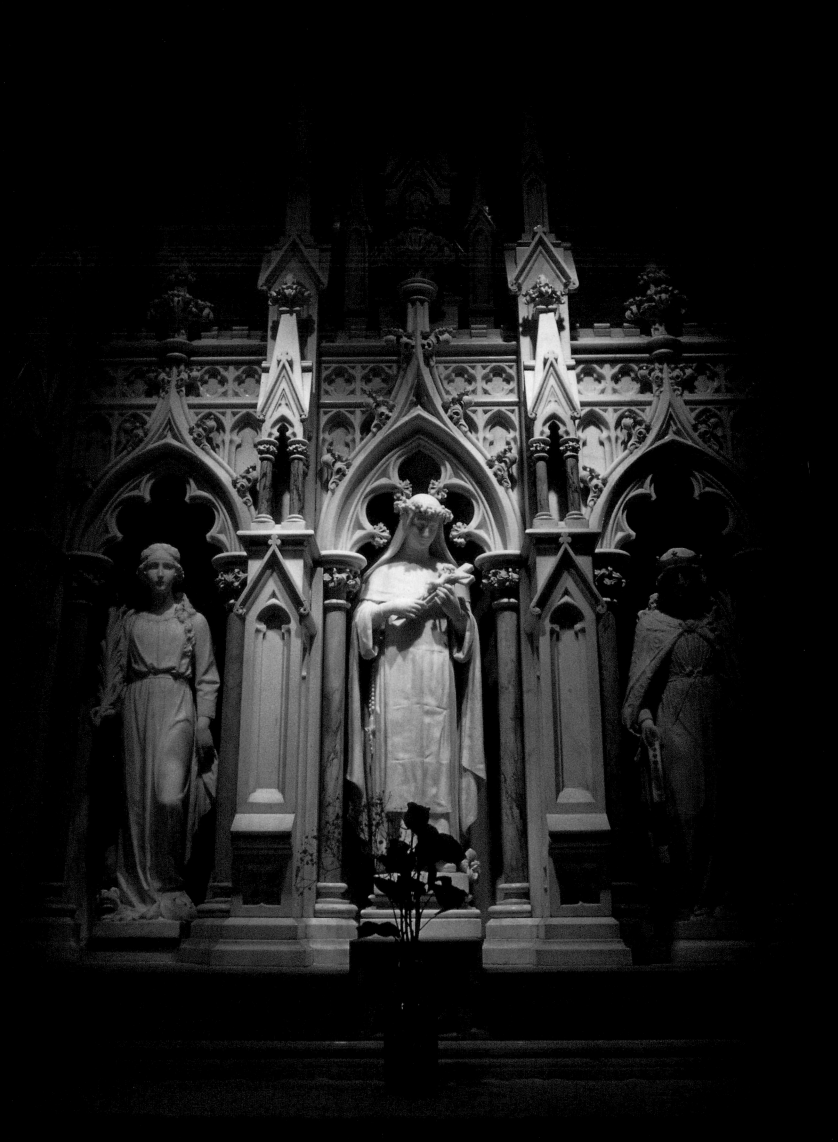

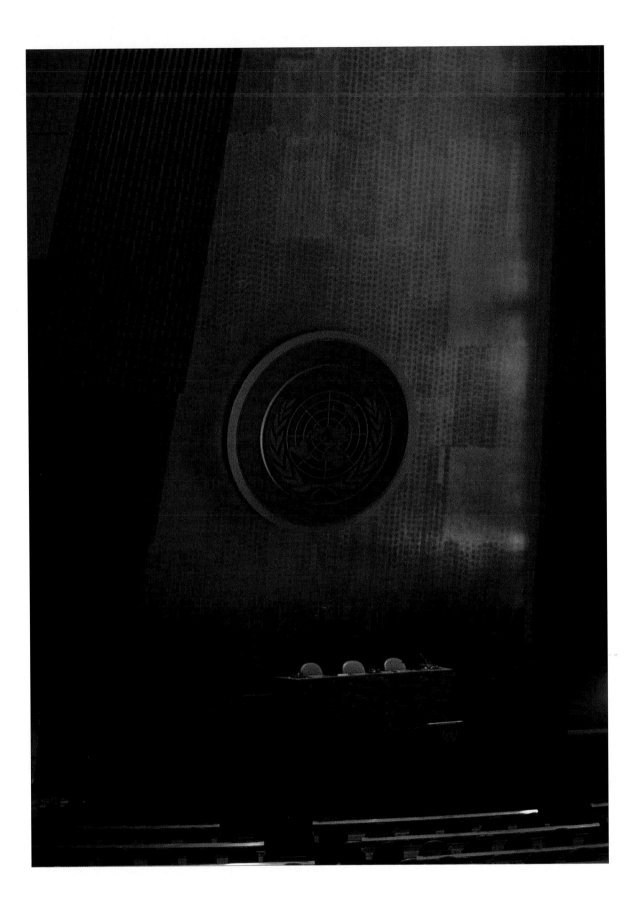

91 **(left)** St. Patrick's Cathedral. St. Patrick's Cathedral, with its French Gothic architecture, is a distinct contrast to the skyscrapers that surround it. This cathedral houses the richest archdiocese in the United States. **(above)** The United Nations Building.

(overleaf) Trump Tower Atrium (left) and the Waldorf Astoria (right).

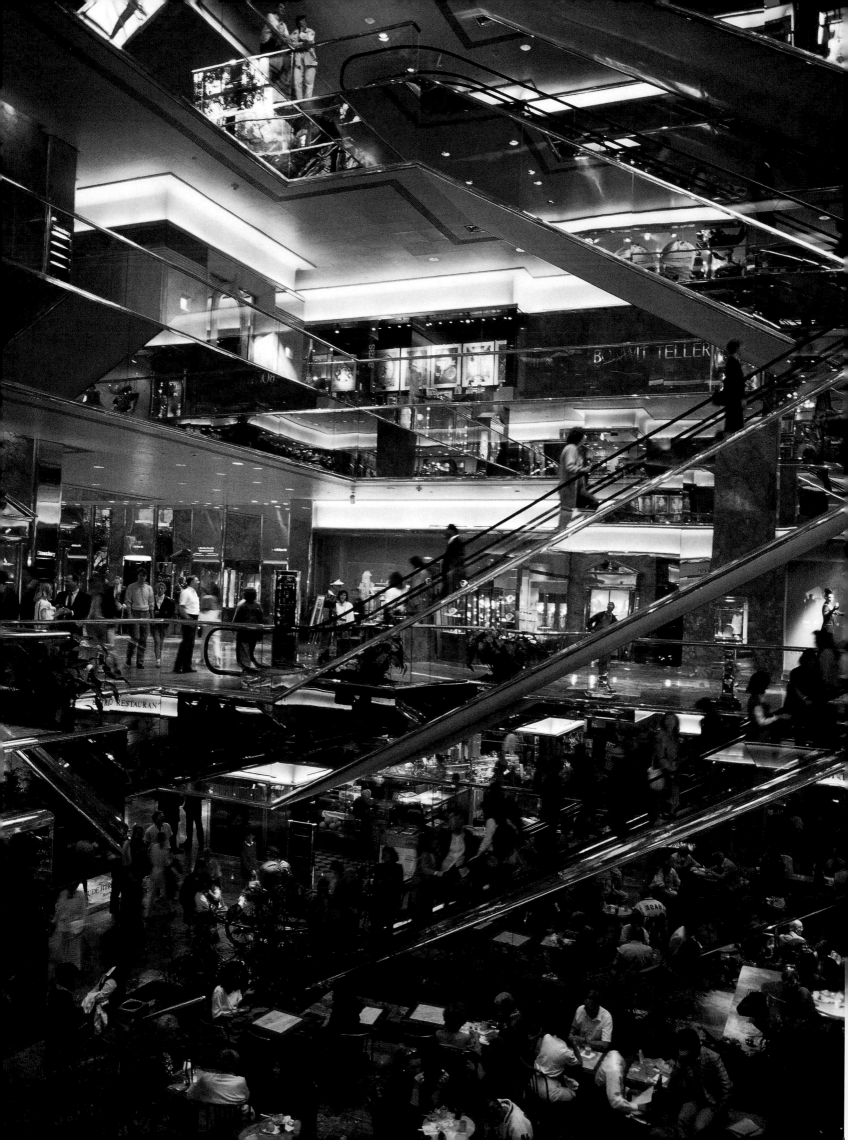

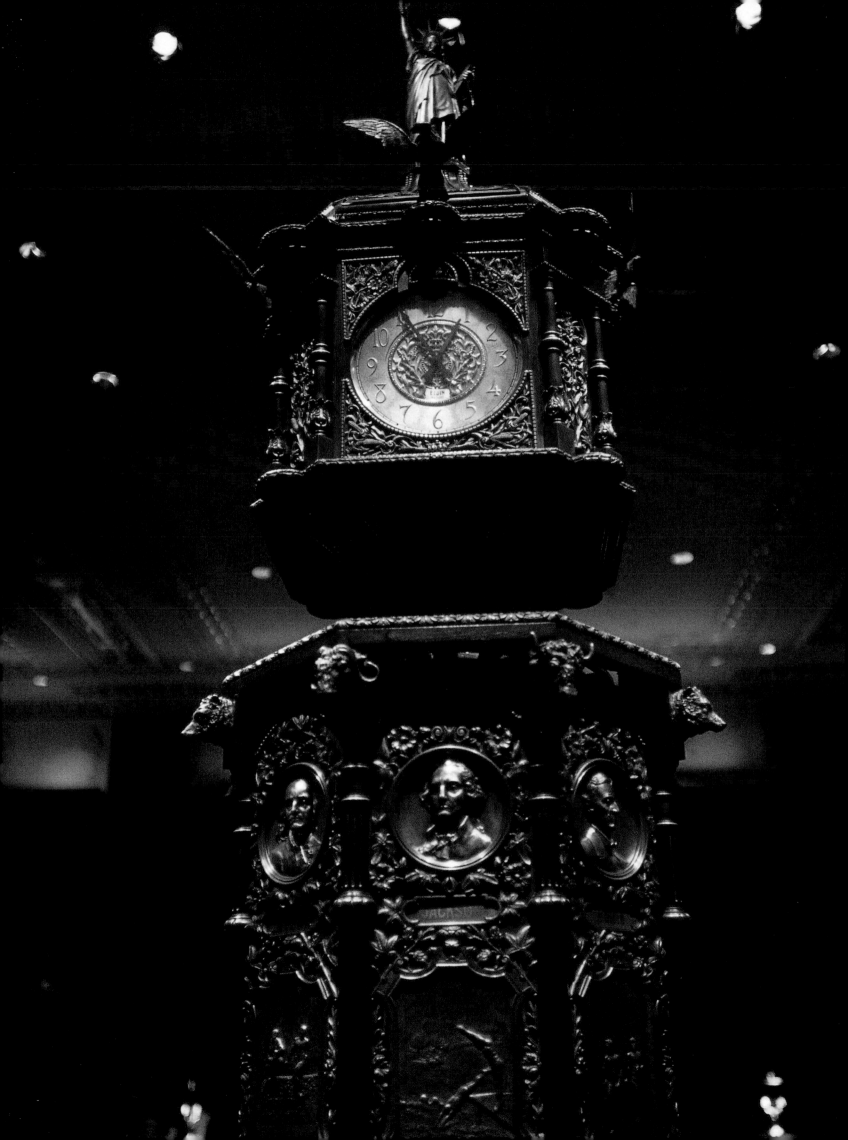

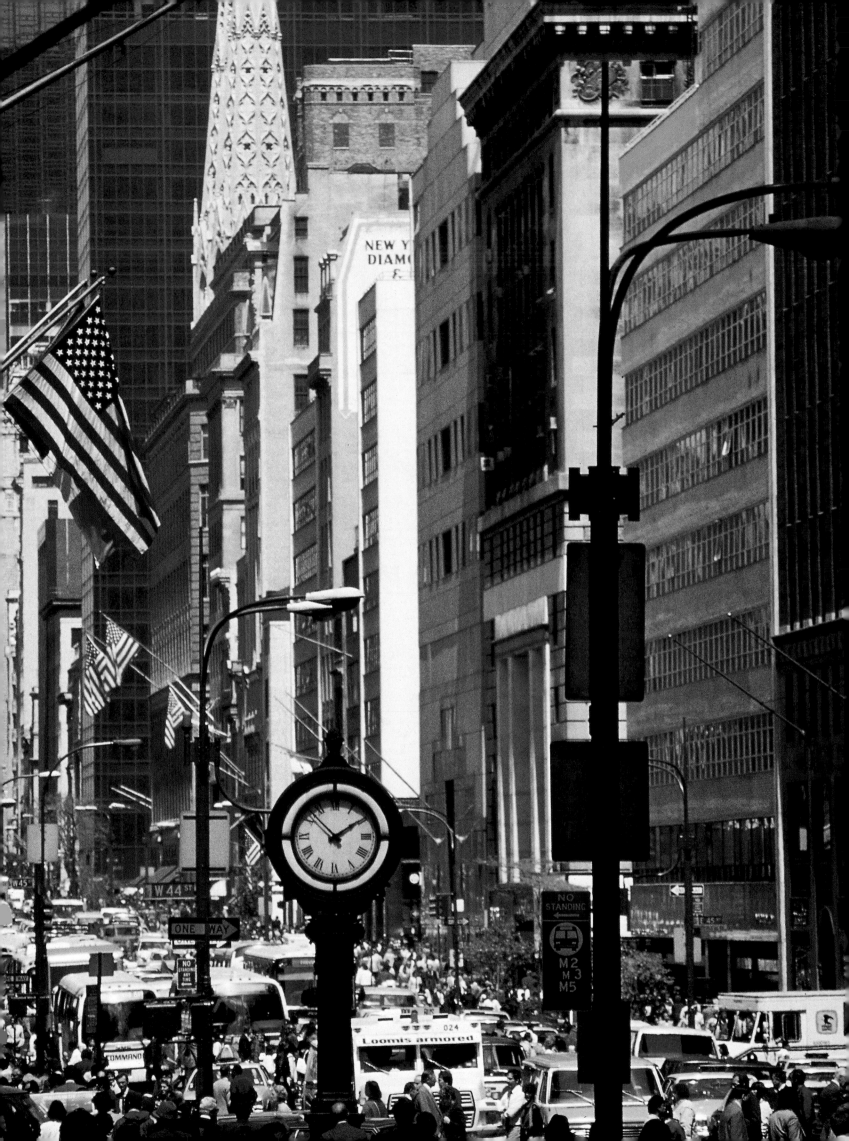

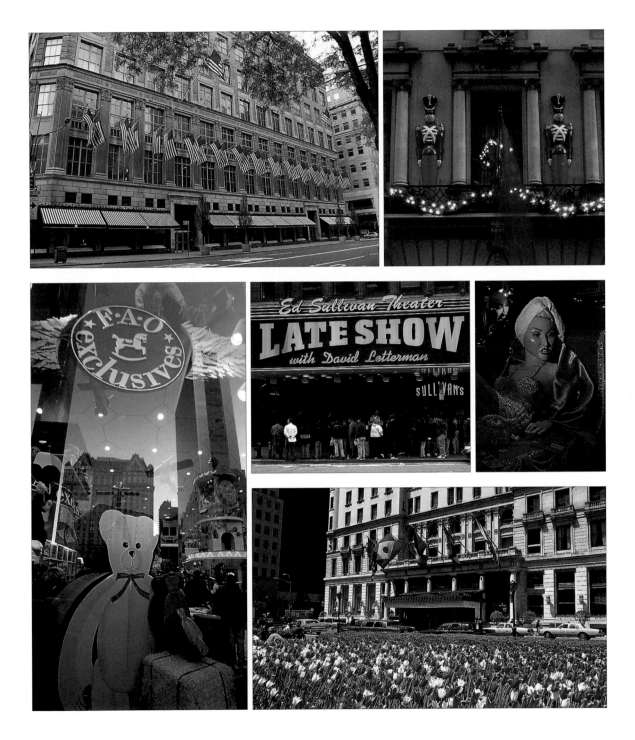

95 **(left)** 5th Avenue. **(top left)** Sak's 5th Avenue. **(top right)** Cartier's at Christmas. **(bottom left)** FAO Schwartz toy store. **(middle)** The Ed Sullivan Theater. **(middle right)** Statue of Madonna at Barney's. **(bottom right)** The Plaza Hotel.

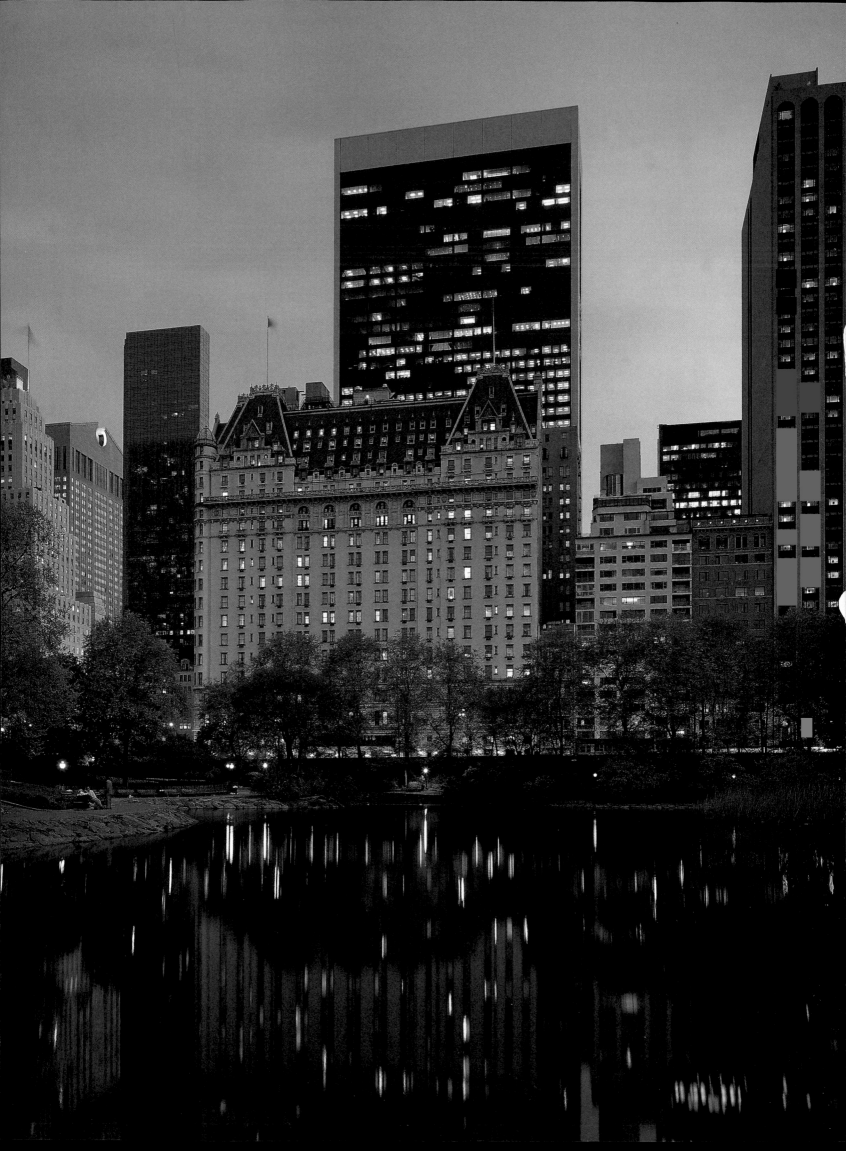

UPTOWN

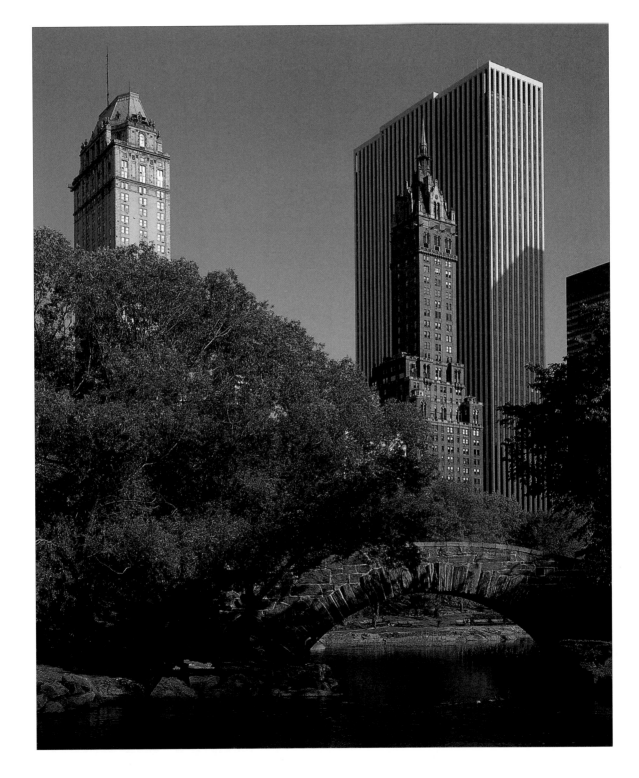

97 **(left)** The pond at Central Park. **(above)** Central Park.

(overleaf) Wollman Rink in Central Park.

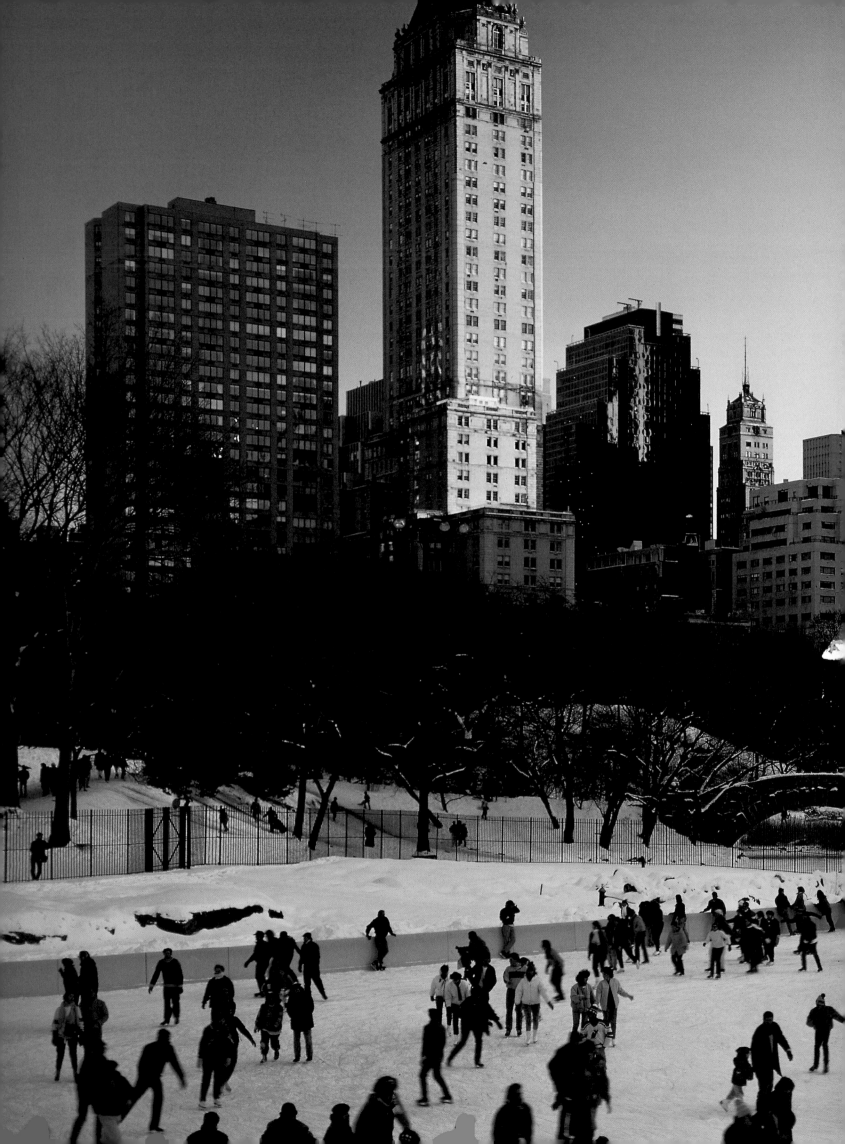

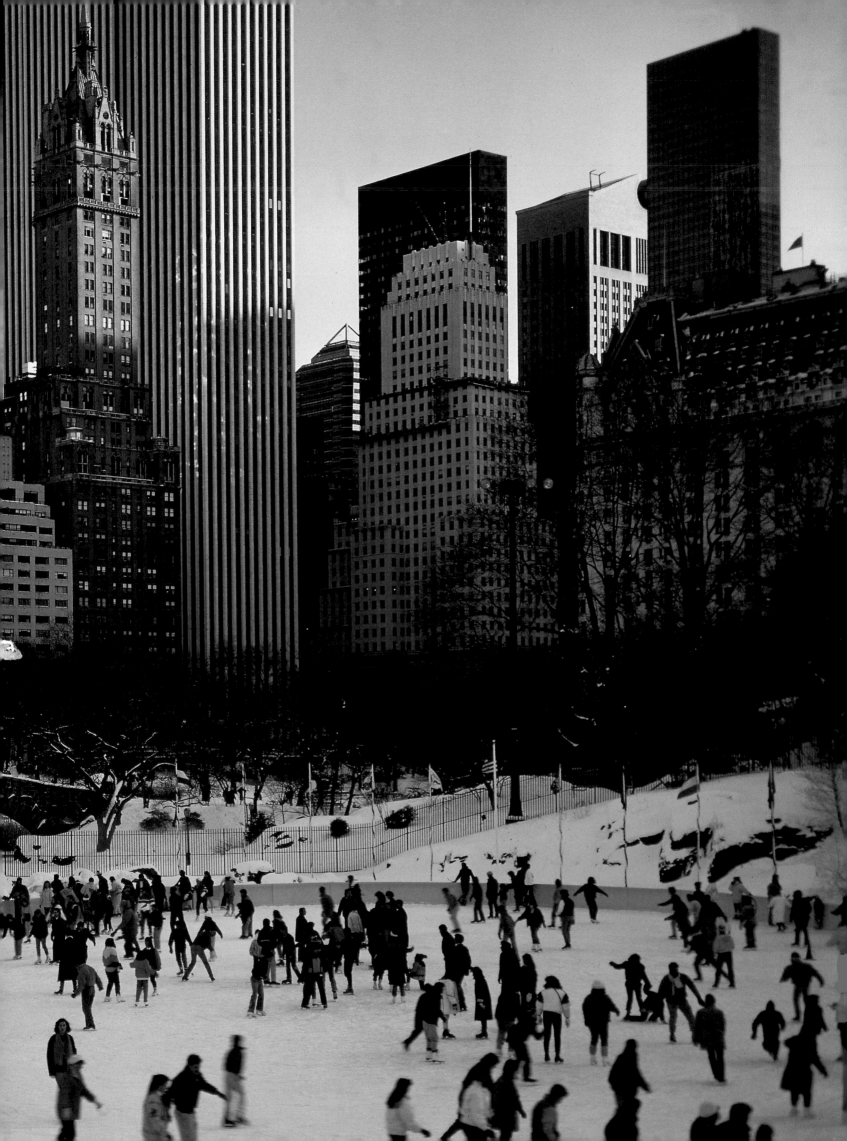

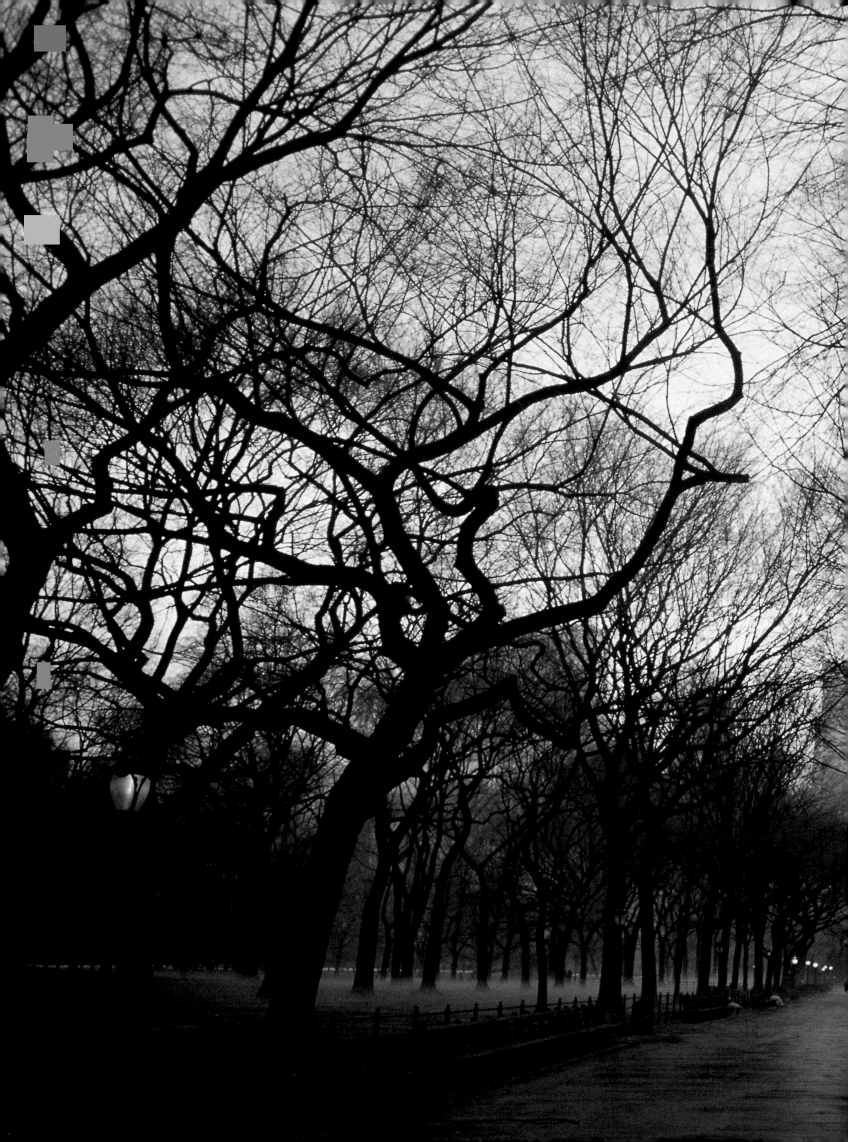

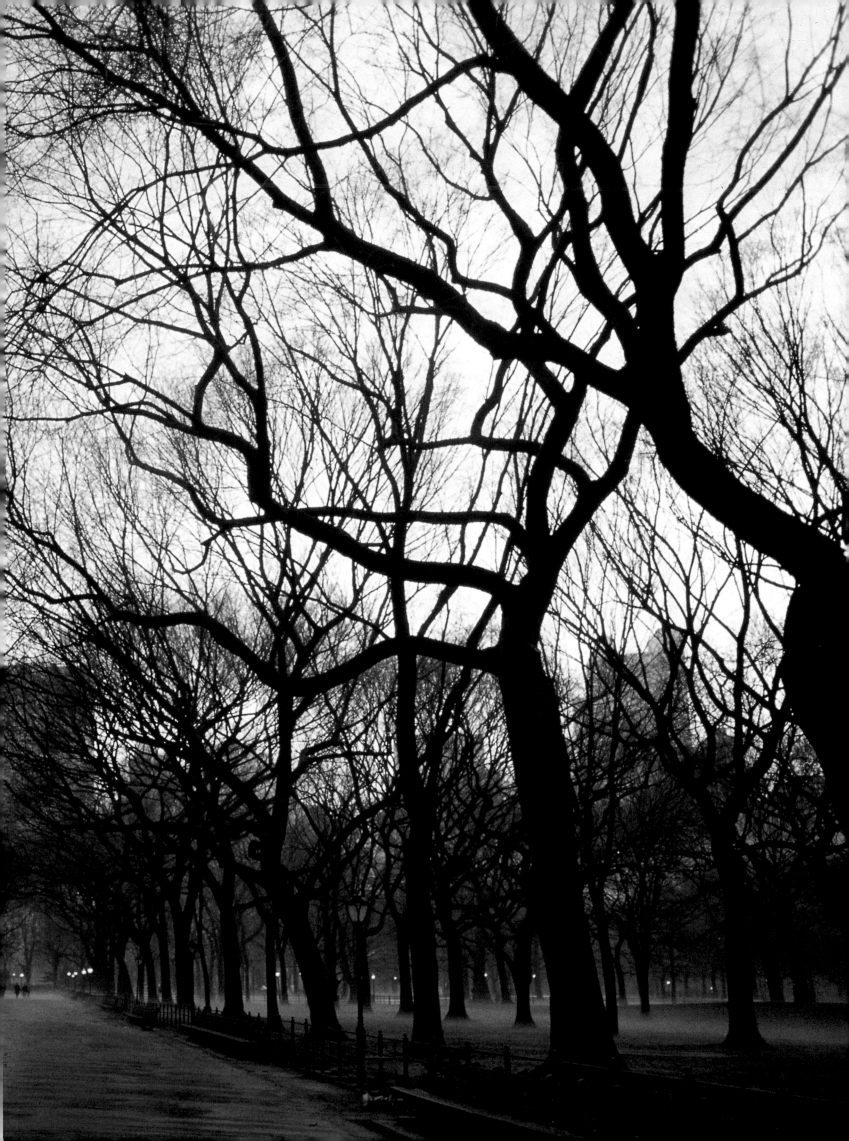

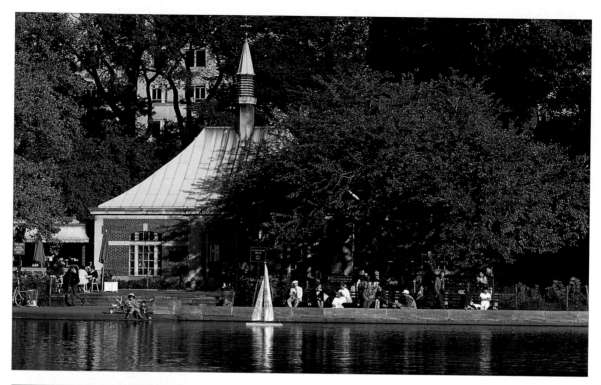

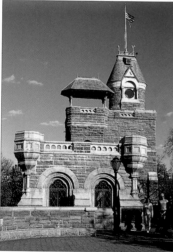

T he nature of New York remains in large part mysterious. We who have lived here all our lives must confess at last that we love a city that we have never wholly known."

—Brendan Gill
20th-century American writer

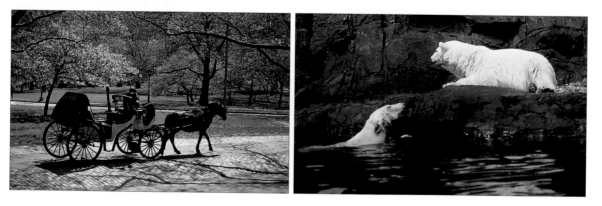

(previous overleaf) Central Park.

(top) The boat house in Central Park. **(middle)** Belvedere Tower in Central Park. **(bottom left)** Horse and carriage in the park. **(bottom right)** The Central Park Zoo. **(opposite)** The Dakota, as seen from Centeral Park.

(overleaf) Statues of the World War I memorial (left) and Columbus Circle (right).

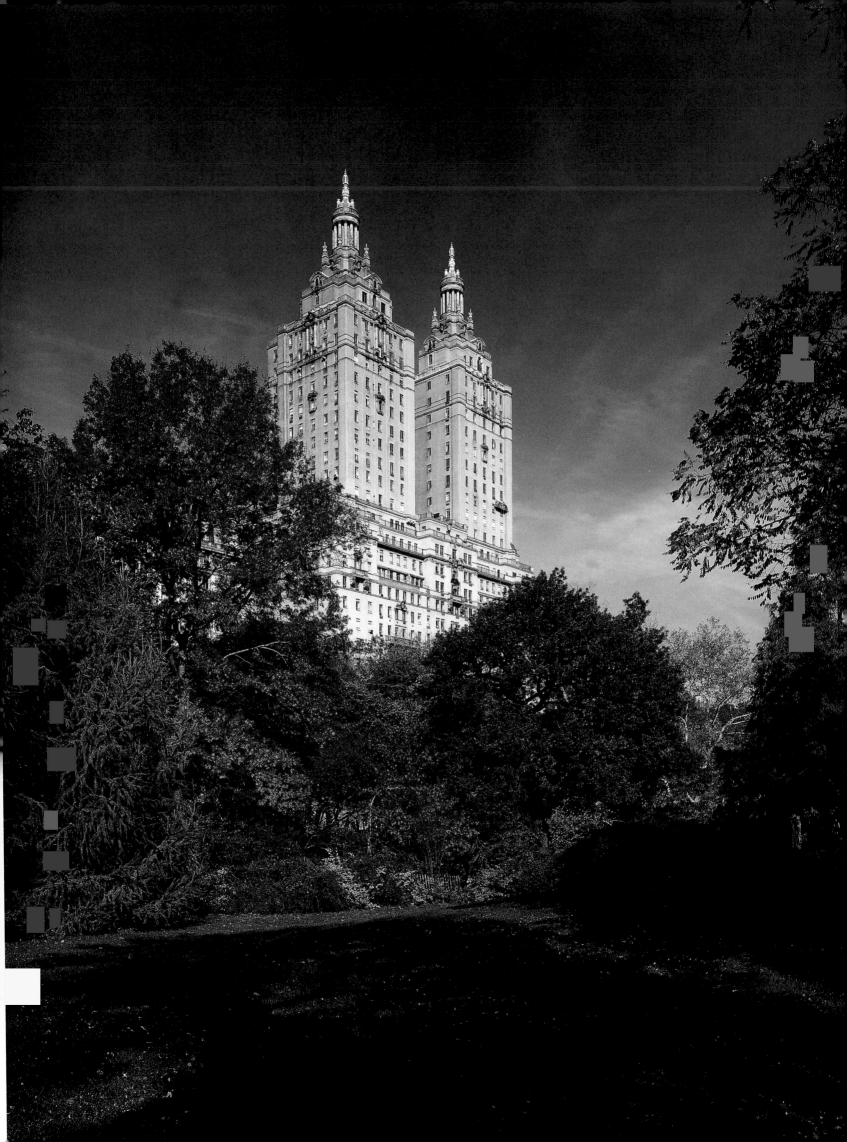

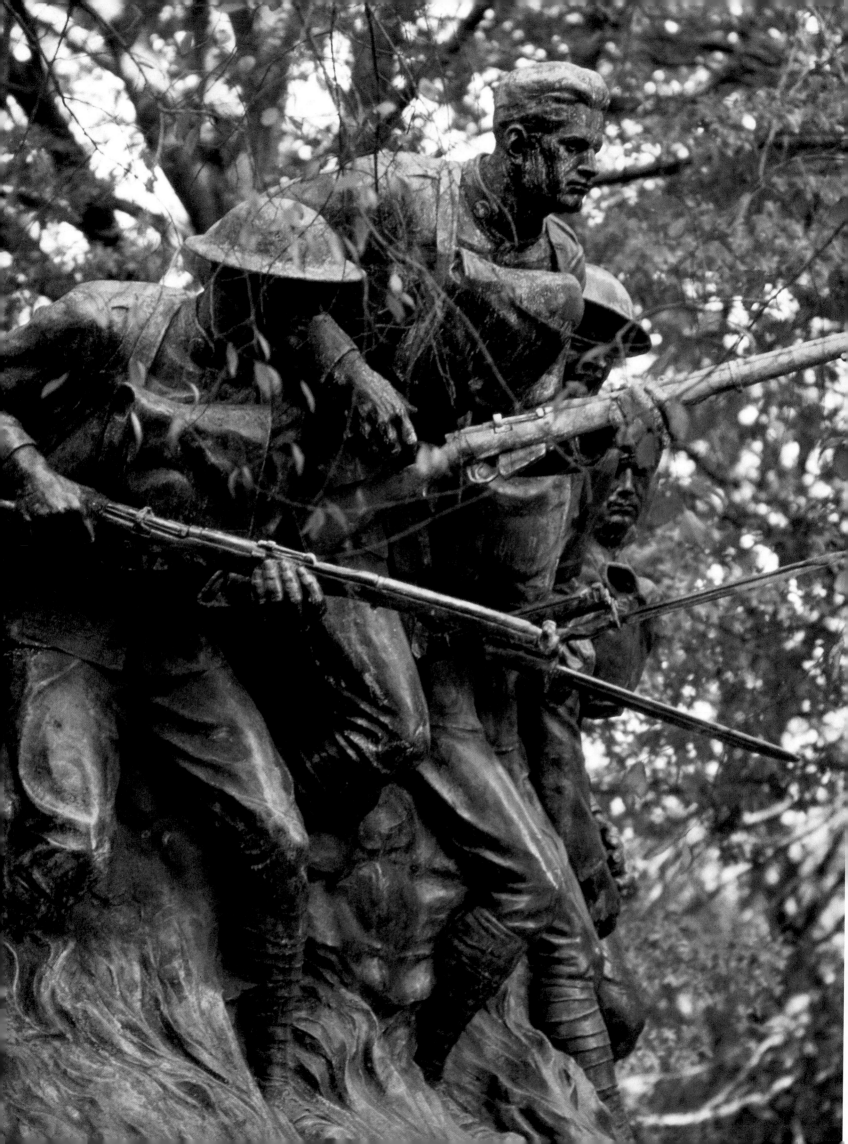

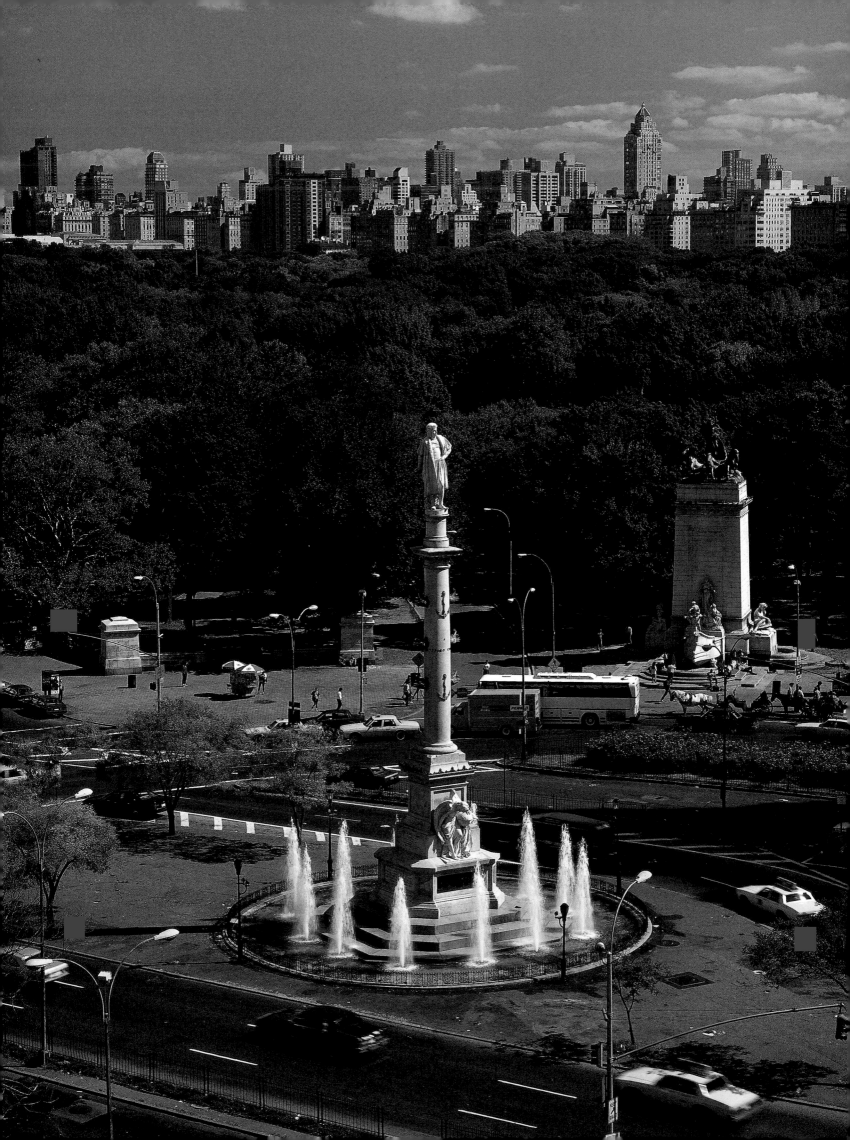

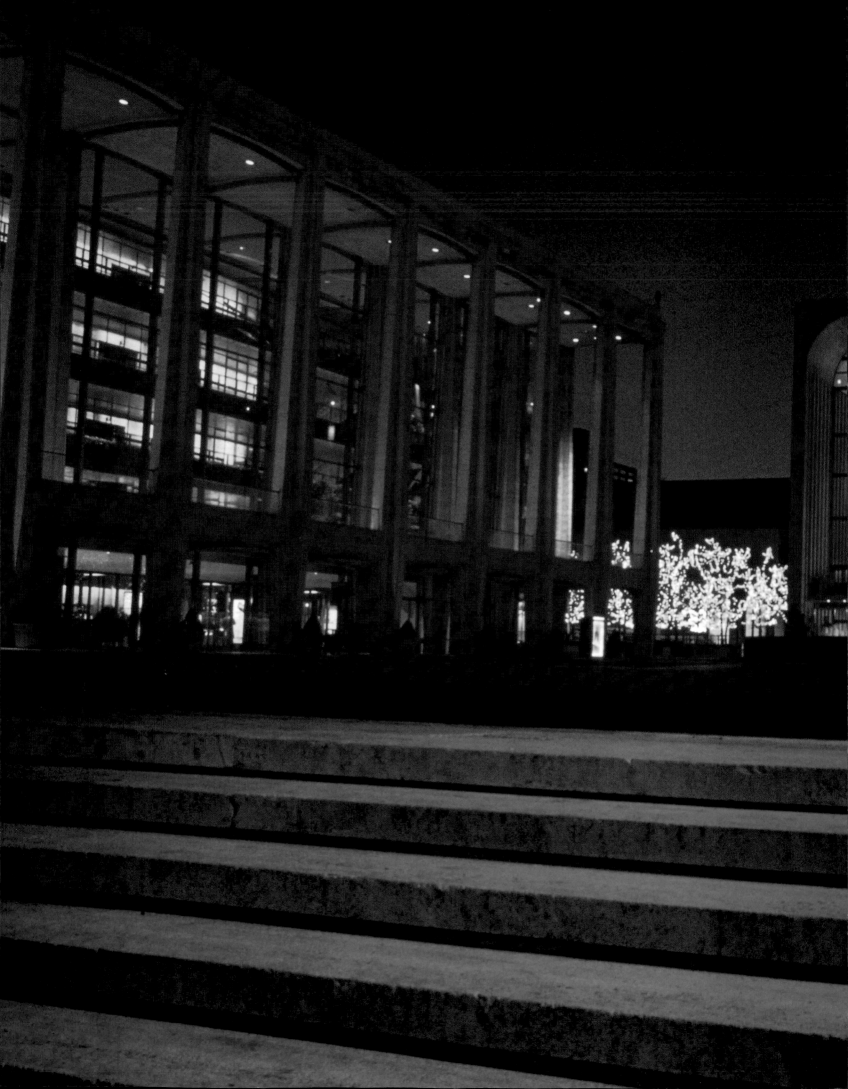

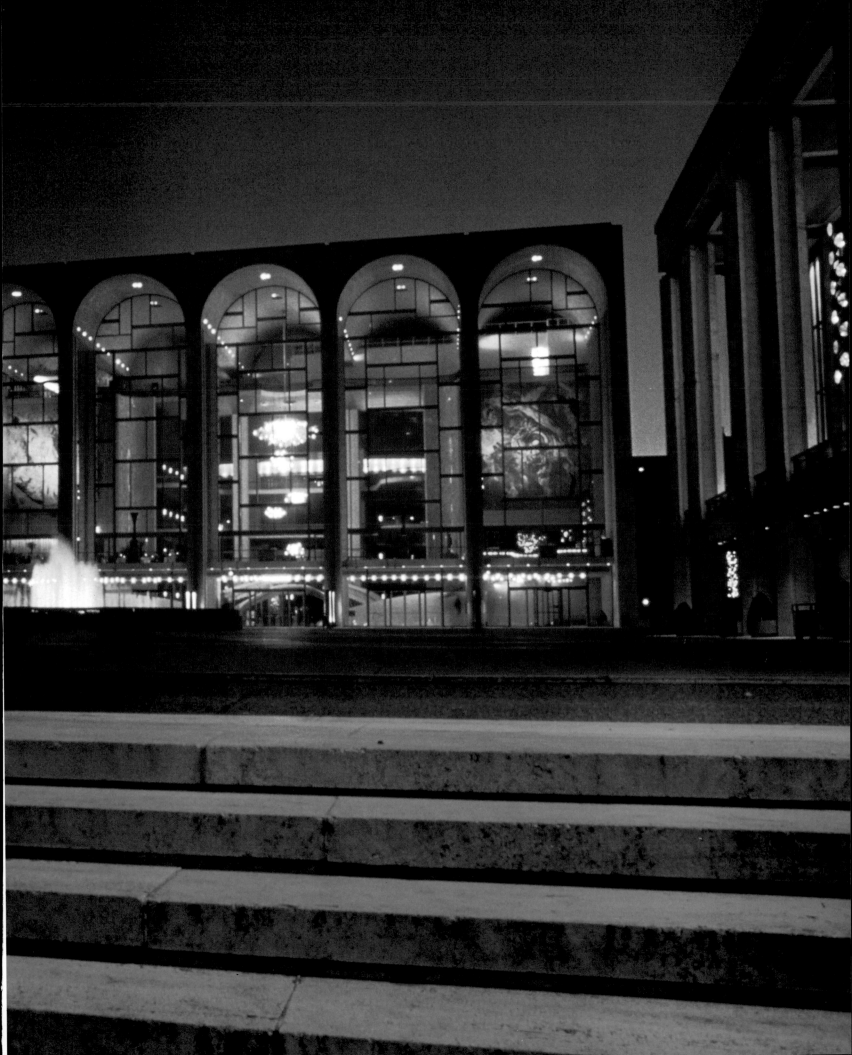

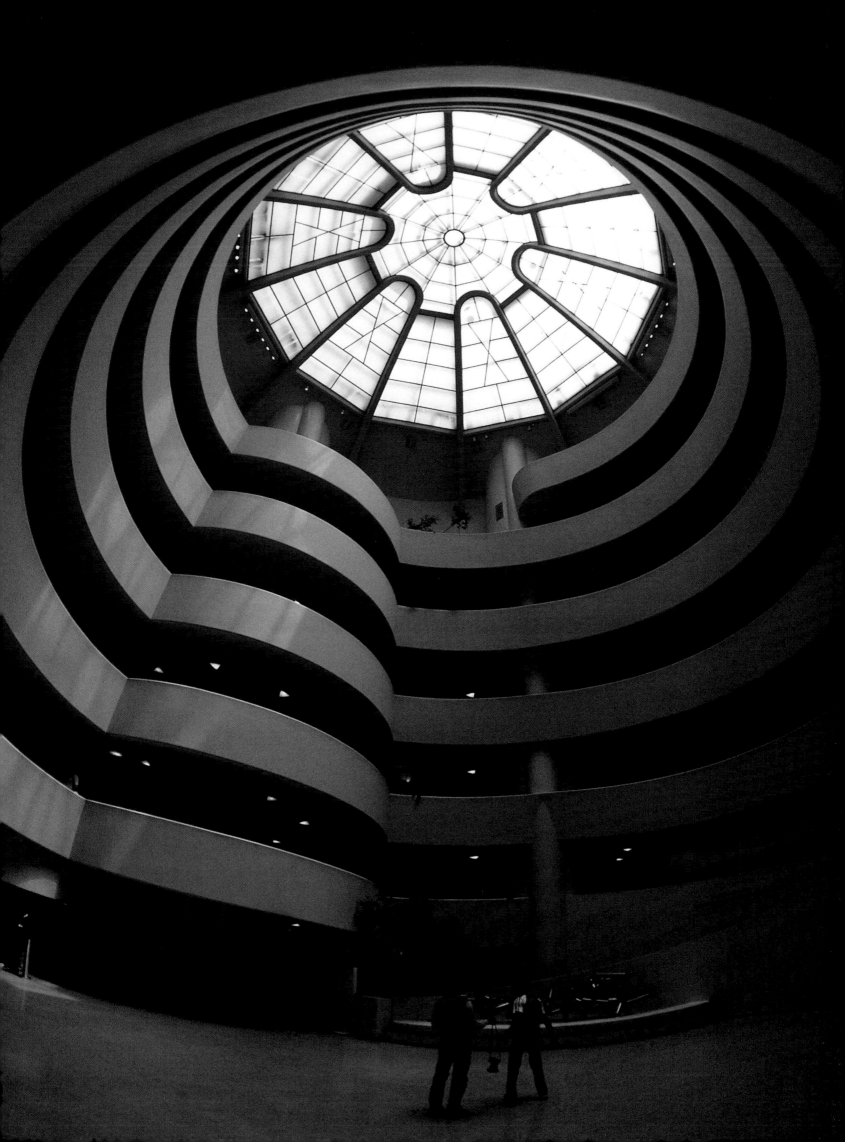

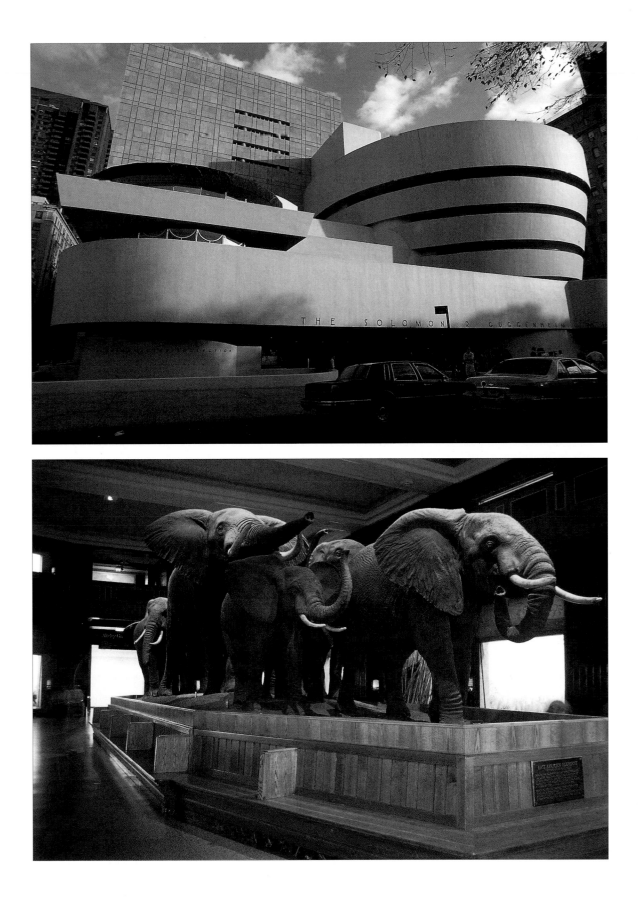

109 **(previous overleaf)** The Lincoln Center.

(left) The Guggenheim Museum. **(above top)** The Guggenheim Museum as seen from the outside.
(above bottom) The American Museum of Natural History.

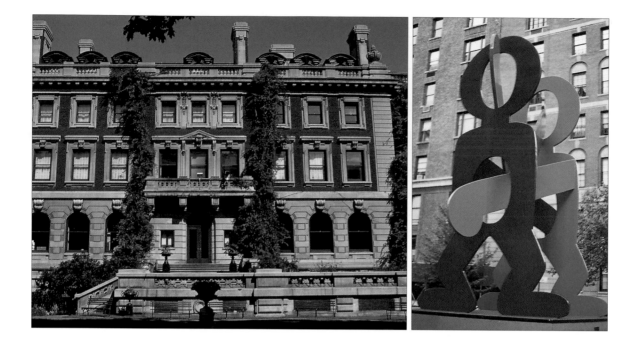

"The only credential the city asked was the boldness to dream. For those who did,

it unlocked its gates and its treasures, not caring who they were or where they came from."

—Moss Hart (1904–1961)
American writer

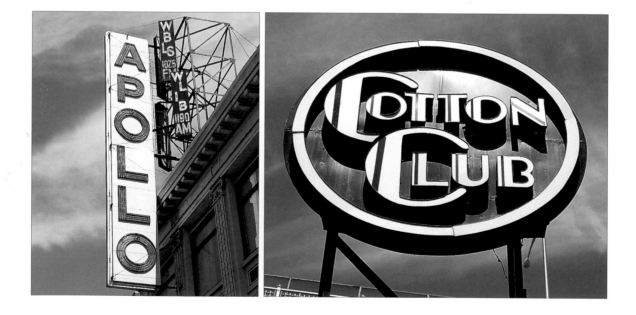

(top left) The Cooper-Hewitt National Design Museum. **(top right)** The Keith Haring exhibit in conjunction with the Whitney Museum. **(bottom left)** The Apollo Theater. **(bottom right)** The Cotton Club.

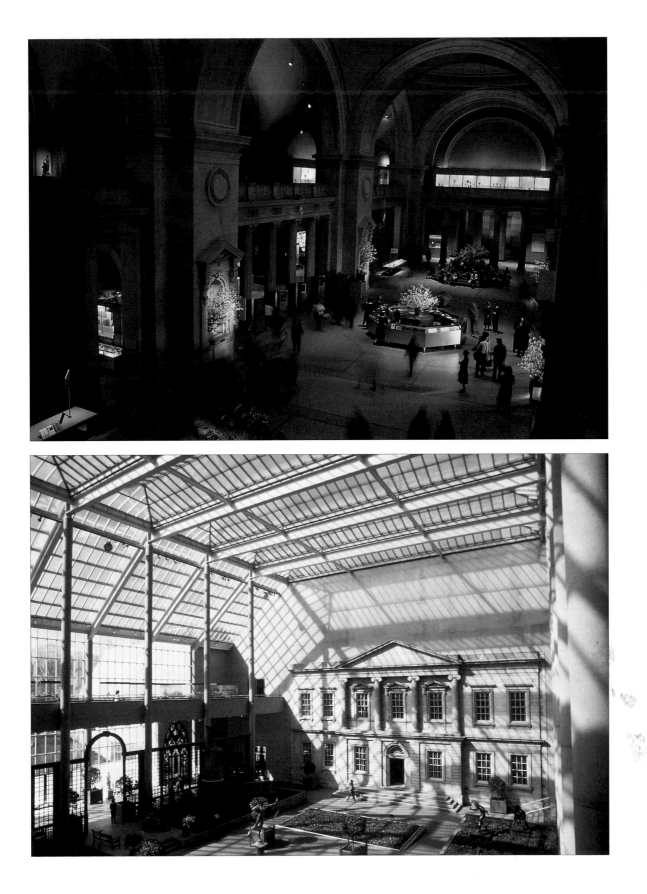

111 **(above and overleaf)** The Metropolitan Museum of Art.

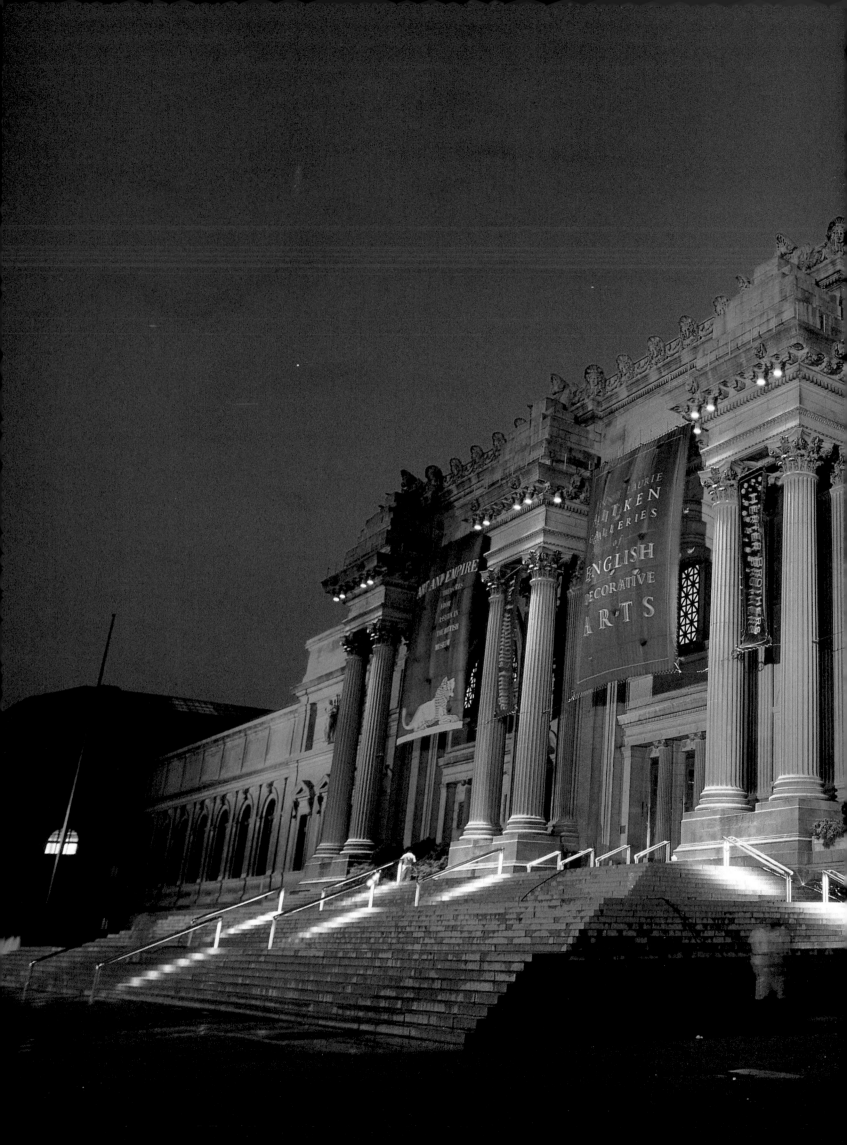

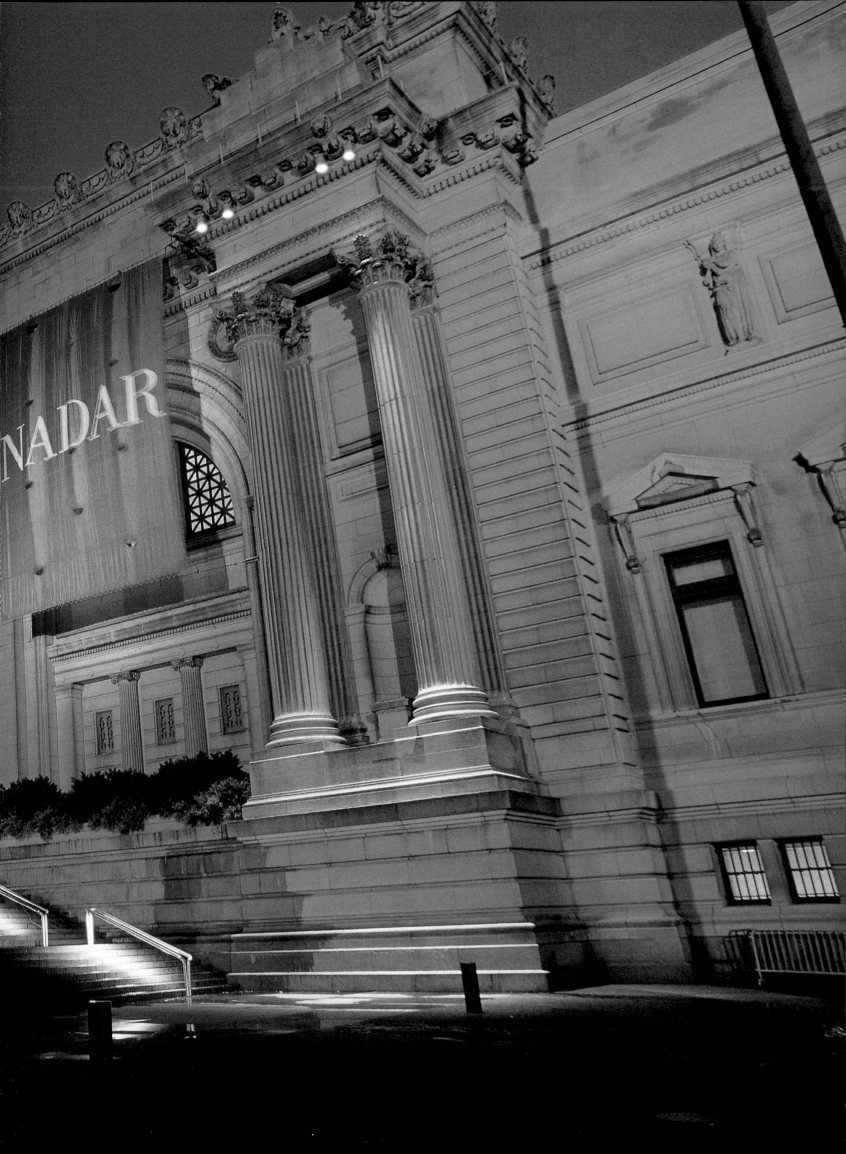

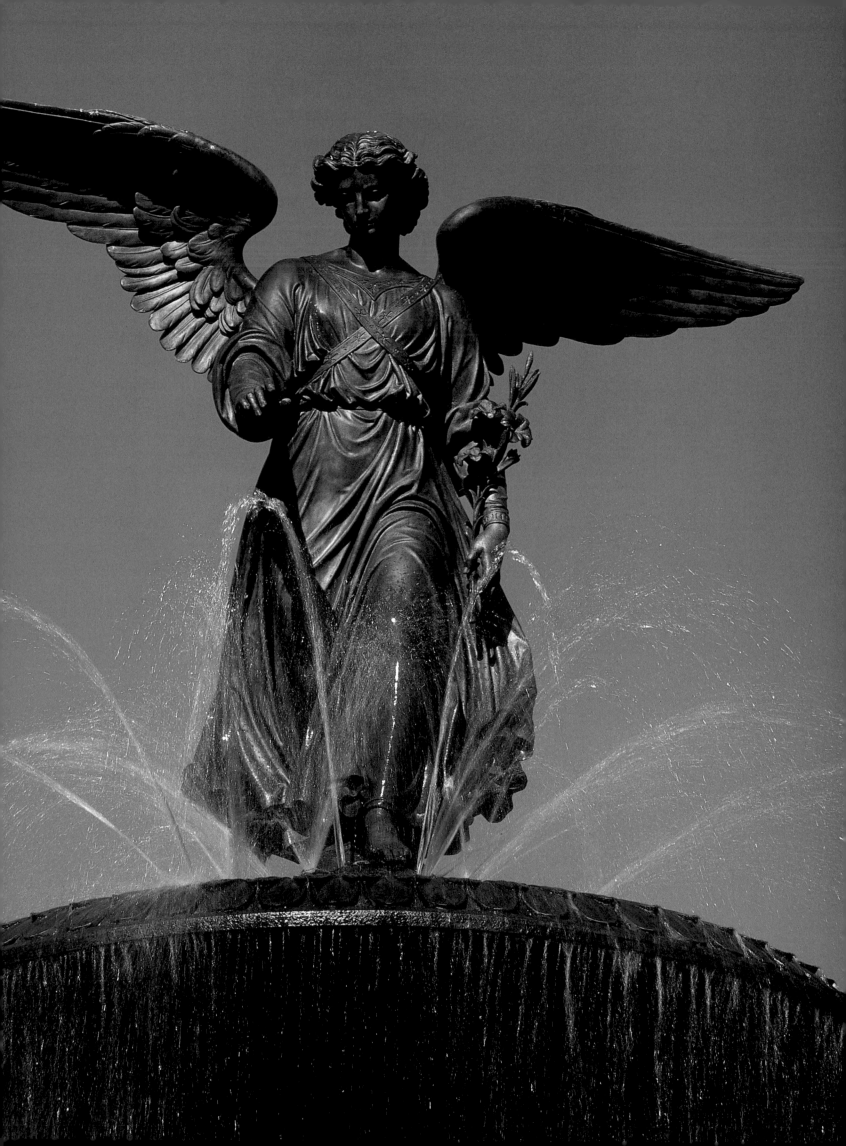

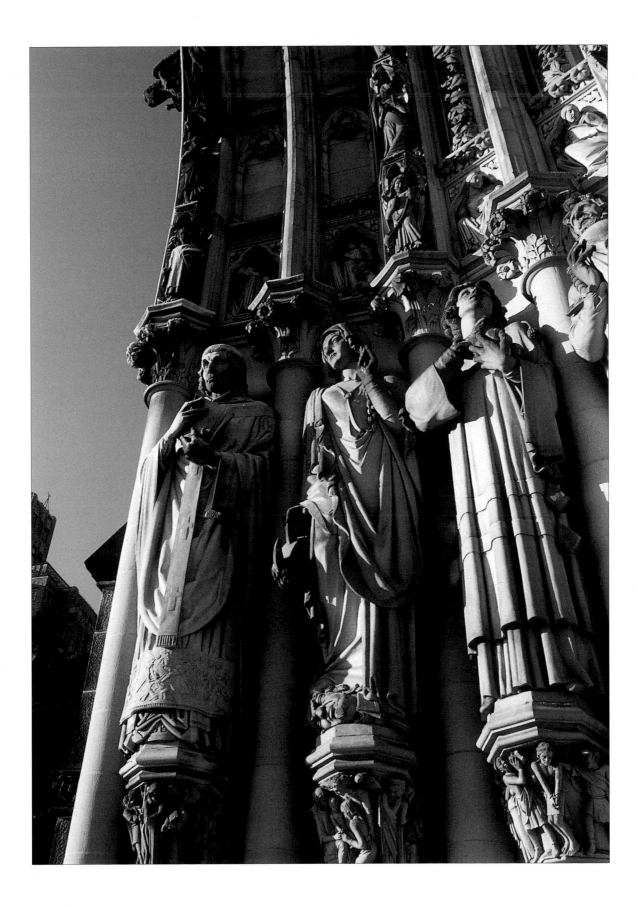

115 **(left)** Bethseda Fountain. **(above)** Cathedral of St. John the Divine. Begun in 1892, the Cathedral of St. John the Divine is still under construction and will be one of the world's largest cathedrals when completed. The cathedral is also known for its unusual Blessing of the Animals. Once a year petitioners bring their pets to the cathedral to be blessed by the bishop.

(overleaf) The Cloisters is comprised of several cloisters from abbeys across France. Financed by John D. Rockefeller Jr., each building was taken apart piece by piece, shipped to New York City, and reconstructed in Manhattan on a bluff overlooking the Hudson River.

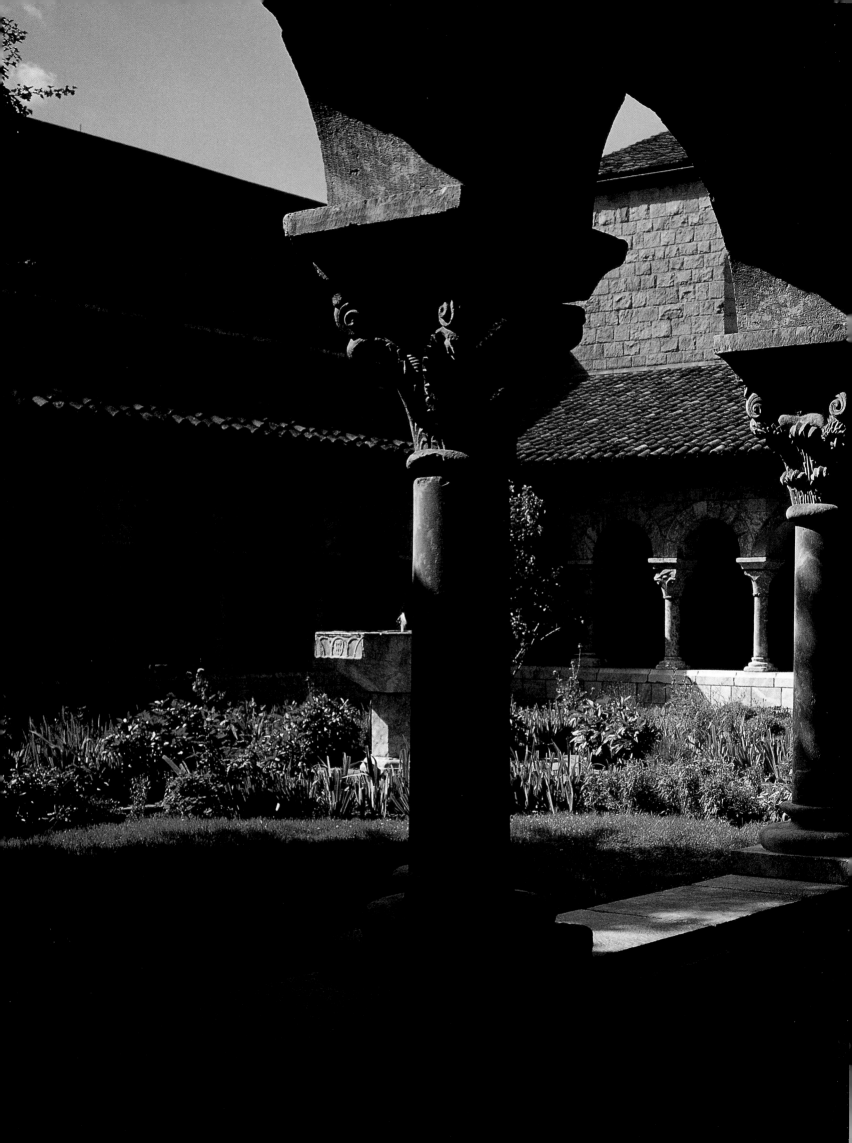

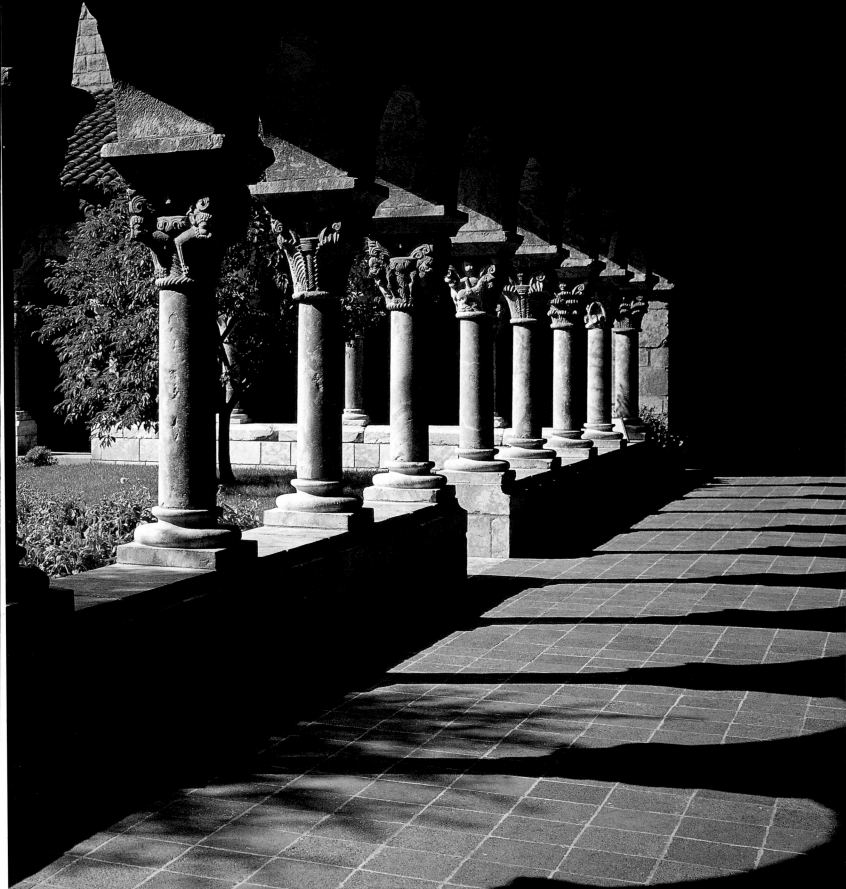

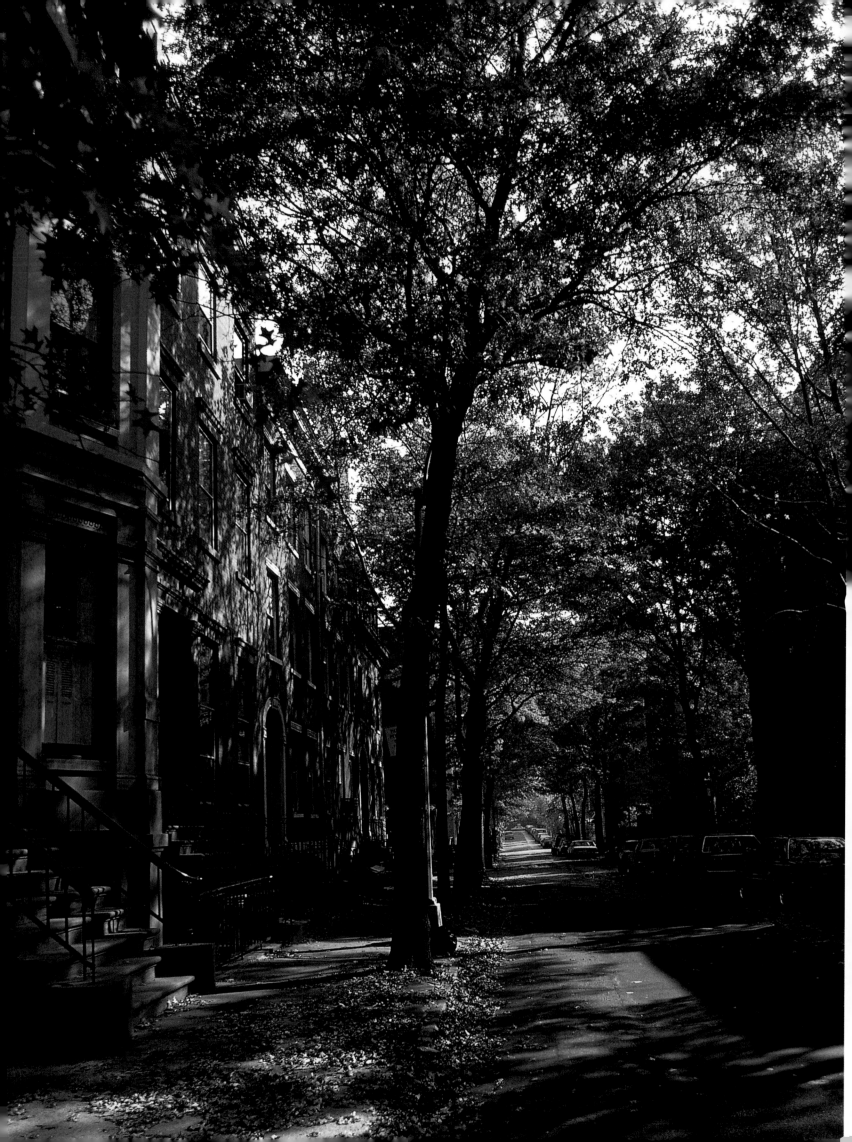

OTHER BUROUGHS

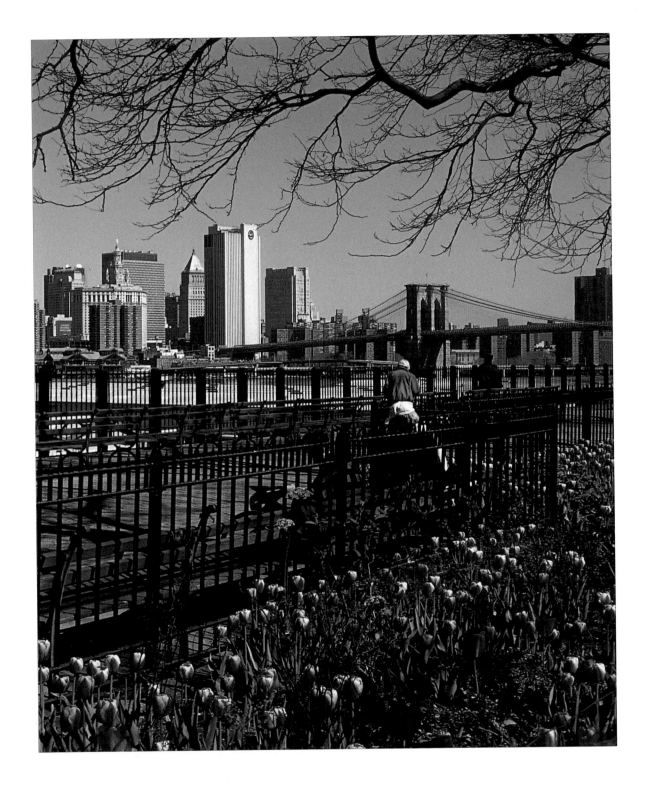

(left) Brooklyn Heights. **(above)** Brooklyn Heights Promenade.

(overleaf) The Brooklyn Botanical Garden.

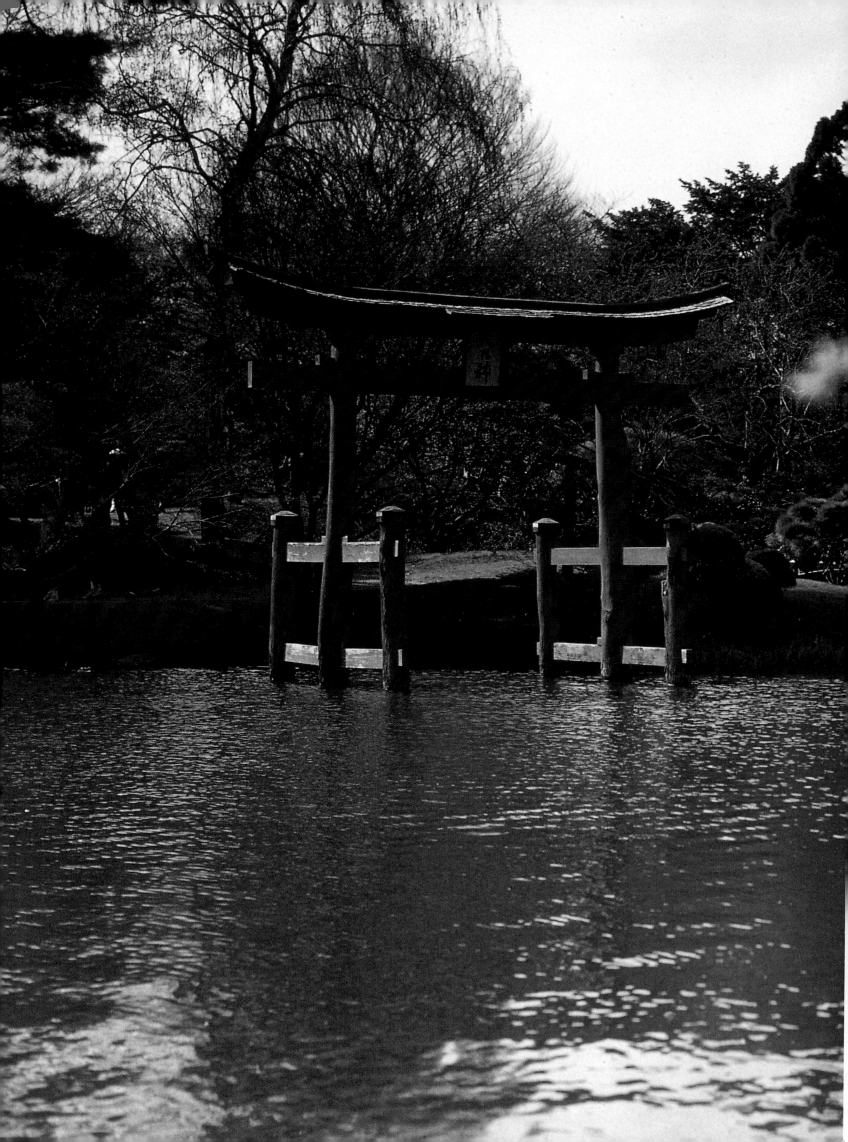

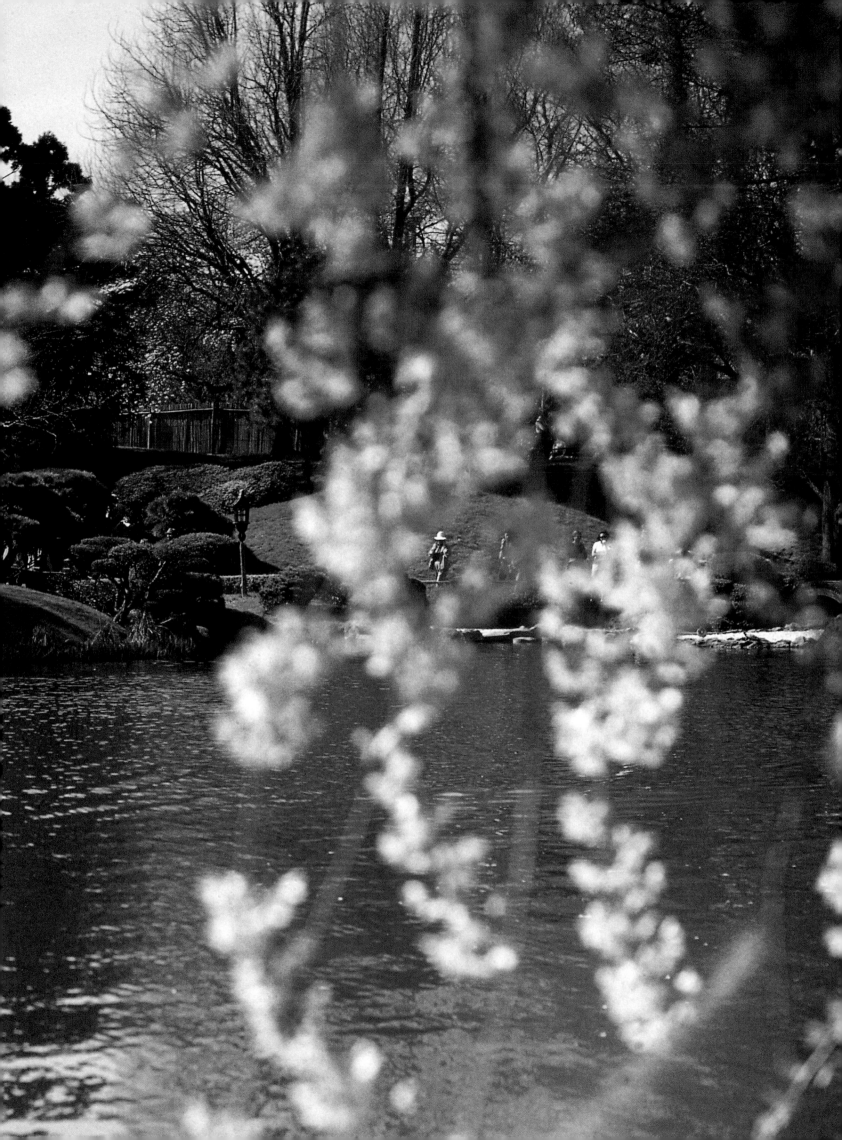

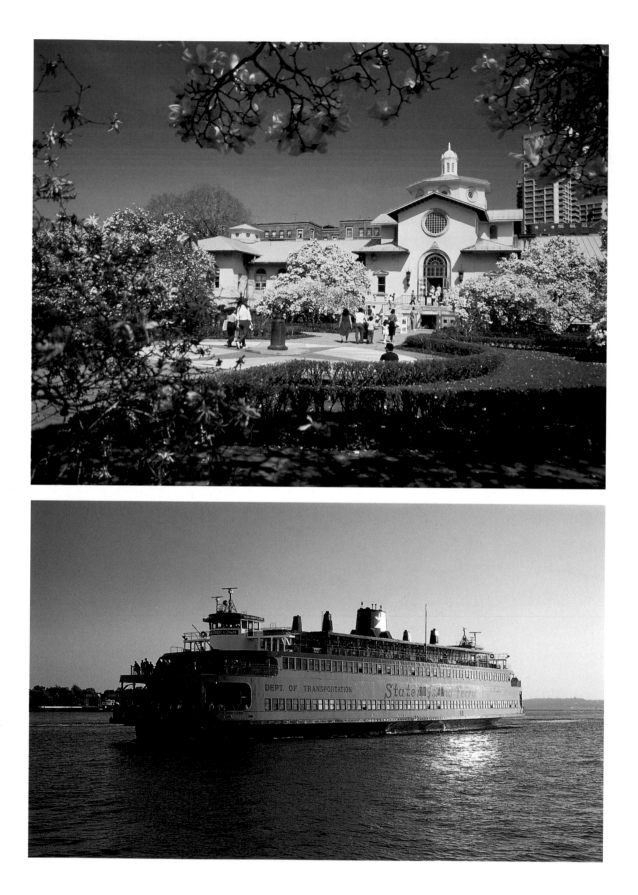

122 **(top)** The Brooklyn Botanical Garden. **(bottom)** Staten Island Ferry.

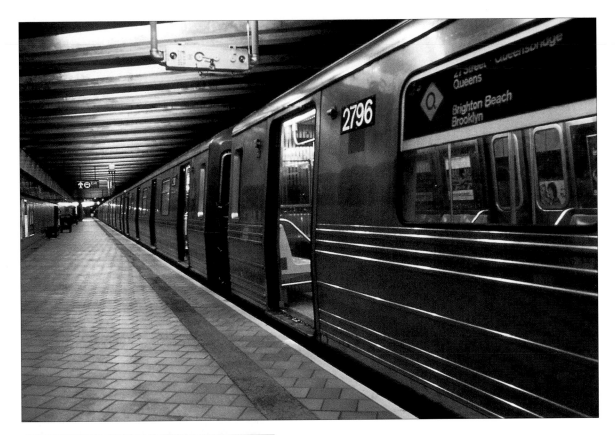

"he present in New York is so powerful that the past is lost."

John Jay Chapman (1862–1933)
American lawyer, essayist, and poet

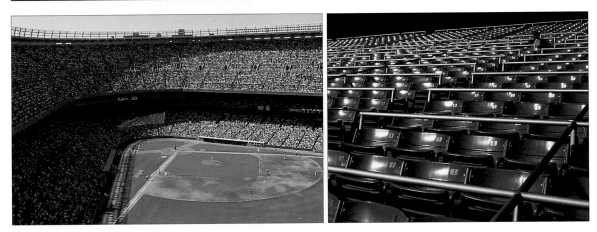

(top) Brooklyn-bound subway. **(middle)** The Brooklyn Bridge as seen from Brooklyn Heights.
(bottom left and right) Yankee stadium.

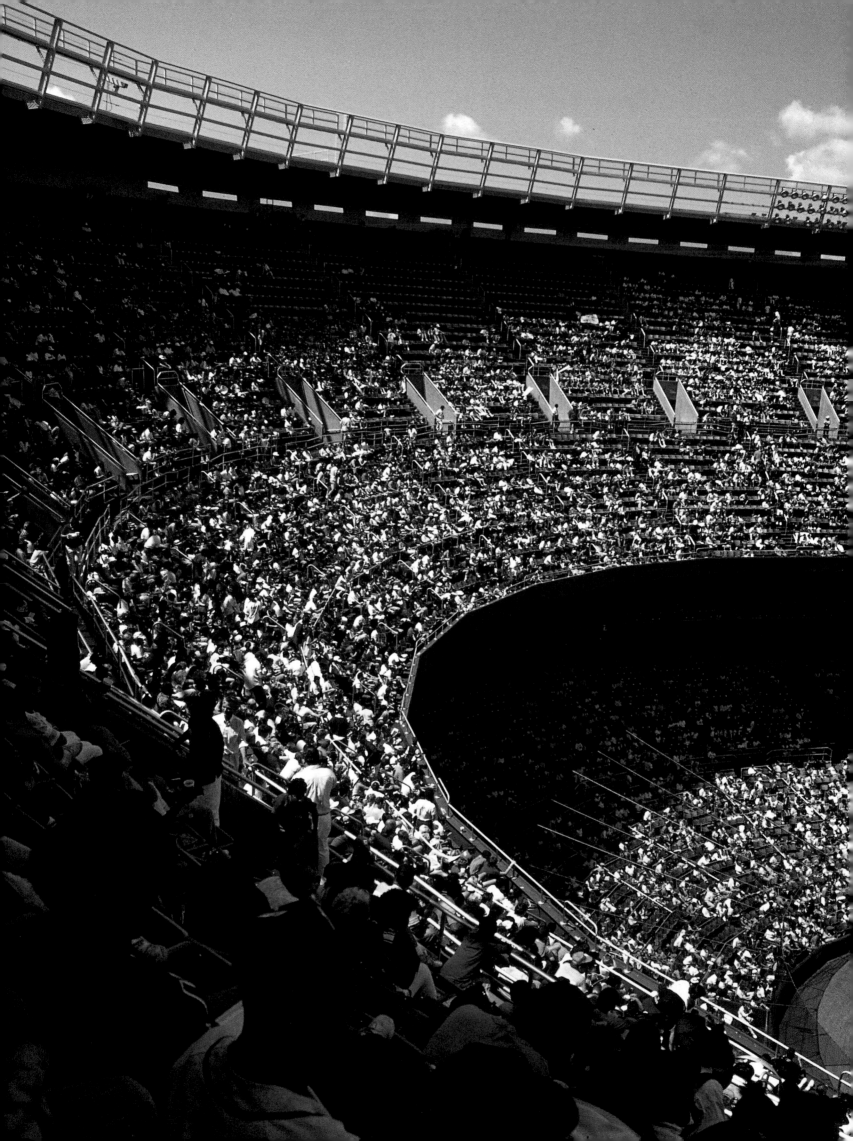

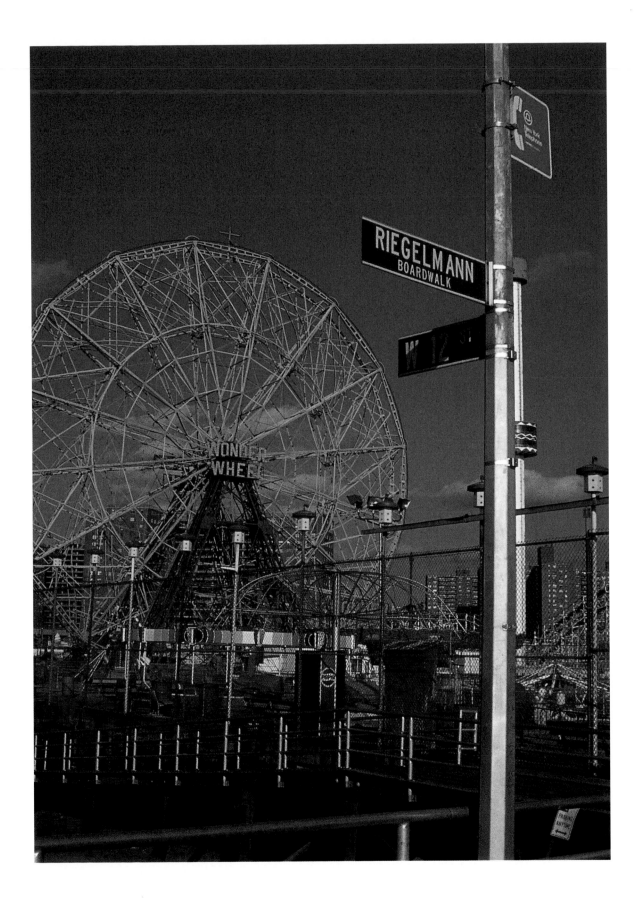

125 **(left)** Shea Stadium. **(above)** Coney Island.

(overleaf) The World's Fair globe and fountain in Queens.

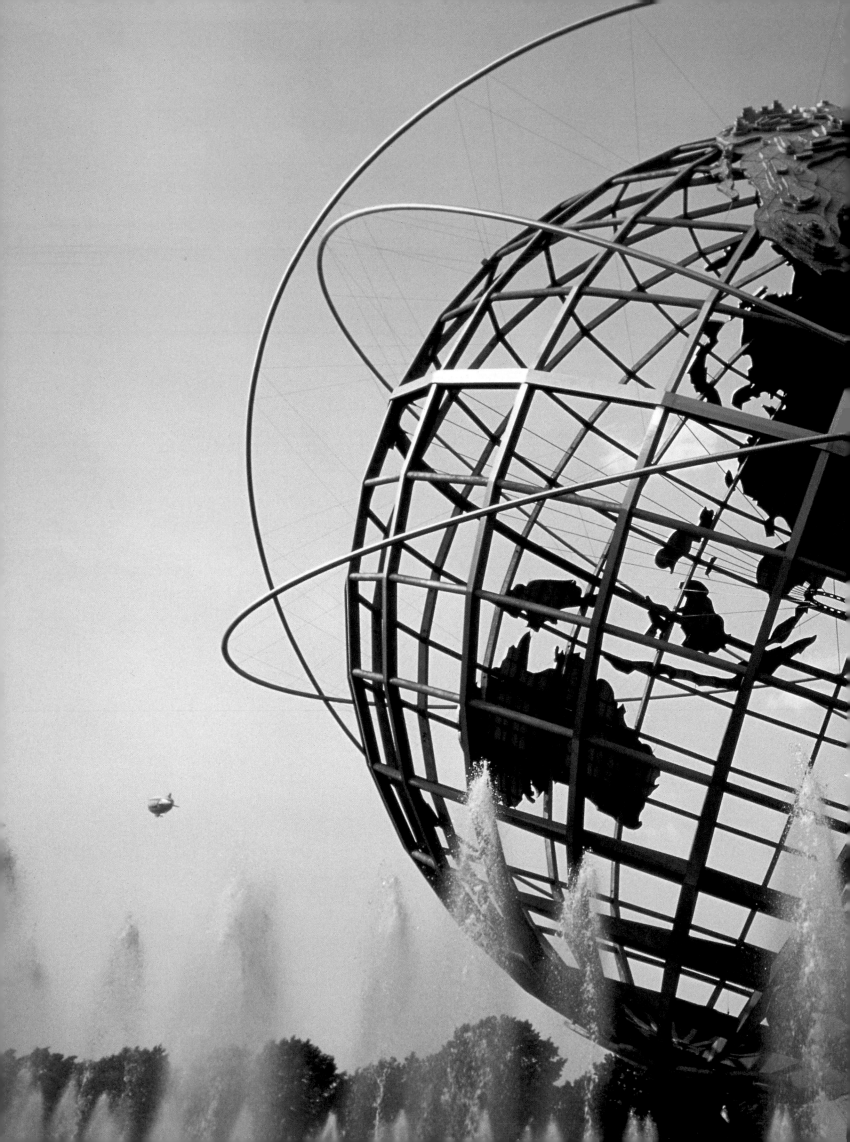

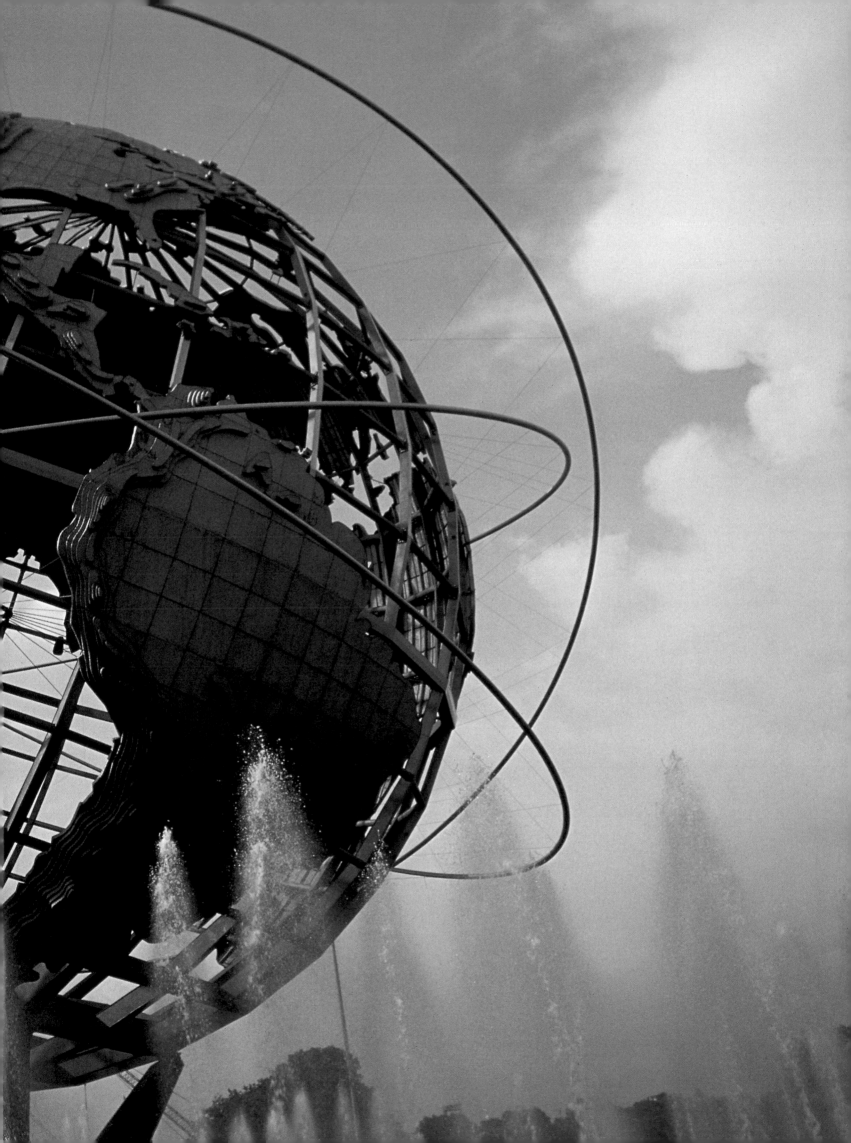

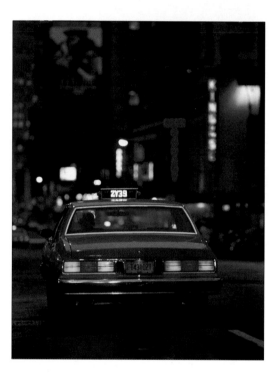

Something about taxi drivers appeals to me tremendously: they're a separate race;

discreet as priests, adventurous as explorers,

independent as cats; they see all, know all, and I suppose do all."

Ogden Nash (1902–1971)
American writer